Ansel Adams
and the Photographers
of the
American West

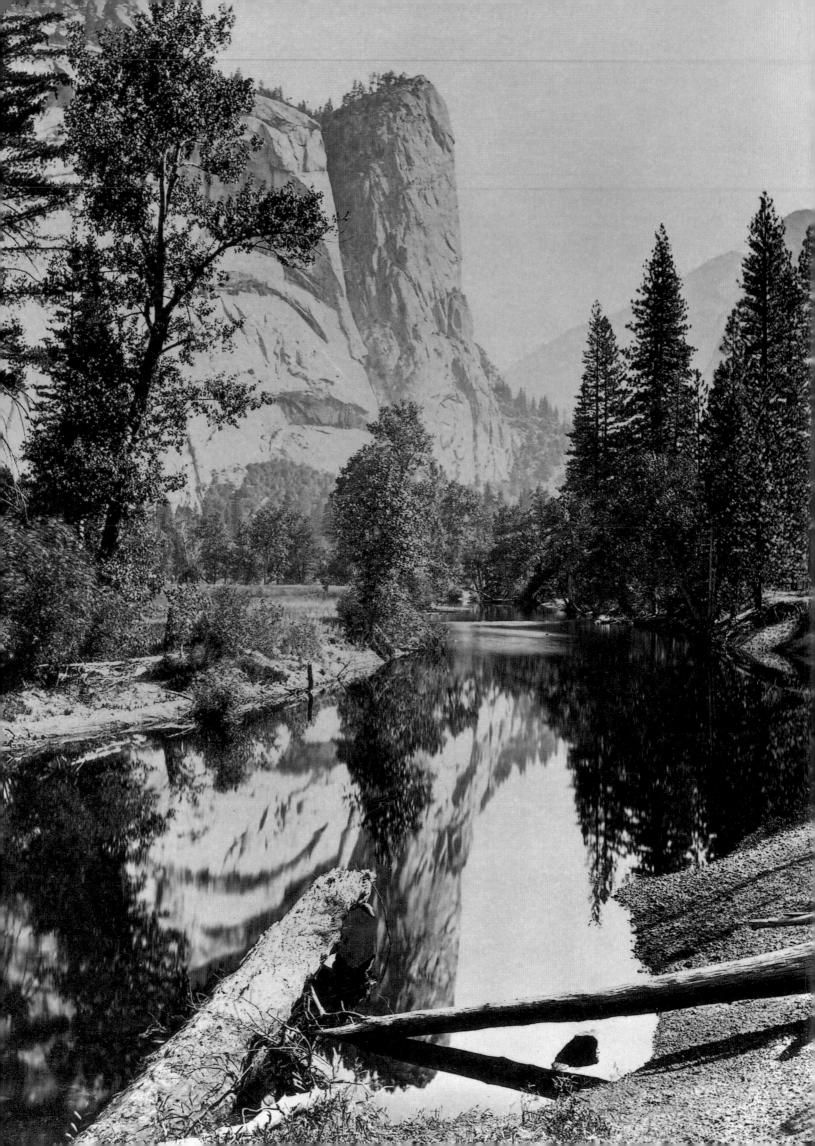

ANSEL ADAMS
and the PHOTOGRAPHERS
of the
AMERICAN WEST

EVA WEBER

THUNDER BAY
P·R·E·S·S

San Diego, California

Thunder Bay Press
An imprint of the Advantage Publishers Group
5880 Oberlin Drive, San Diego, CA 92121-4794
www.advantagebooksonline.com

All notations of errors or omissions should be addressed to Thunder Bay Press, editorial department, at the above address. All other correspondence (author inquiries, permissions) concerning the content of this book should be addressed to World Publications Group, Inc., 455 Somerset Avenue, North Dighton, MA 02764, www.wrldpub.com

ISBN 1-57145-807-7

Library of Congress Cataloging-in-Publication Data available upon request.

Printed in China.

1 2 3 4 5 06 05 04 03 02

p. 2:
Carleton E. Watkins
Washington Columns,
Yosemite, No. 81. c. 1866
RARE BOOK DEPARTMENT,
HISTORICAL PHOTOGRAPHS
THE HUNTINGTON LIBRARY,
SAN MARINO, CALIFORNIA

CONTENTS

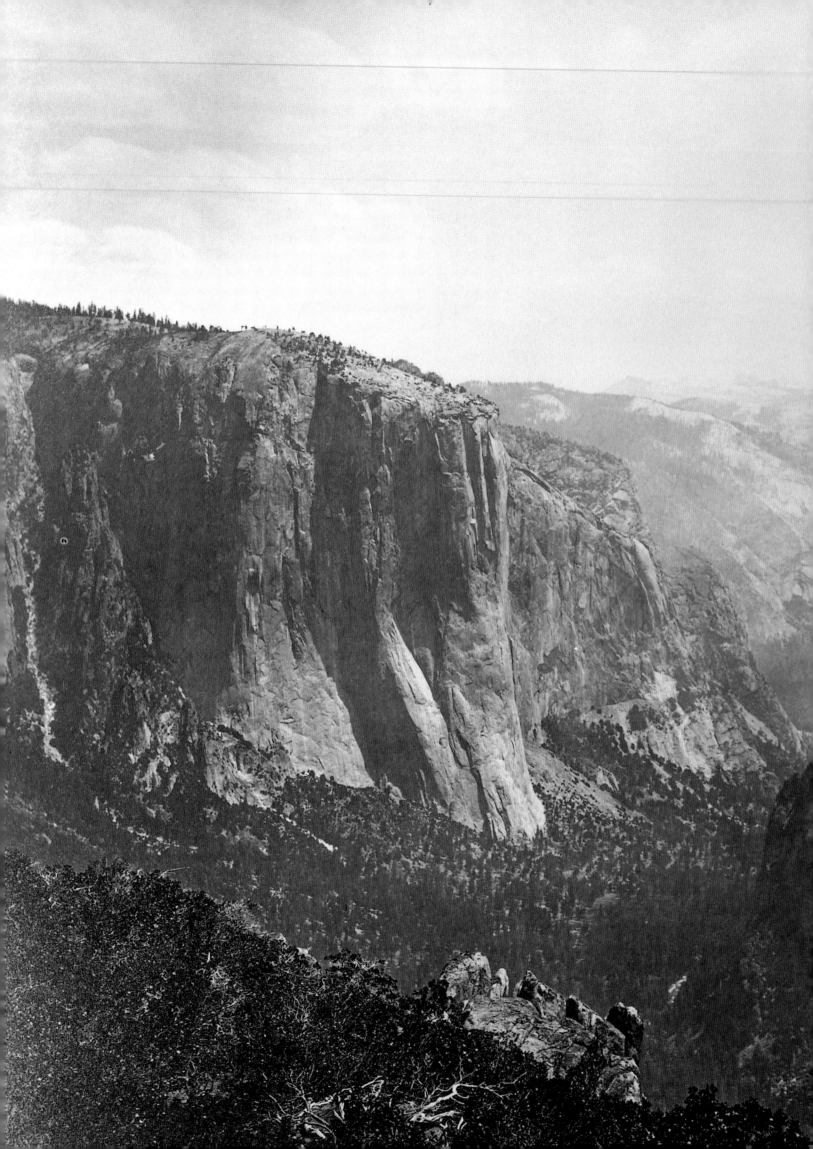

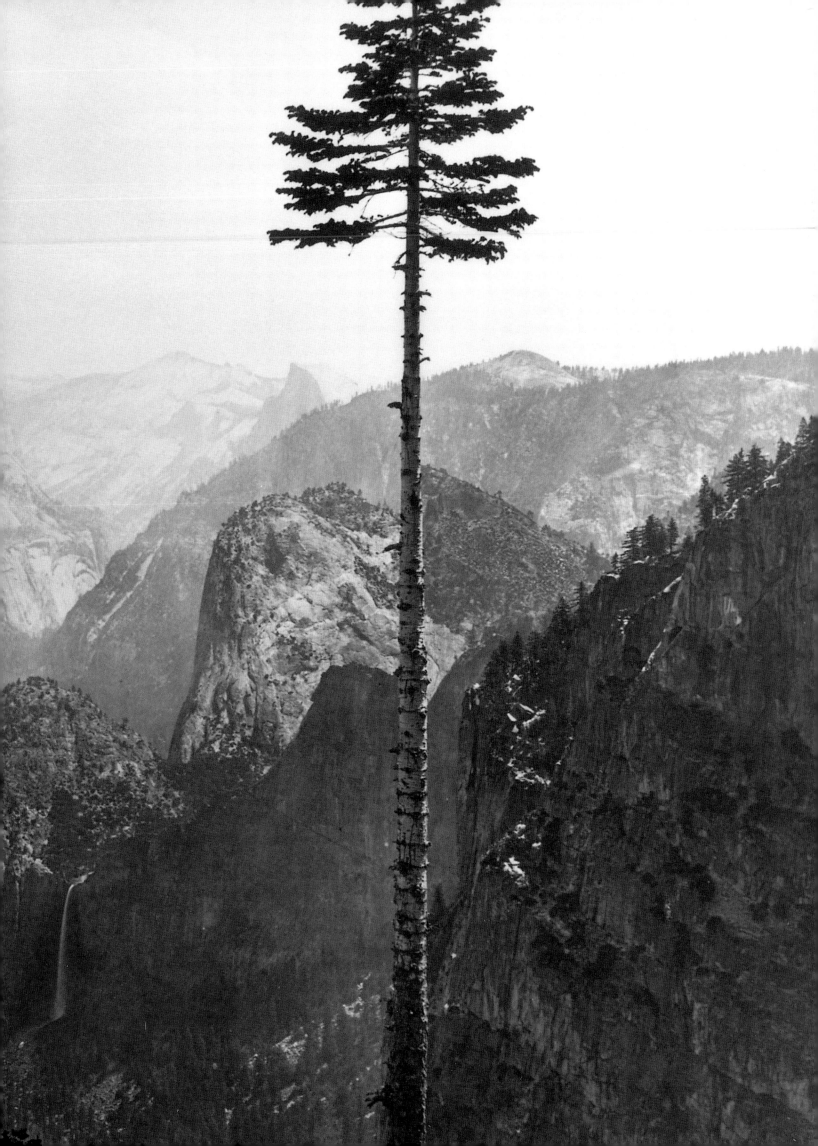

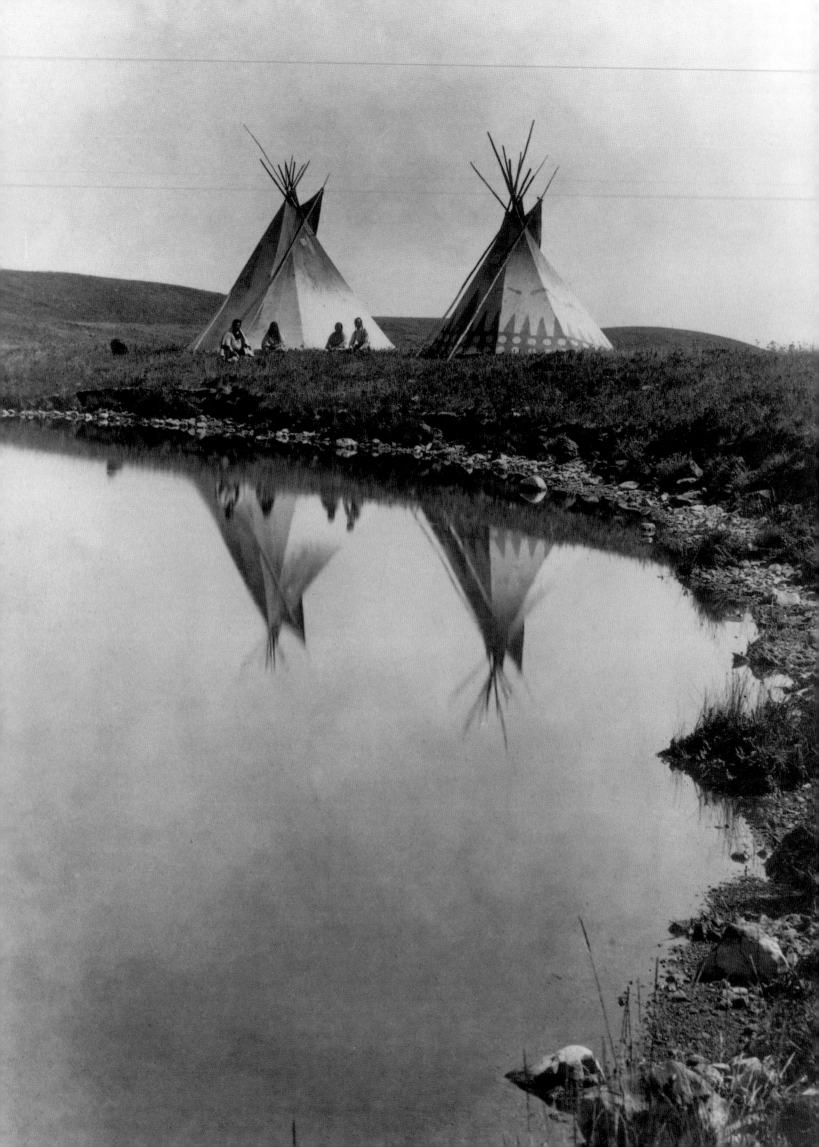

Introduction

The wilderness areas of the American West have been a subject of photography since the middle of the nineteenth century. After photography in the form of daguerreotypy had arrived in America, advancements in photographic technology made it possible to expose and develop reproducible glass-plate negatives out in the field. This was the method used by the cameramen of the Civil War in the early 1860s and by the first great photographers of the West. At about the same time, Carleton Watkins traveled from San Francisco to the breathtakingly scenic Yosemite Valley and there completed a series of photographs hailed for their artistry. Some 60 years later, a young Ansel Adams also came to Yosemite, which inspired him to make his first pictures. Adams's classic works depicting the West's national parks were produced in the early 1940s. Many reflect older landscape traditions, and he saw his photographs as an expression of nature's spirituality. The geological descriptiveness of his images parallels work done by early expedition photographers. Some of these cameramen also documented, for ethnographic purposes, the pueblo peoples and architecture of the Southwest, a region to which Adams was drawn as well. The colorful and tragic history of the West and its Native Americans was captured by those who sought to satisfy the public appetite for such images. As the Indians were confined to reservations, photographer Edward S. Curtis re-created their life as he imagined it might have been. Another immense body of photographs of the West and its people during the 1930s was produced by New Deal documentarians who sought to improve the lot of the poor and dispossessed. In a departure from his more familiar photographs, Adams also assembled a photo-essay on the Japanese-Americans unjustly interned at California's Manzanar camp. In the 1950s, Adams began to use his spectacular views of the national parks to spread an environmentalist message. In employing his landscape photographs for propaganda purposes, he was following again in the footsteps of his nineteenth-century predecessors, whose own magnificent views had helped to win a protected status for Yellowstone and the Yosemite Valley.

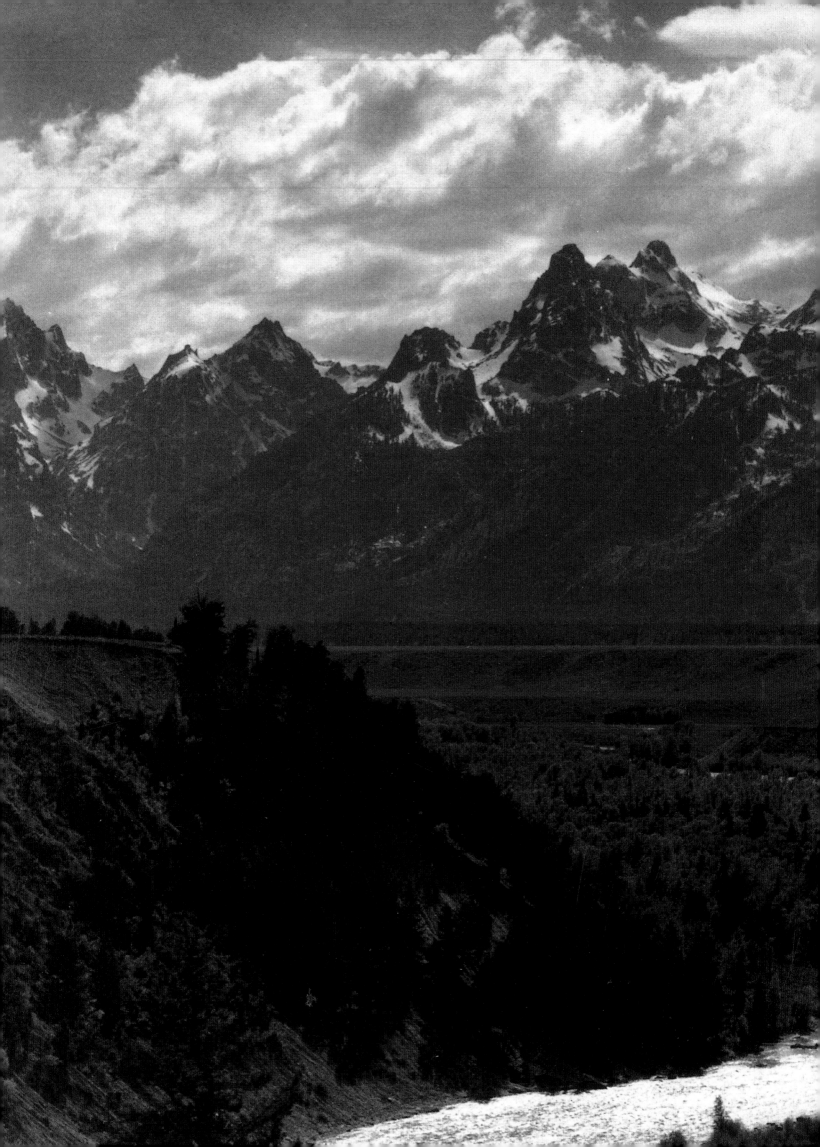

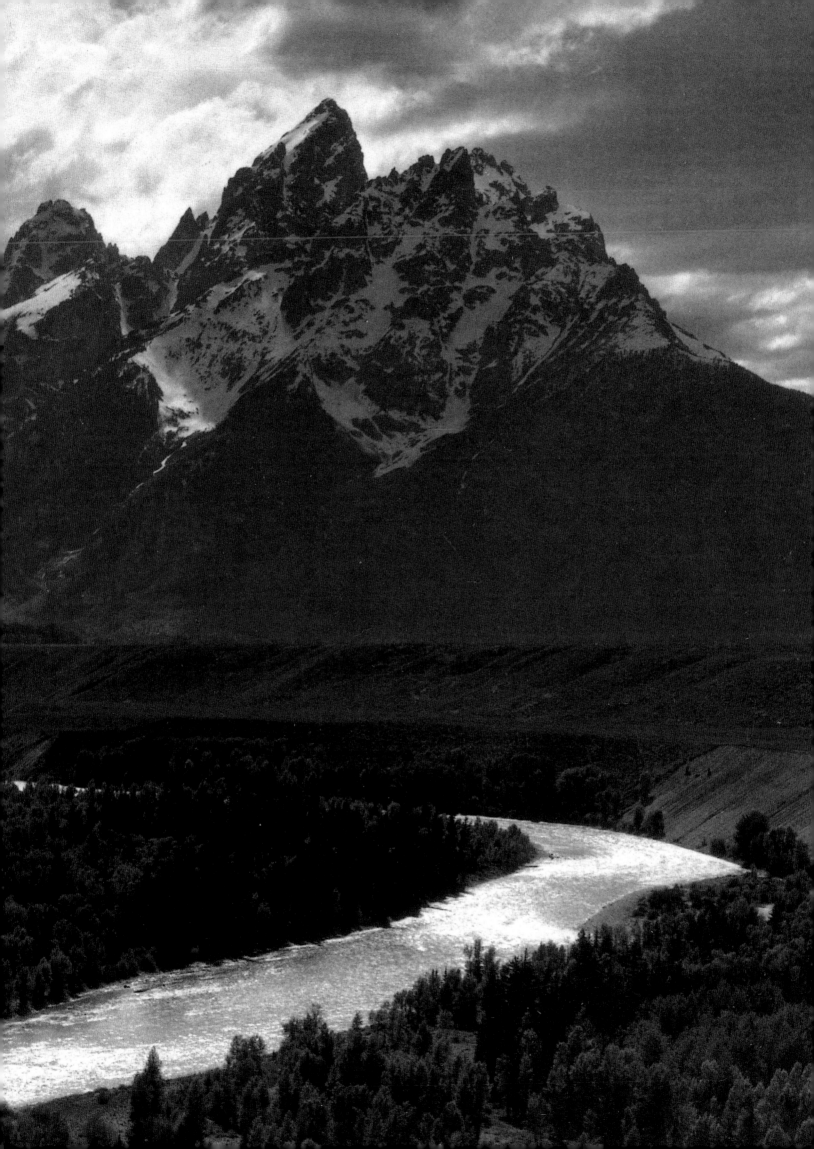

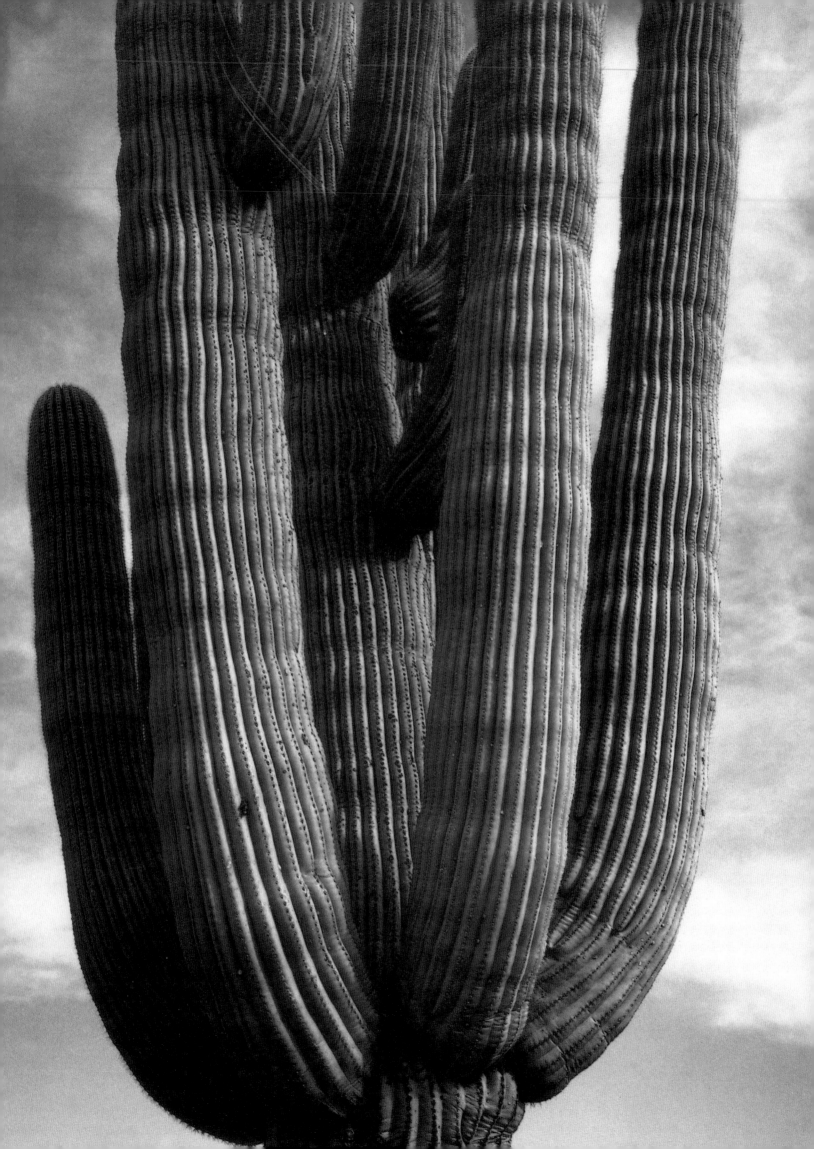

ANSEL ADAMS

Ansel Adams is a figure of towering stature in the history of photography. Not only was he America's greatest landscape photographer of the twentieth century, but he also worked mightily to restore photography to the status of a fine art. He fought, as well, to protect the pristine wilderness that was his primary subject. As a photographer, teacher, and environmentalist, he came to dominate the discourse in each of these areas during his last decades. Yet, his achievement was not an isolated phenomenon. When Adams is considered in the wider context of the photography of the American West, he emerges remarkably a product of his place and times. Traditions, techniques, and themes reaching back into the nineteenth century informed his art and activities. His contemporary world of modernist art trends, commercial exigencies, and socio-political upheavals also influenced his output and his attitudes. His connections to and diversions from America's Western photography of the past and of his lifetime helped shape Adams into the unique individual and artist that he was.

Ansel Easton Adams (1902–84) was born in San Francisco to a middle-class family which claimed descent from the presidential Adams family and which had the resources to provide him with private tutoring after 1915, when he became too hyperactive to stay calm in school. Yet he was able to exert enough self-control to teach himself to play the piano and to read music in 1914. As part of his unorthodox education, his father purchased a pass to the 1915 Panama-Pacific Exposition, which Ansel visited nearly every day for a year. There he learned to use and demonstrate a number of scientific and musical instruments.

In early 1916, Adams became infected with influenza. He relieved his long convalescence by poring over a guide book that described the attractions of Yosemite National Park, located some 150 miles east of San Francisco in California's Sierra Nevada range. He was so entranced by this inventory of Yosemite's charms that he persuaded his family to visit the area the next summer on a vacation trip. This was the occasion on which he made his first photographs with a Kodak box camera. Back in San Francisco, he became apprentice to a photo-finisher who processed some 1,000 prints per day.

Yosemite was to remain of vital importance to Adams for the rest of his
life: he tried to spend at least part of each year there. It was the venue where he
became a photographer, where he made a marriage and his first home away
from San Francisco, where he continually returned in order to renew his spirit
and health, and where he took many of his most memorable images. He often
repeated the same view in varying conditions of light, climate, and season—
in effect, creating a composite portrait through time of his beloved valley.
Yosemite was emblematic of Adams's lifelong attraction to the mountains and
to the wilderness as a source of spiritual sustenance and of artistic themes.

The secluded beauty of the Yosemite Valley, carved out by prehistoric
glaciers and surrounded by dramatic cliffs, domes, spires, and waterfalls, was
reminiscent of an enchanted Shangri-La, the magical hidden valley of fiction.
Its virgin wilderness was the aspect that Adams explored in his photographs,
and he fastidiously excluded any trace of the detritus of tourism that had
arisen there, beginning soon after its settlement by non-Native Americans.
By the end of the 1930s, Yosemite was dotted with hotels, rental cabins, ski
lodges, campgrounds, stables, dance halls, sports facilities, a museum, and
park administration structures, all made accessible by 23 miles of highway,
275 miles of roads, and 688 miles of trails.

Yosemite had been famous as a natural wonder since the 1850s. Although
a party of trappers led by Joseph Walker had crossed the area twice in 1833–34
and had been the first group of transients to see the Giant Sequoia trees, the
Yosemite (or Ahwahnee) Valley remained home to the Yosemite Indians until

they were ousted by a military expedition in the early 1850s. In 1855 the first tourist excursion arrived in Yosemite and initiated the commercial exploitation that led to its federal designation as a California state park in 1864. In 1868 conservationist and nature writer John Muir first arrived. Overwhelmed by Yosemite's natural beauty, he began in 1890 to lobby for its designation as a national park, and in 1905 led President Theodore Roosevelt, an active conservationist, on a four-day camping trip in Yosemite. Ironically, its popularity as a tourist destination was the key to his success. Yosemite's reputation had opened up a considerable business opportunity for photographers, notably Carleton Watkins and Eadweard Muybridge, in the 1860s. Each created and successfully marketed various series of artistic photographs depicting Yosemite landscapes.

Although Adams's Yosemite photographs often resembled the spectacular vistas of his nineteenth-century predecessors, his underlying motivation came to parallel the ideas of John Muir. Muir had sought in his writings to re-create for the reader his own transcendent experience of climbing the mountains, but he also used his vivid descriptions of the Sierra Nevada as a tool to win support for the protection and preservation of such still largely pristine areas from commercial exploitation and from federal intervention. Although Adams is not immune from the criticism that he later over-commercialized his own landscape work, he also used it, often in tandem with its widespread marketing, to become as influential a conservationist in his own time as Muir had been in his era. But all that still lay in the future.

Indeed, several years after his first visit to Yosemite, Adams became a direct beneficiary of Muir's efforts. Although Adams never met Muir, who died in 1913, he became quite familiar with Muir's numerous articles and books about the Sierra Nevada. It was as an employee of the Sierra Club, founded as a recreational and conservationist organization by Muir in 1892, that Adams was able to begin to hone his skills as a photographer.

Adams became the seasonal caretaker of the Sierra Club's Yosemite lodge in the summer of 1920, an occupation that was to extend over four years. During this time, he regarded photography as secondary to what he believed to be his true vocation—music. He pursued a dedicated regime of intense practice, culminating in occasional public performances. At Yosemite he practiced piano in the studio of landscape painter Harry Best, whose daughter Virginia he would marry in 1928.

His early photography, which Adams regarded as an engaging hobby and a source of additional income, followed the conventions of the then-fashionable pictorialist photography, characterized by poetic and soft-focus images that resembled Impressionist paintings. This blurry effect was enhanced further by means of darkroom manipulations of the negative and print. His compositions also often reflected his knowledge of the nineteenth-century landscape tradition of Yosemite painters and photographers Albert Bierstadt, Thomas Moran, Watkins, and Muybridge.

In those years he led the life of a physically vigorous mountaineer, conducting solo and Sierra Club group expeditions into the more remote Sierra. There, while experiencing the high-altitude epiphanies of nature's cosmic unity as described by Muir and others, he began to direct his photographic efforts toward capturing and re-creating such moments of intense spirituality. From the mid-1920s on, Adams began to assemble proof albums of his photographs from the trips taken by Sierra Club members, who then could order prints.

This early series of Yosemite images tracks his progress from an amateur pictorialist who recorded each ascent to a self-conscious modernist devoted to straight photography, who explored his mountainous subject matter through the use of sharp focus, varied framings, and different viewpoints under the fluctuations of the changing natural light. He also discovered the technical means, by using colored filters, to control the tonal range of his images and hence produce the artistic result he had imagined prior to making his exposure. This previsualization, as he later termed it, became a central concept of Adams's work, and he codified it in 1941 in the Zone System, a way of controlling exposure, development, and printing methods to achieve the previsualized result. Paradoxically, while straight photography as a new artistic movement espoused realism, he continued to manipulate the negative and the print, even to the point of erasing obtrusive graffiti from a rock face in the darkroom, much as he had as a pictorialist creating landscapes of a more fictive genre. When he found an especially striking subject, he would make more than one exposure so that he would have an extra negative with which to experiment. He also experimented with different cameras and formats—in 1935 with a miniature camera and with creating photomurals, and in 1963 with a Polaroid camera. He did some color photography as well, but black-and-white photography was to remain his favored medium. What influenced this preference was that "its inherent abstraction takes the viewer out of the morass of manifest appearance and encourages inspection of the shapes, textures, and qualities of light…"

Around this time, he extended his circle of acquaintances from mountain climbers and musicians to other serious photographers, painters, and Albert Bender, a wealthy San Franciscan who sponsored his first production as a visual artist, the portfolio *Parmelian Prints of the High Sierras*. On excursions in the late 1920s to Carmel on California's northern coast, and to New Mexico's Santa Fe and Taos, he visited the era's artistic enclaves. In Taos he met photographer Paul Strand, whose recent works—produced after his own 1915–17 conversion to straight photography—galvanized Adams in 1930 to the retroactive realization that photography rather than music was to be his life's purpose. His musical career was not wasted though, as he was able to translate the self-discipline acquired from years of piano practice to the art and science of photography, which he often viewed through a musical sensibility: "The performance of a piece of music, like the printing of a negative, may be of great variety and yet retain the essential concept."

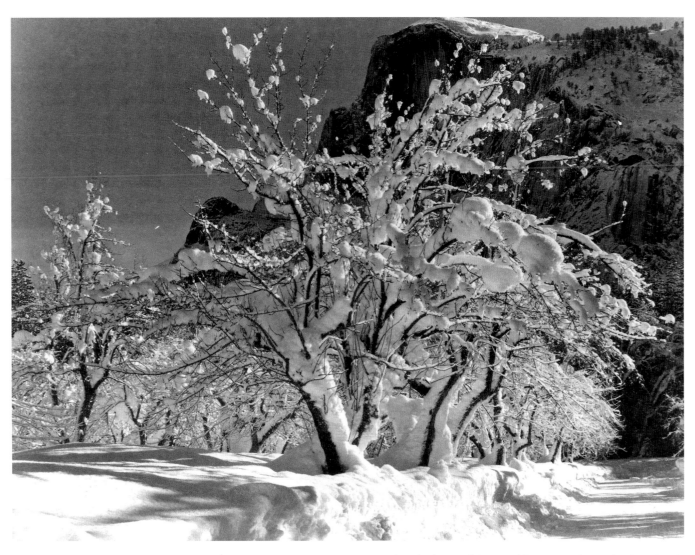

Ansel Adams
Half Dome, Apple Orchard
Yosemite National Park,
California
National Archives

Once he chose this course, he dedicated himself to it with undiminished energy and ambition for the next seven years. In 1931 he began to publish reviews and criticism, and to propound his ideas about photography in print, in lectures, and in great numbers of letters. He also continued to produce books. The first had been *Taos Pueblo* (1930), with a text by Mary Austin. Over the next decades he provided photographs for, wrote, or collaborated on some twenty-five books, six of them technical manuals. In addition, he produced five portfolios, the last in 1970. Among his subjects were Yosemite, the Sierra Nevada, the national parks, Death Valley, the Southwest, Hawaii, the Tetons, and Yellowstone. With his books, Adams also played an important role in improving the quality of photographs issued as reproductions. His numerous magazine articles included ones on other American photographers, on photography as an art, on photographic technique, and on environmentalism. There were photographic essays as well, most of them on the natural wonders of Western scenery.

In 1932, together with Edward Weston, Willard Van Dyke, Imogen Cunningham, Sonia Noskowiak, and Henry Swift, he founded the informal organization of West Coast photographers called Group f/64 to explore the expressive possibilities of straight photography and to promote the making of

technically flawless prints. Of this group, Weston also produced a series of impressive Western landscapes. Adams's own work at this period was an integral part of these investigations. By the frequent use of extreme close-ups and of strong contrasts of light and dark, he sought to capture texture, geometry, rhythm, and pattern in an often two-dimensional effect that approached and echoed the modernist trends of cubism and abstraction.

In 1933 Adams journeyed to New York to cultivate a relationship with Alfred Stieglitz, then the great American impresario of modernism and of photography as a fine art. After his return, Adams imitated Stieglitz's art gallery by establishing his own San Francisco gallery—a project in which he soon lost interest. Over these years, he continued to master his legendary technique both in the field and in the darkroom. These methods he detailed in *Making a Photograph*, which became an influential vehicle of his practical knowledge and of his ideas on artistic composition. He also had started to promulgate this material in lectures and in teaching students of photography, activities he was to continue for the rest of his life. In late 1936, Stieglitz awarded Adams the highest possible honor by showing 45 of his photographs in a highly successful one-man show at his Manhattan gallery, An American Place. Adams was the first photographer to be exhibited by Stieglitz since his 1917 show for Paul Strand.

The cumulative pressure of all this was too much. After his return home in mid-December, he suffered a physical and mental collapse which became an extended depression. To alleviate the stresses causing this crisis, Adams set out to simplify his life by moving with his family first to Berkeley, and then, in May 1937, to Yosemite. (In 1962 he moved to his final home, a splendid new house on the Carmel coast.) But the bad karma persisted—the Berkeley house was seriously damaged by an earthquake, and his Yosemite studio was ravaged in a fire that destroyed much of his work, although many negatives, fortunately, were saved.

A commission to produce the book *Sierra Nevada: The John Muir Trail* (1938) turned his attention back to the mountains as a photographic theme and as a source of spiritual consolation. The book helped to win national-park status for the Kings Canyon region in 1940. While photographing for this volume, he became interested in depicting the effects of sunlight on the terrain. Of particular interest to him was the arrival of dawn, an event that coincided with his own lifting depression and renewed feelings of hope. Other transient effects that caught his attention were snow, rushing waters, and especially the clouds, both dramatic and delicate, that accentuated his panoramic mountain views. He once described billowing clouds as landscapes in celestial form. His juxtaposition of the "eternal quietude of stone" with such ephemeral elements suggested the mutability of nature and an analogy to the interrelationship of matter and spirit.

In this series he also included close-up photographs, including a tree root, a rock segment, and the surface of a burned tree stump. Of these, he

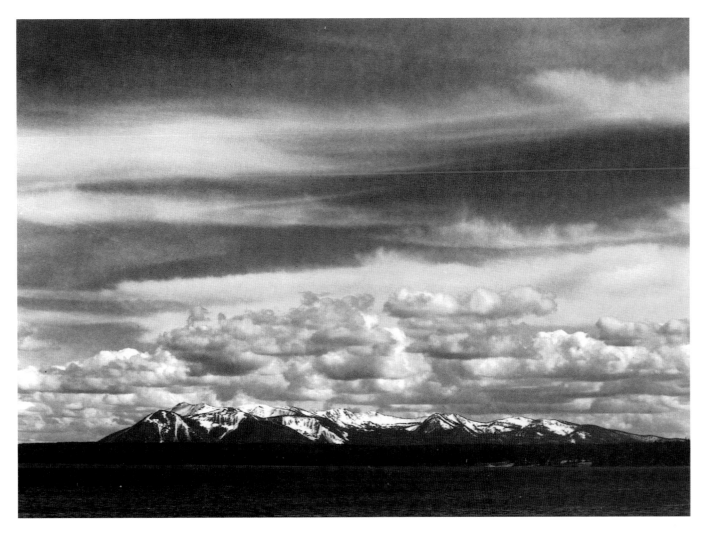

Ansel Adams
Yellowstone Lake,
Mount Sheridan
Yellowstone National Park,
Wyoming
National Archives

commented that they "all relate with equal intensity to the portrayal of an impressive peak or canyon." In his depiction of both the "grandeur and poignant minutiae," he linked microcosm and macrocosm in nature's "eternal incarnations of the spirit which vibrate in every mountain, leaf, and particle of earth, in every cloud, stone, and flash of sunlight…"

In 1939 he returned to his goal of carving out a role as Stieglitz's heir, to become a leading figure of the American art world, when he directed for the San Francisco Golden Gate Exposition the huge exhibition "A Pageant of Photography." By now he had grown into a more tolerant and appreciative attitude toward photography's complex history. This effort brought him to the notice of Beaumont and Nancy Newhall, who were instrumental in establishing and directing the department of photography as a fine art at New York's Museum of Modern Art (MOMA). Adams contributed to the plans for organizing the department, as well as to those for its inaugural exhibition. In 1942 he assembled the exhibit "Photographs of the Civil War and American Frontier." In 1944 he conducted a lecture series, and the following year he taught a photo course at the museum. However, his own work had to wait for a MOMA solo exhibit until 1979, after the departure of department director Edward Steichen, whose policies he had opposed. Emboldened by his experience as a MOMA consultant, Adams went on in

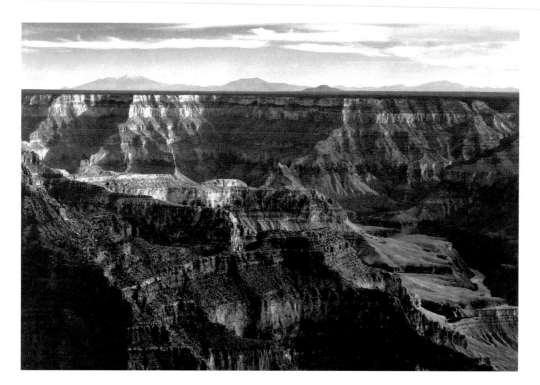

Ansel Adams
*Grand Canyon National Park,
Arizona*
NATIONAL ARCHIVES

1946 to found the photography department at the California School of Fine Arts (later the San Francisco Art Institute), in 1967 to organize the Friends of Photography, and in 1975 to help establish the University of Arizona's Center for Creative Photography in Tucson to house his own archive. From the 1950s to the '70s, he also collaborated with Nancy Newhall on a series of books, exhibitions, and other projects.

There is some truth to the accusation that Adams was out of touch with the political realities of his era. He didn't support the labor cause as did other leading photographers and artists during the Depression years. In fact, he criticized the government-funded social documentarians of the 1930s for veering toward leftist propaganda. While other gifted photographers like Dorothea Lange depicted the breadlines of the unemployed and evicted migrant farm workers, Adams retreated to the Sierra Nevada to photograph his glorious mountains again. Yet he did eventually go to work for the government as a consultant to the armed forces on reconnaissance photography and, in 1942, for the Office of War Information, which produced patriotic domestic propaganda. In 1943 he documented interned Japanese-Americans at Manzanar, California.

His most important and lucrative government work came in 1941, when Secretary Harold Ickes invited him to join the Interior Department's Mural Project, which assembled artwork to adorn the agency's new building. Ickes had seen and later purchased for his office a mural-screen by Adams of an oversized close-up of a fern and leaves. He had also met him when Adams came to Washington in 1936 to lobby for the designation of Kings Canyon as a national park; Adams later added the photographs from the Kings Canyon portfolio to his Mural Project work. His mandate was to photograph areas administered by the Interior Department, including national parks, Indian lands, and reclamation projects. From October 1941 through June 1942,

he took 225 photographs in the West and Southwest. He tried unsuccessfully to extend his commission beyond this period by citing its patriotic nature. According to Adams, this magnificent scenery was a symbol of what the United States was fighting for in World War II—a demonstration of America's "scope, wealth, and power." His Mural Project works (from which all his photographs in this volume were selected) now are considered classic Ansel Adams landscapes in their depiction of nature in its grand, primordial, and spiritually uplifting aspects. As it turned out, however, these photographs were never made into murals.

After the war, a 1946 Guggenheim Fellowship, renewed in 1948, allowed him to continue photographing the national parks both within and beyond the West. By then he had become even more interested in the photographic representation of the passage of time. Publishing some of this later work in *My Camera in the National Parks* (1950), with a text promoting an environmentalist stance, he described these wonders of nature as "symbols of spiritual life," as sacred places that would not tolerate development or pollution. This message of preservation reached its culmination in the 1955 Sierra Club exhibit and book. *This Is the American Earth*, prepared with Nancy Newhall. This enormously influential project, which included images by other leading photographers as well, helped to define the emerging environmentalist movement. After that, Adams devoted increasing amounts of time and effort to promoting an environmentalist agenda by means of personal lobbying, organizational activities, lectures, exhibits, and his photographs.

From the 1960s on, Adams took fewer and fewer new photographs and devoted more of his time to reprinting older negatives in reworked versions that featured the more dramatic aspects of the Western landscape, often by increasing the contrast between light and dark areas. The sheer volume of the prints he produced and sold helped increase appreciation for photography by art institutions and in the world of popular culture, where Adams became a well-known and even beloved figure. Indeed, when he announced in 1975 that he would stop filling orders for individual prints at the end of the year, some 3,000 orders poured in; it took him three years to catch up with the backlog. All this added fuel to the boom in fine art photography and collecting. Although his reprints added to the confusion about the dating of his photographs, this matter caused him little concern.

During his later years, Adams was recognized by numerous honors and awards. Among them were his 1966 election as Fellow of the American Academy of Arts and Sciences, his 1980 Presidential Medal of Freedom, and his portrait on the cover of *Time* magazine in 1979 as "the Grand Old Man of a still young art." The posthumous honors were perhaps the most appropriate. Over 200,000 acres in the Sierra Nevada were set aside as the Ansel Adams Wilderness Area, and on the first anniversary of his death in 1984, a crag above his favorite spot was named Mount Ansel Adams. This is where his ashes came to their final resting place.

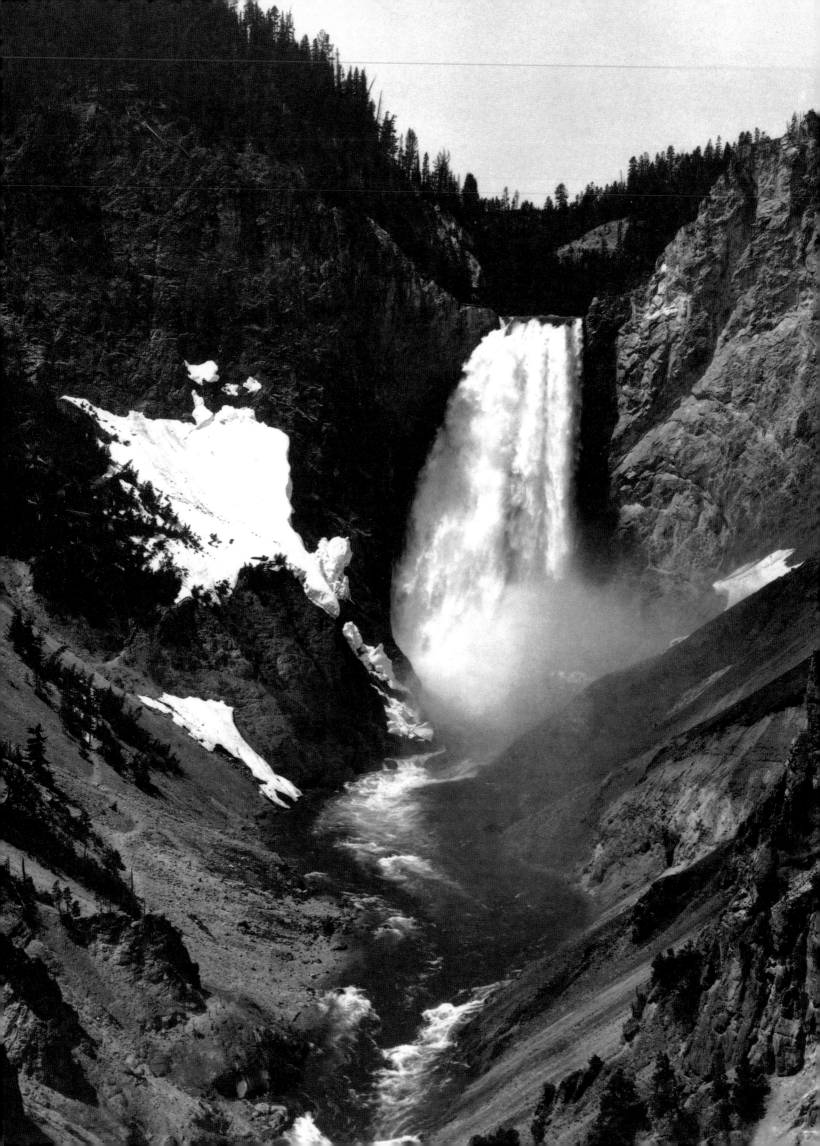

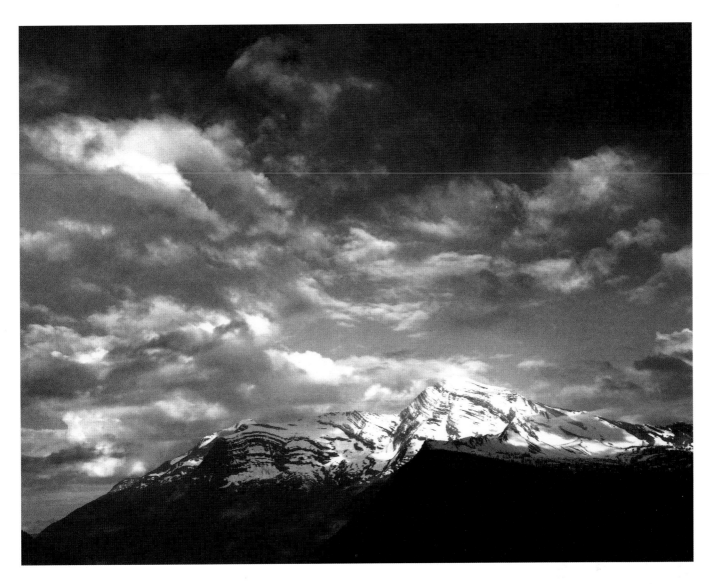

Opposite:
Ansel Adams
Yellowstone Falls
Yellowstone National Park, Wyoming
NATIONAL ARCHIVES

Above:
Ansel Adams
Heaven's Peak
Glacier National Park, Montana
NATIONAL ARCHIVES

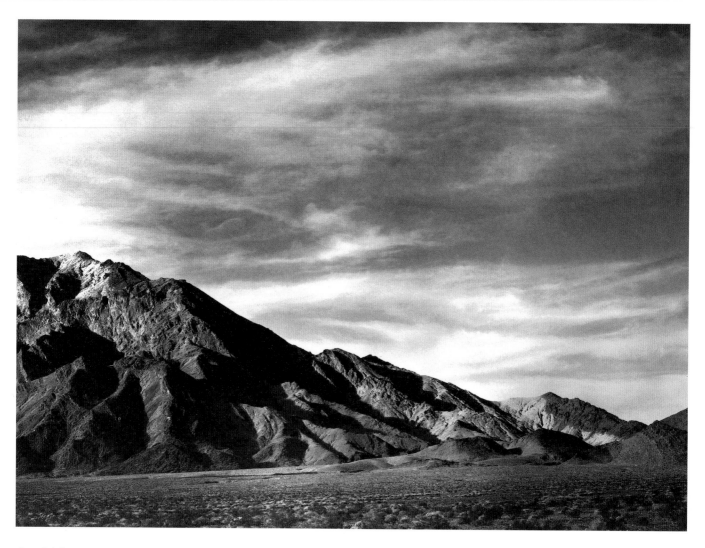

Ansel Adams
Near Death Valley
Death Valley National Monument,
California

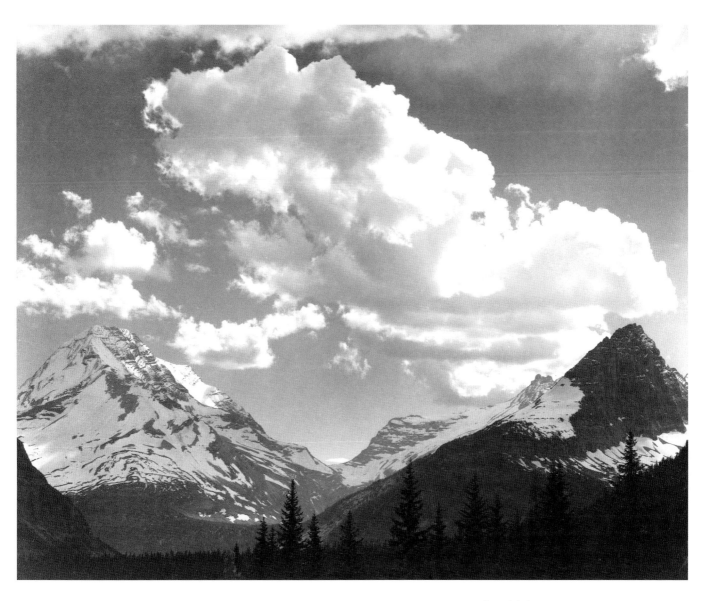

Ansel Adams
In Glacier National Park, Montana

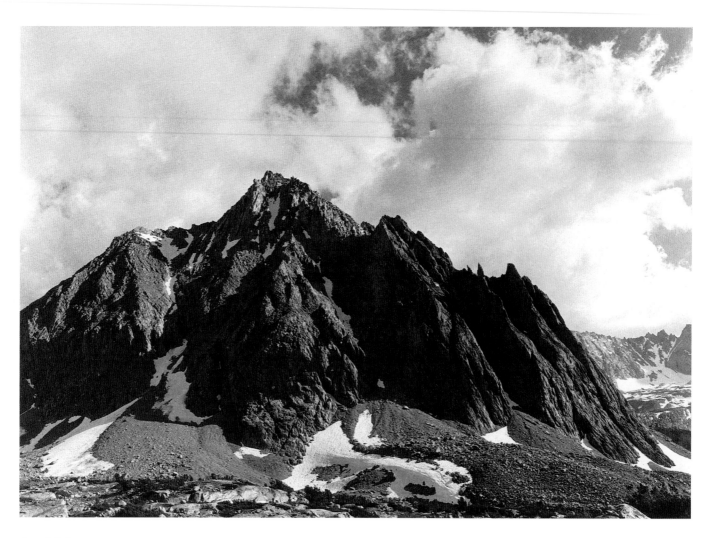

Ansel Adams
Center Peak, Center Basin
Kings River Canyon, California

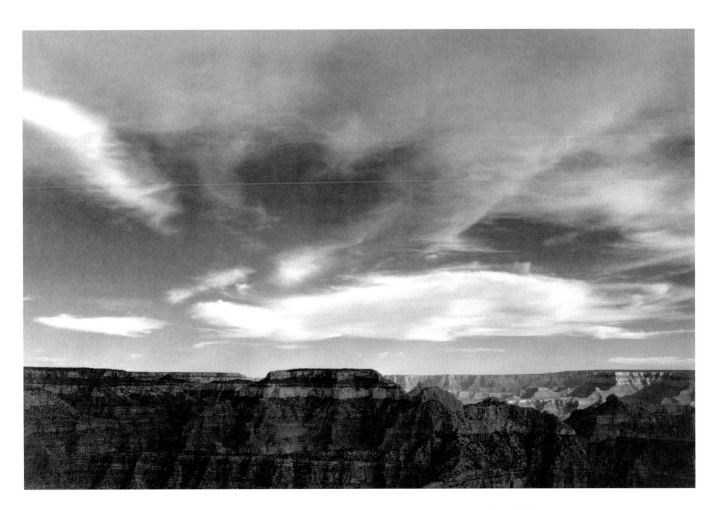

Ansel Adams
Grand Canyon National Park, Arizona

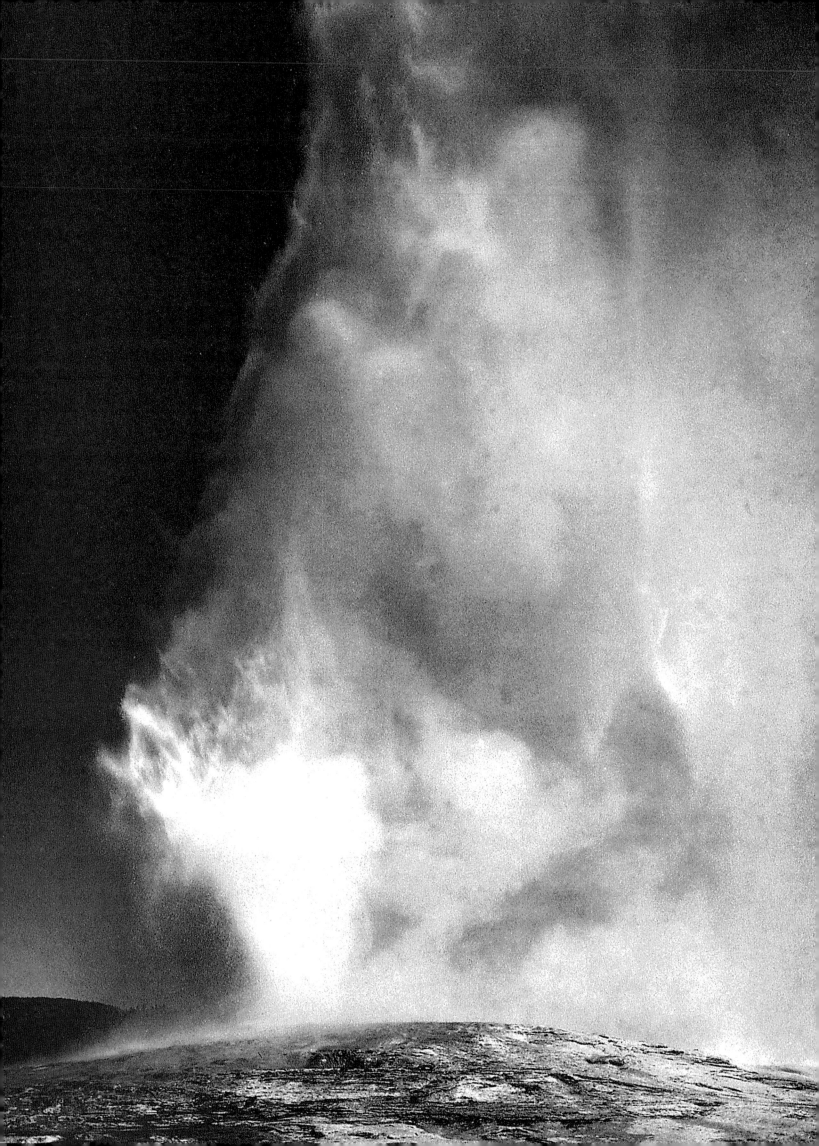

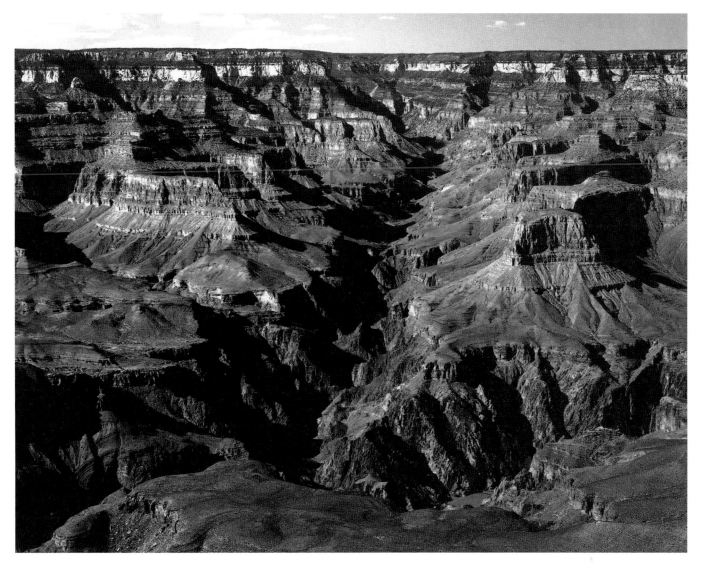

Opposite:
Ansel Adams
Old Faithful Geyser
Yellowstone National Park, Wyoming
NATIONAL ARCHIVES

Above:
Ansel Adams
Grand Canyon National Park, Arizona
NATIONAL ARCHIVES

p. 30–31:
Ansel Adams
Grand Canyon National Park, Arizona
NATIONAL ARCHIVES

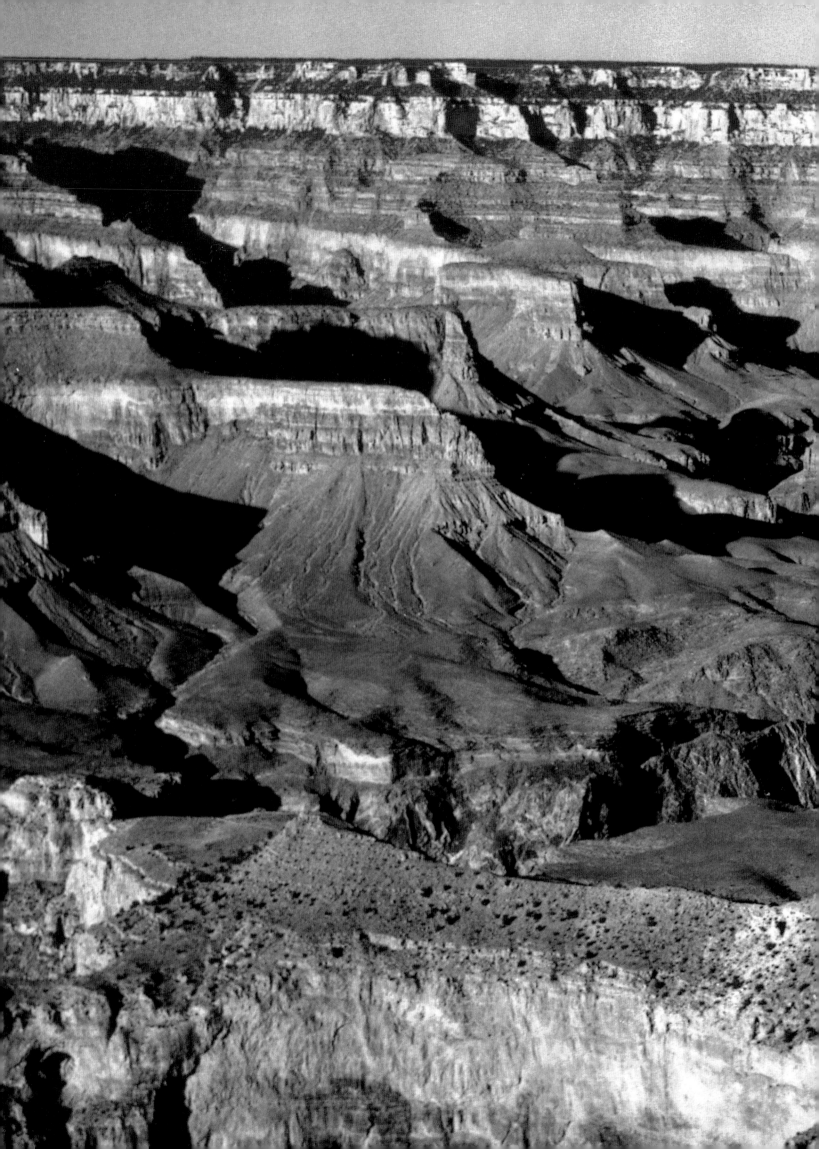

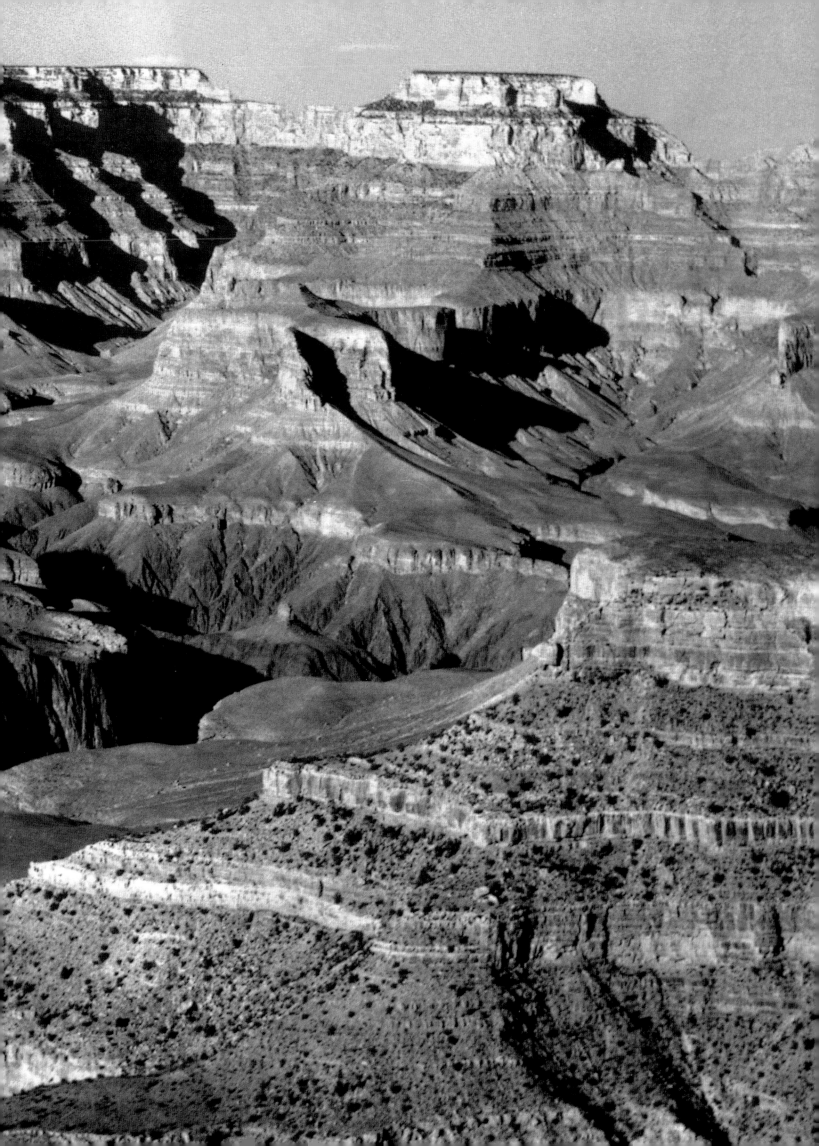

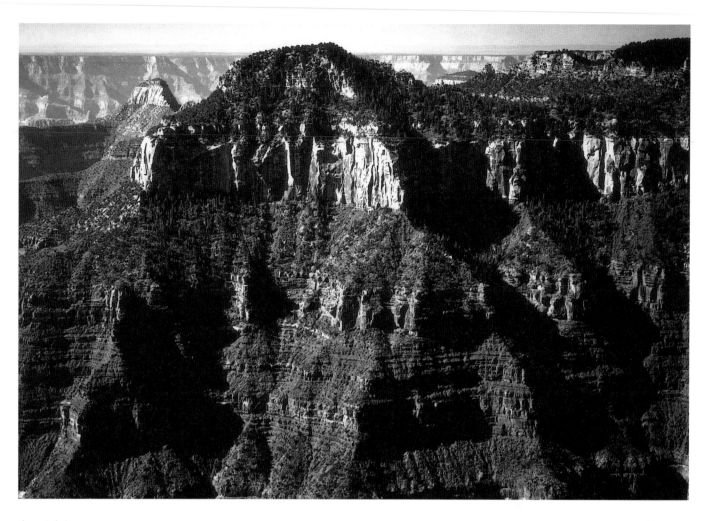

Ansel Adams
Grand Canyon National Park, Arizona

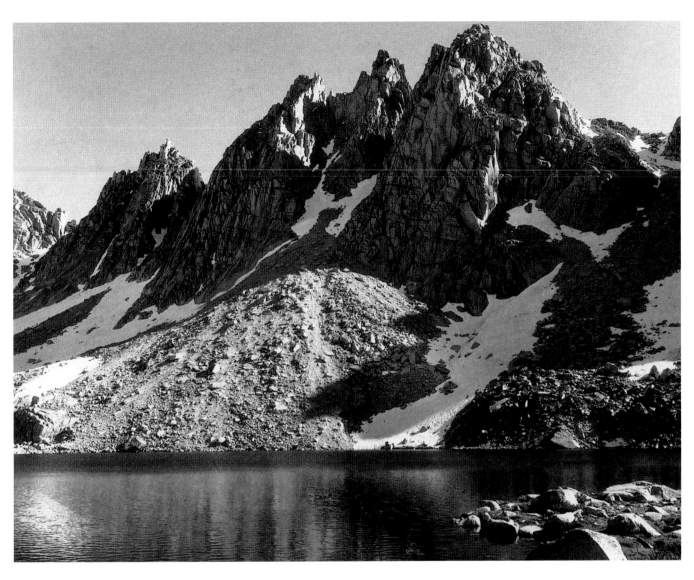

Ansel Adams
Kearsage Pinnacles
Kings River Canyon, California

Ansel Adams
Rocks at Silver Gate
Yellowstone National Park, Wyoming
NATIONAL ARCHIVES

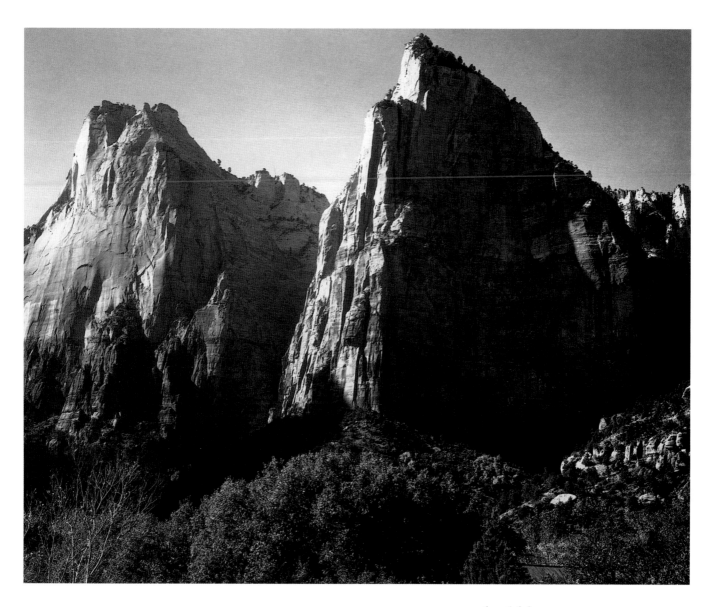

Ansel Adams
Court of the Patriarchs
Zion National Park, Utah

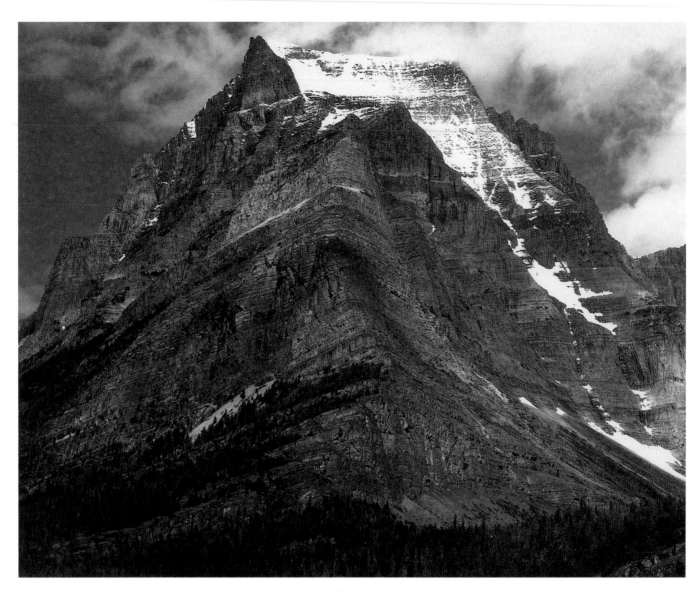

Ansel Adams
Going-to-the-Sun Mountain
Glacier National Park, Montana

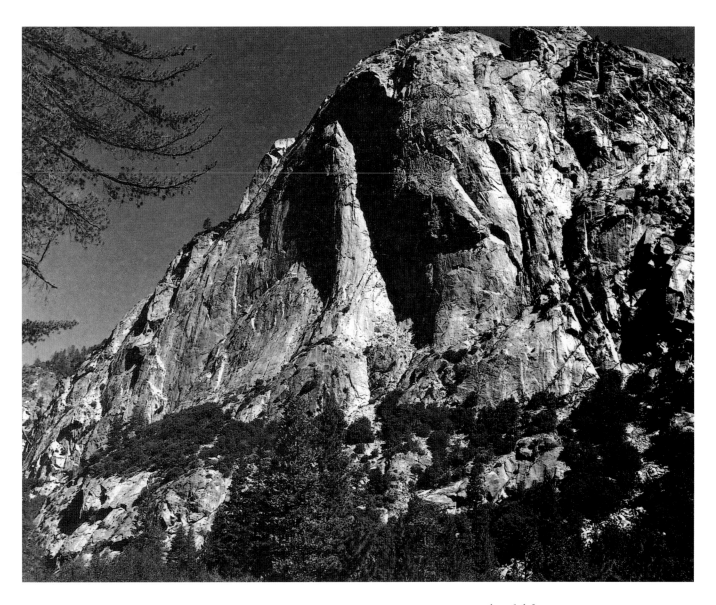

Ansel Adams
North Dome
Kings River Canyon, California

p. 38–39:
Ansel Adams
Bishop Pass
Kings River Canyon, California

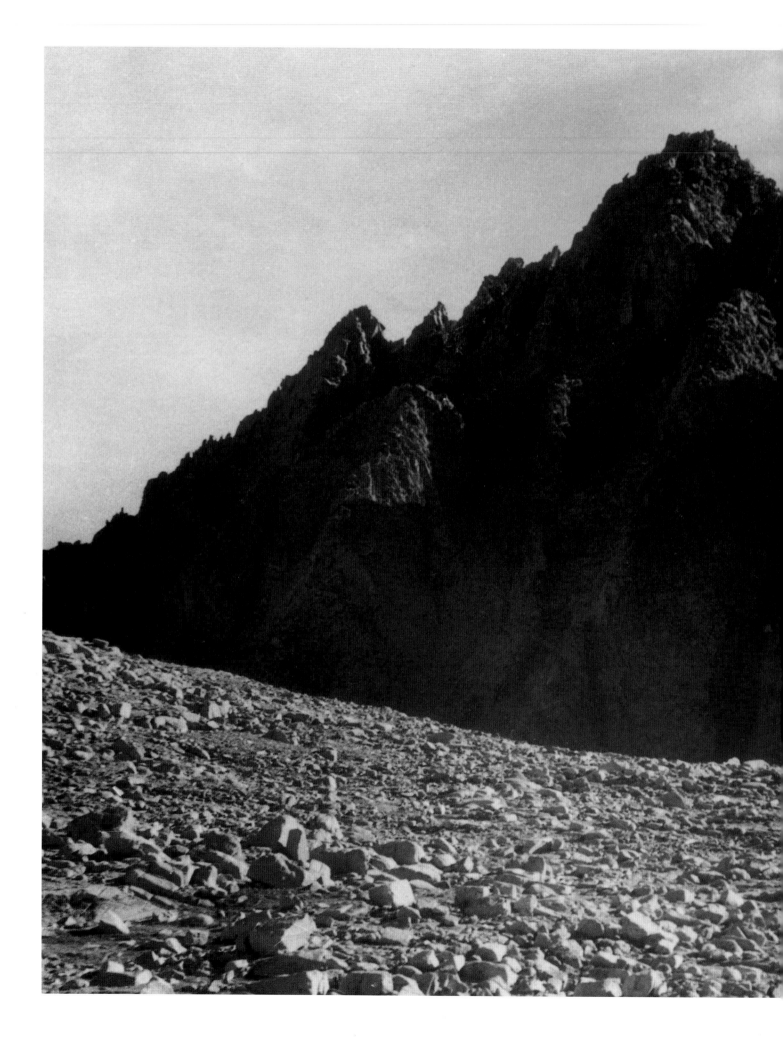

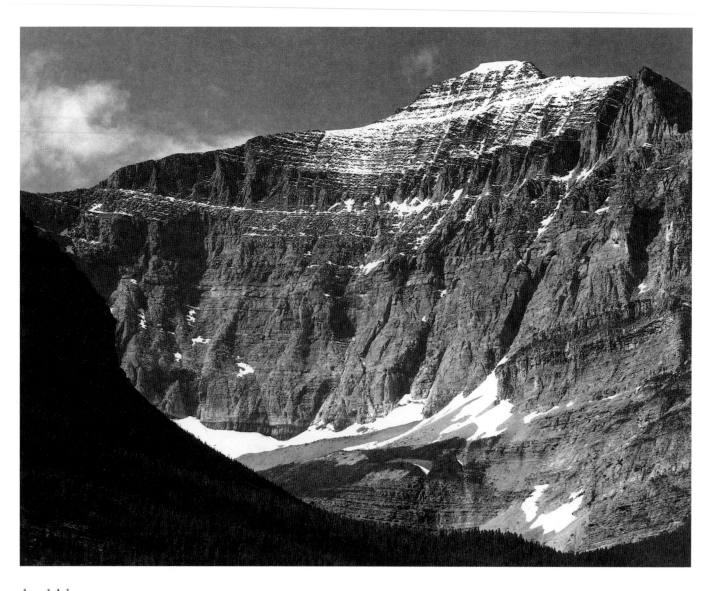

Ansel Adams
From Going-to-the-Sun Chalet
Glacier National Park, Montana
NATIONAL ARCHIVES

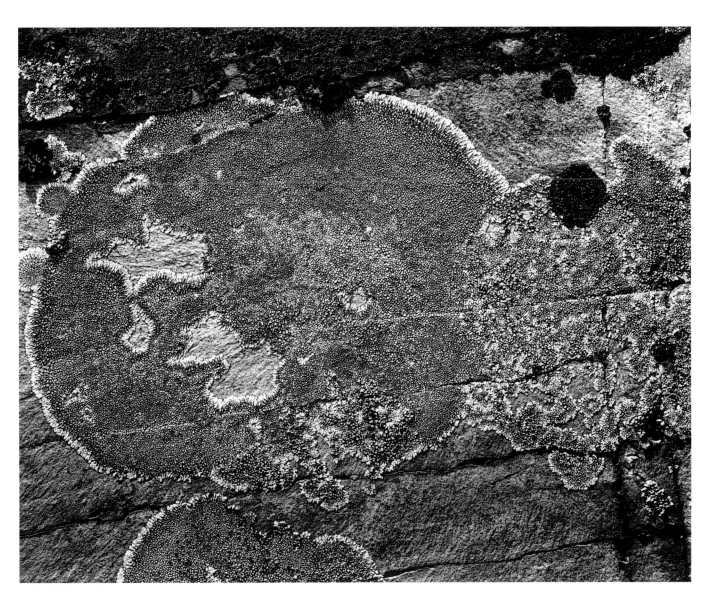

Ansel Adams
Lichens
Glacier National Park, Montana

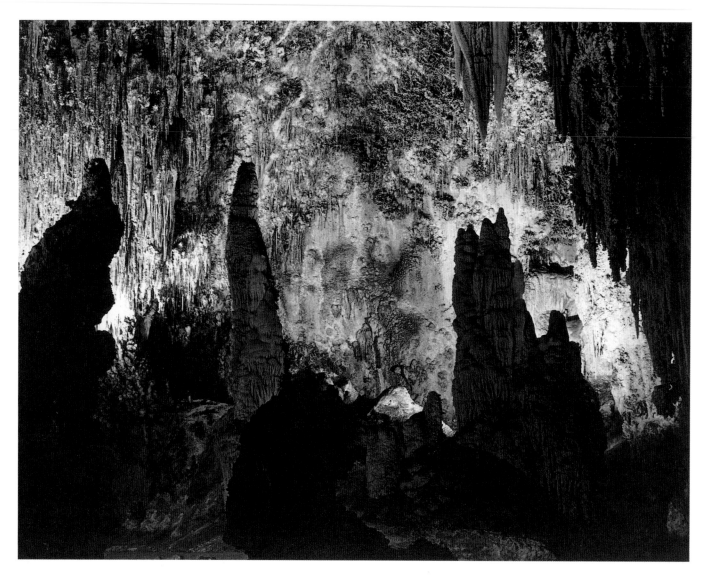

Ansel Adams
In the Queen's Chamber
Carlsbad Caverns National Park,
New Mexico

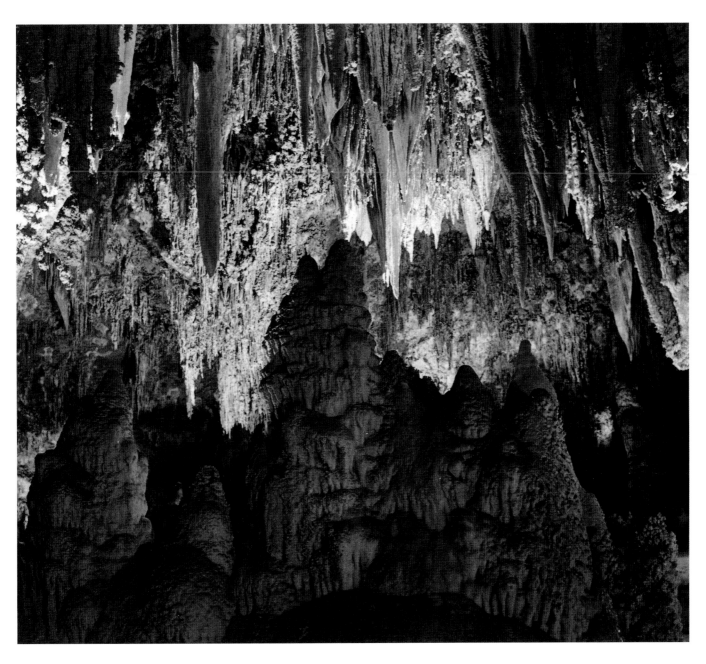

Ansel Adams
*Formations along the Wall of the
Big Room, near the Crystal Spring Home*
Carlsbad Caverns National Park,
New Mexico

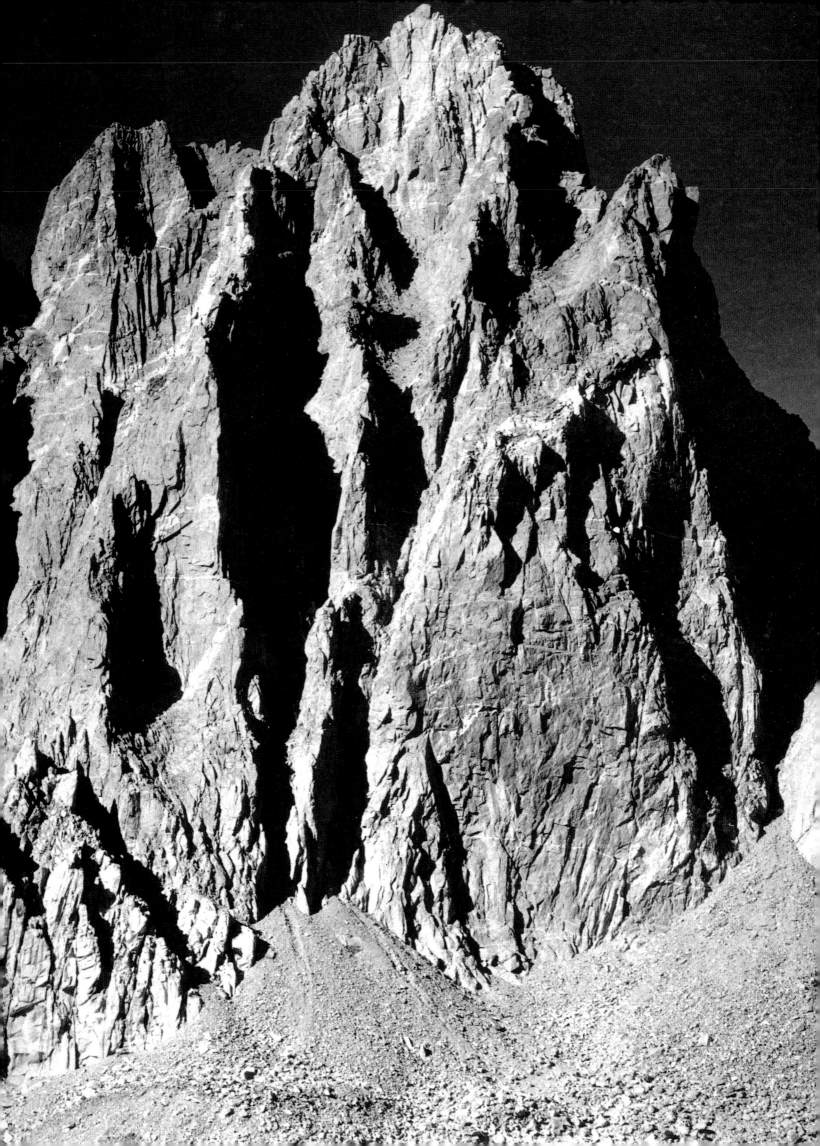

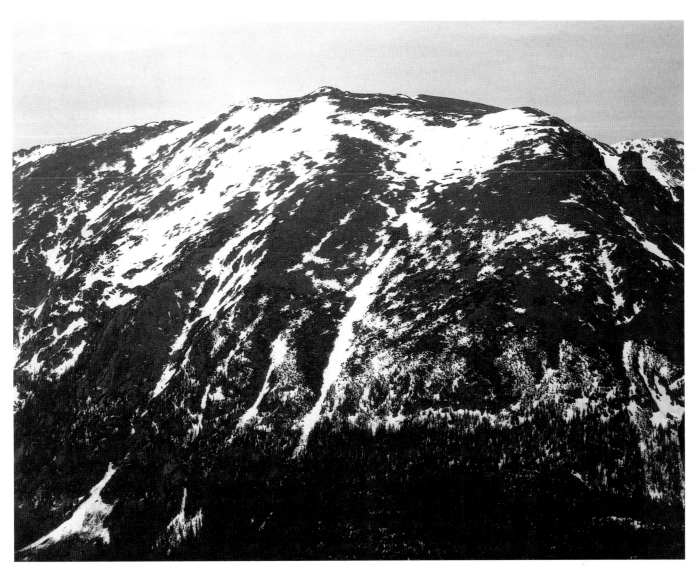

Opposite:
Ansel Adams
Mount Winchell
Kings River Canyon, California
NATIONAL ARCHIVES

Above:
Ansel Adams
In Rocky Mountain National Park,
Colorado
NATIONAL ARCHIVES

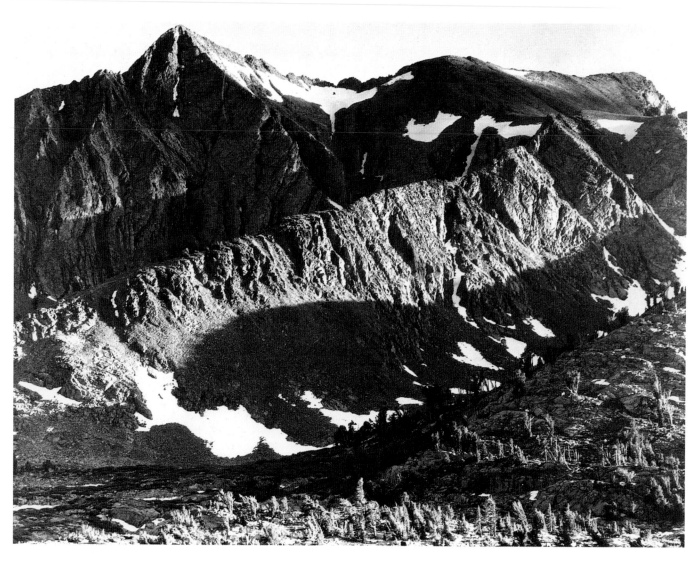

Ansel Adams
Peak above Woody Lake
Kings River Canyon, California
NATIONAL ARCHIVES

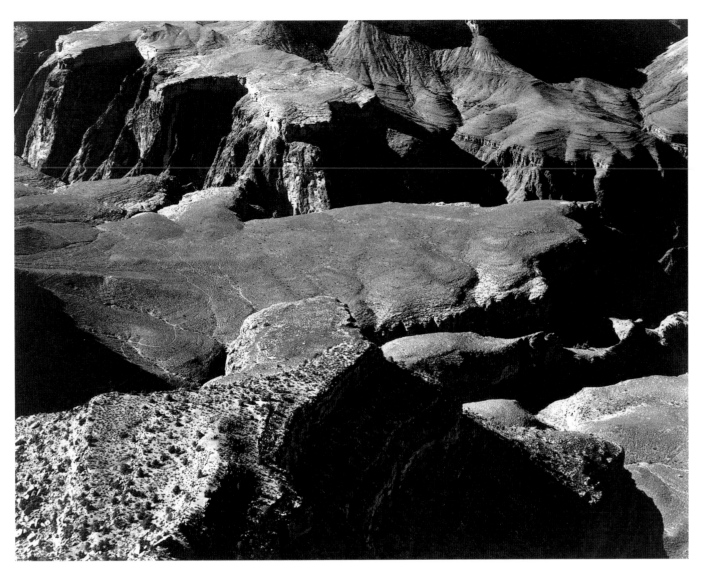

Ansel Adams
Grand Canyon National Park, Arizona
National Archives

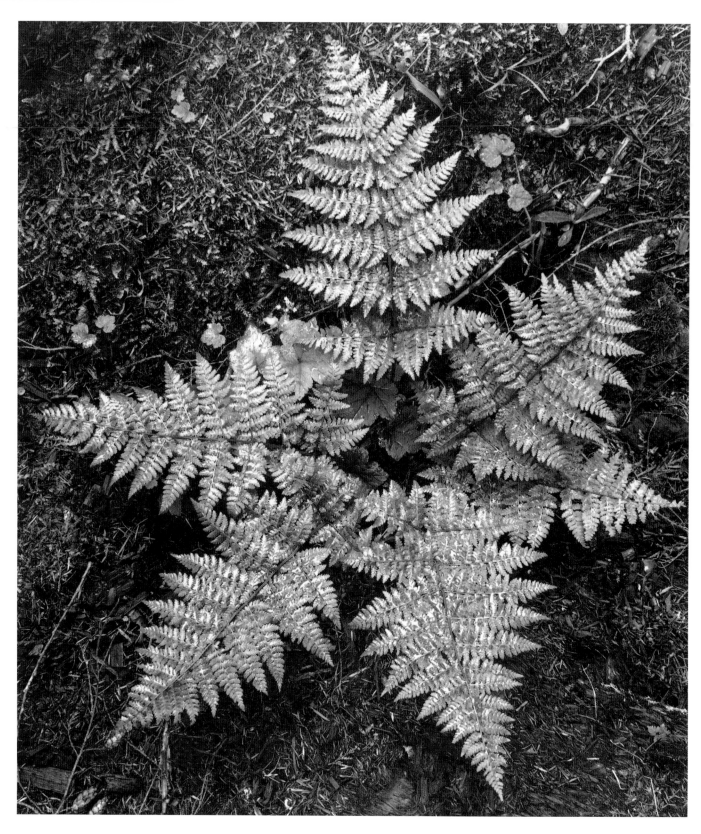

Ansel Adams
In Glacier National Park, Montana
NATIONAL ARCHIVES

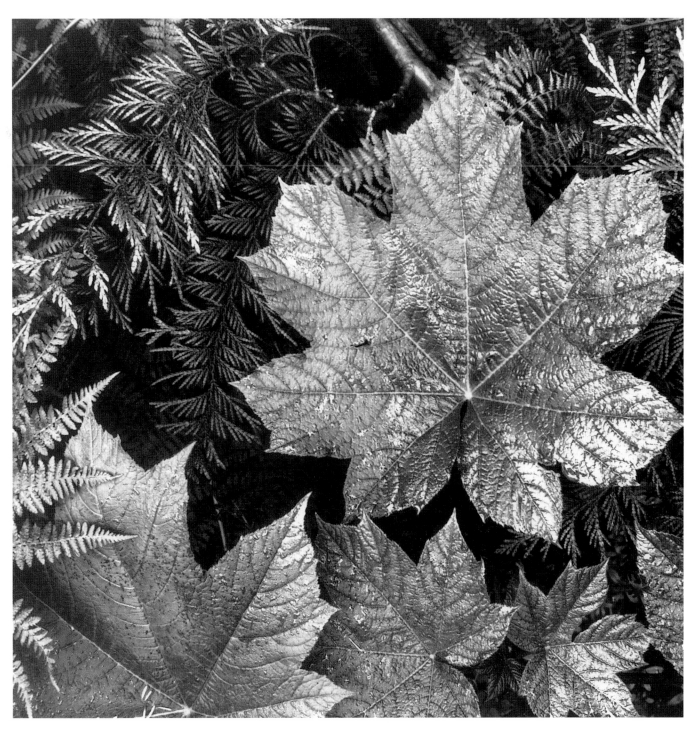

Ansel Adams
In Glacier National Park, Montana

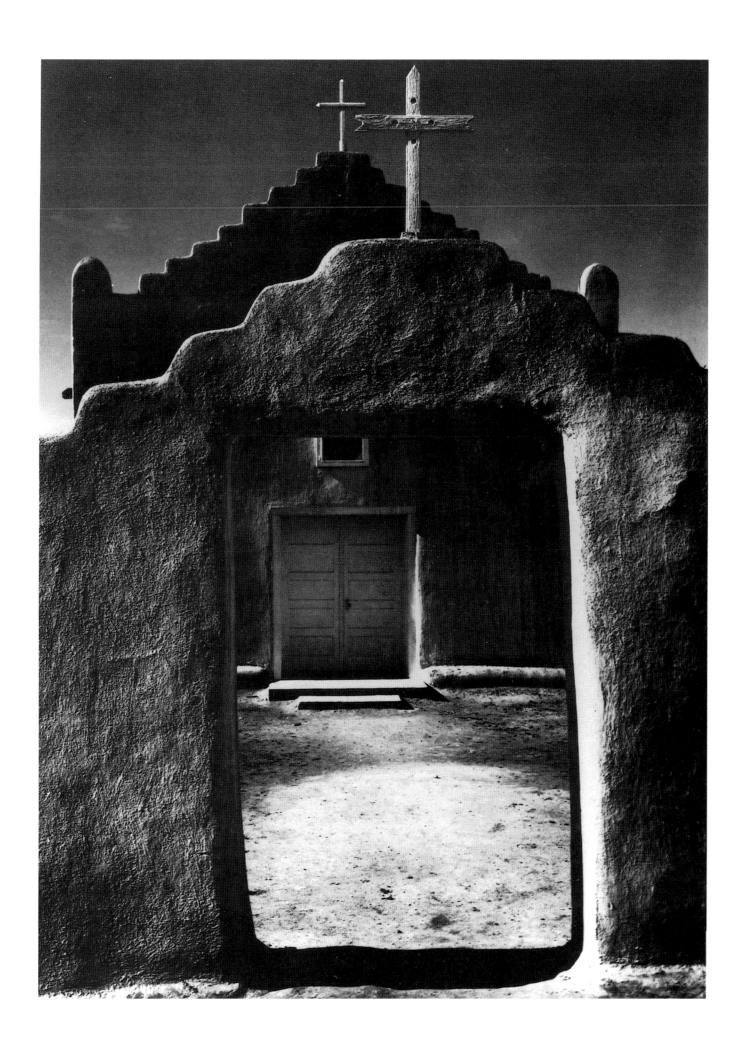

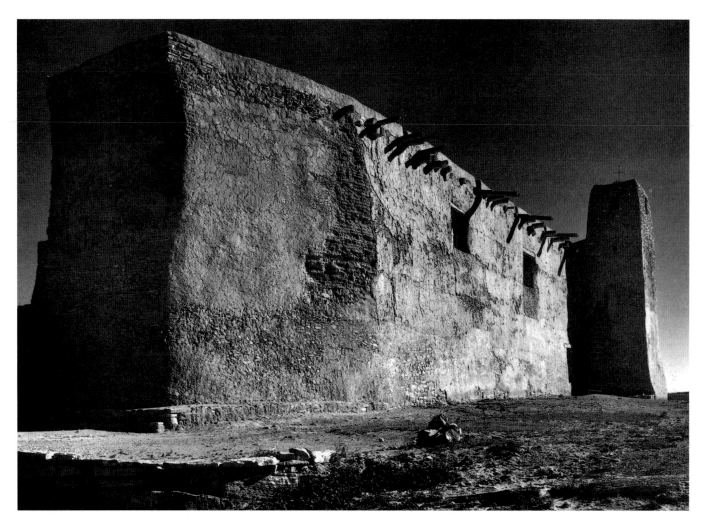

Ansel Adams
Church, Acoma Pueblo, New Mexico

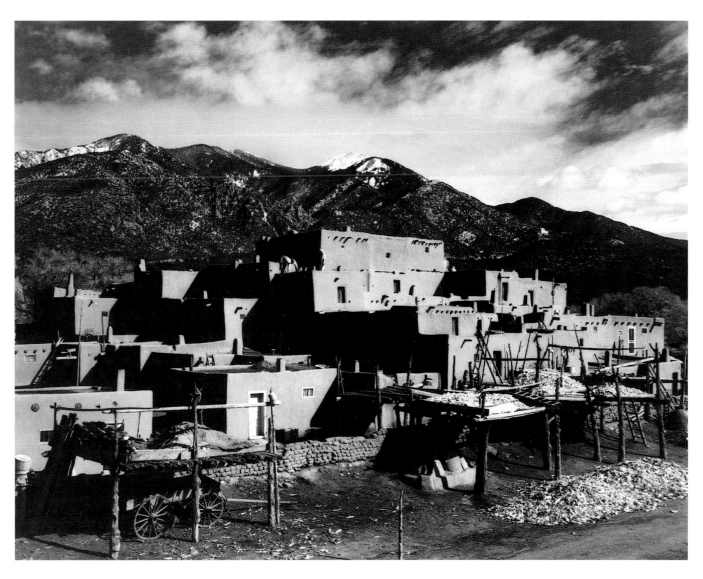

Ansel Adams
Taos Pueblo, New Mexico

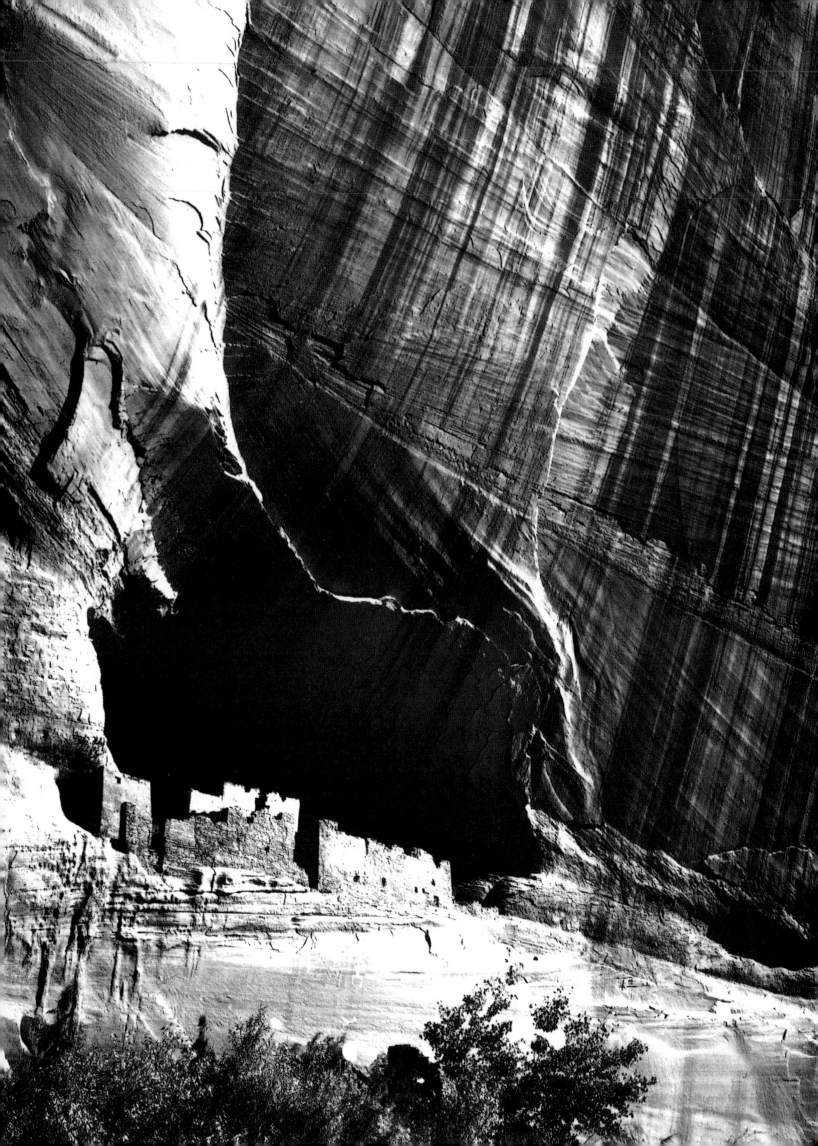

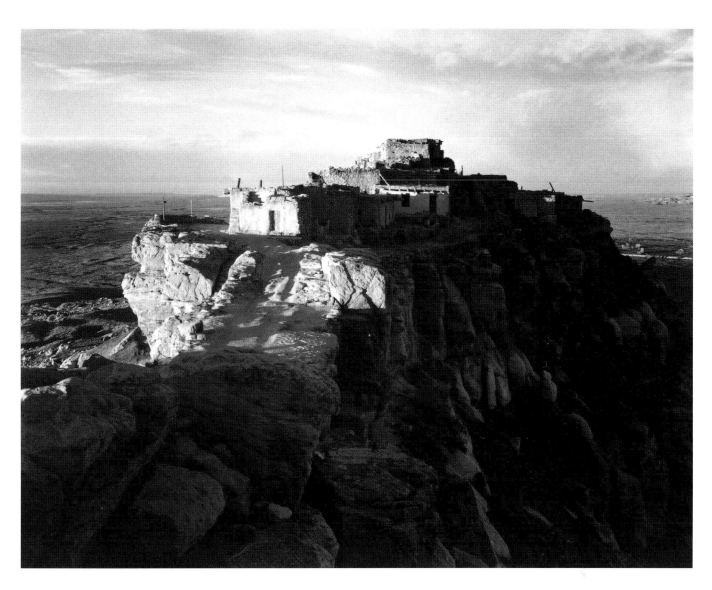

Opposite:
Ansel Adams
Canyon de Chelly, Arizona
NATIONAL ARCHIVES

Above:
Ansel Adams
Walpi, Arizona
NATIONAL ARCHIVES

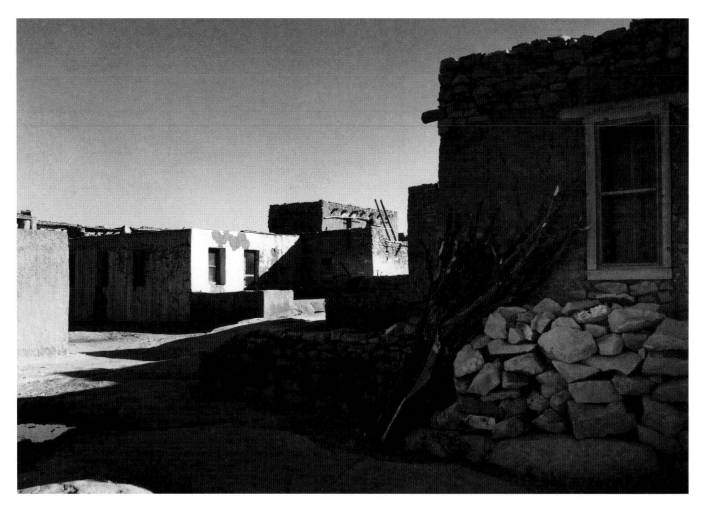

Above:
Ansel Adams
Acoma Pueblo, New Mexico
NATIONAL ARCHIVES

Opposite:
Ansel Adams
Mesa Verde National Park, Colorado
NATIONAL ARCHIVES

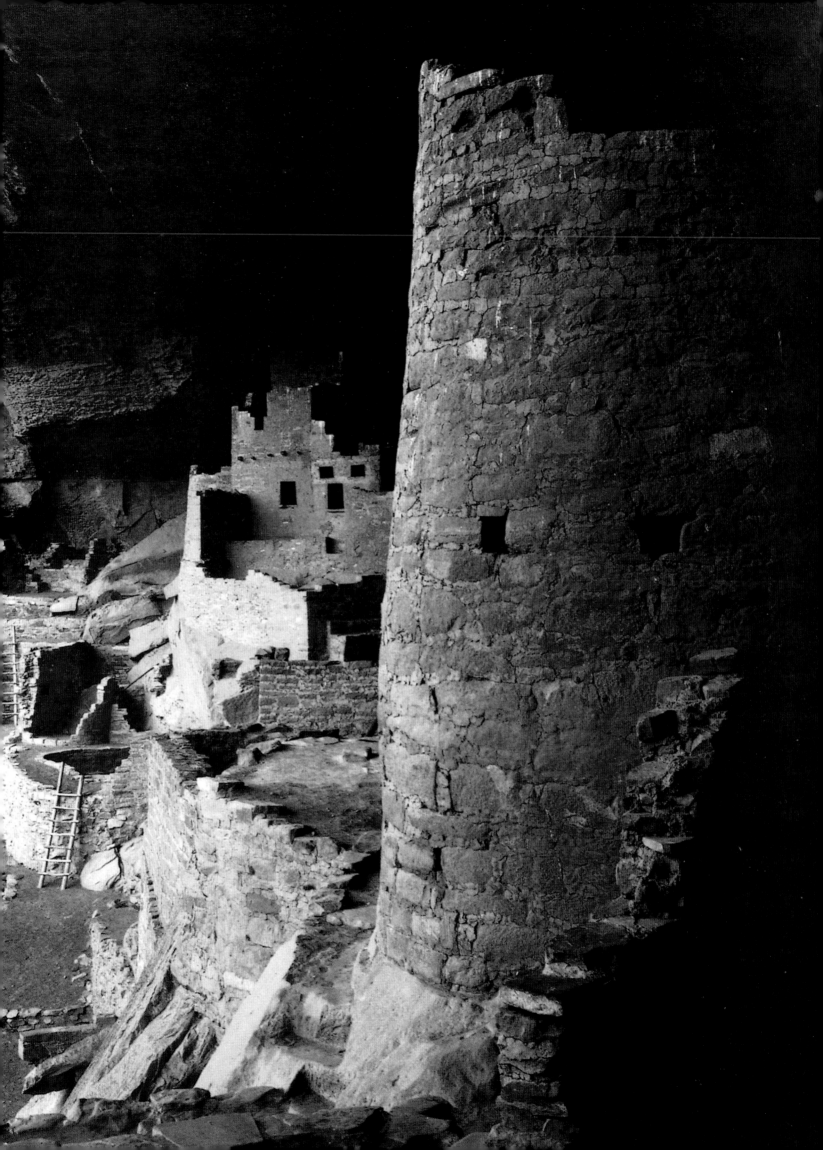

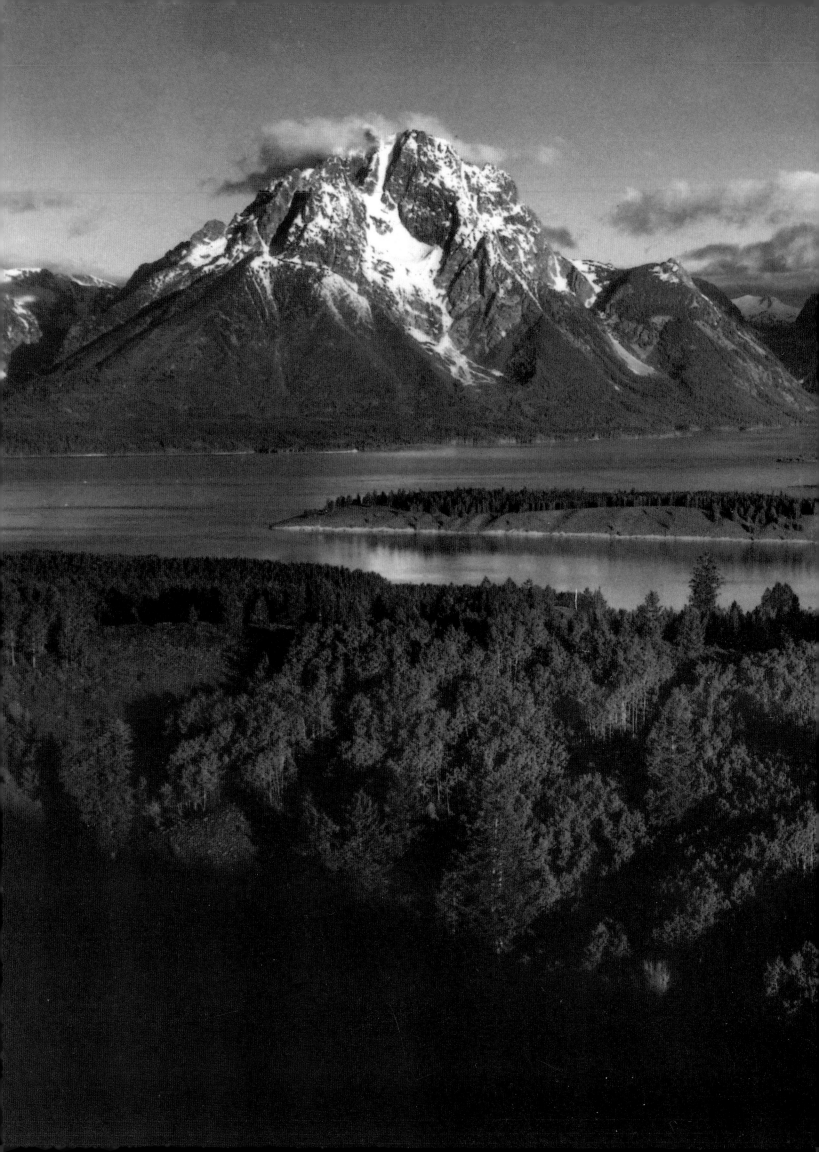

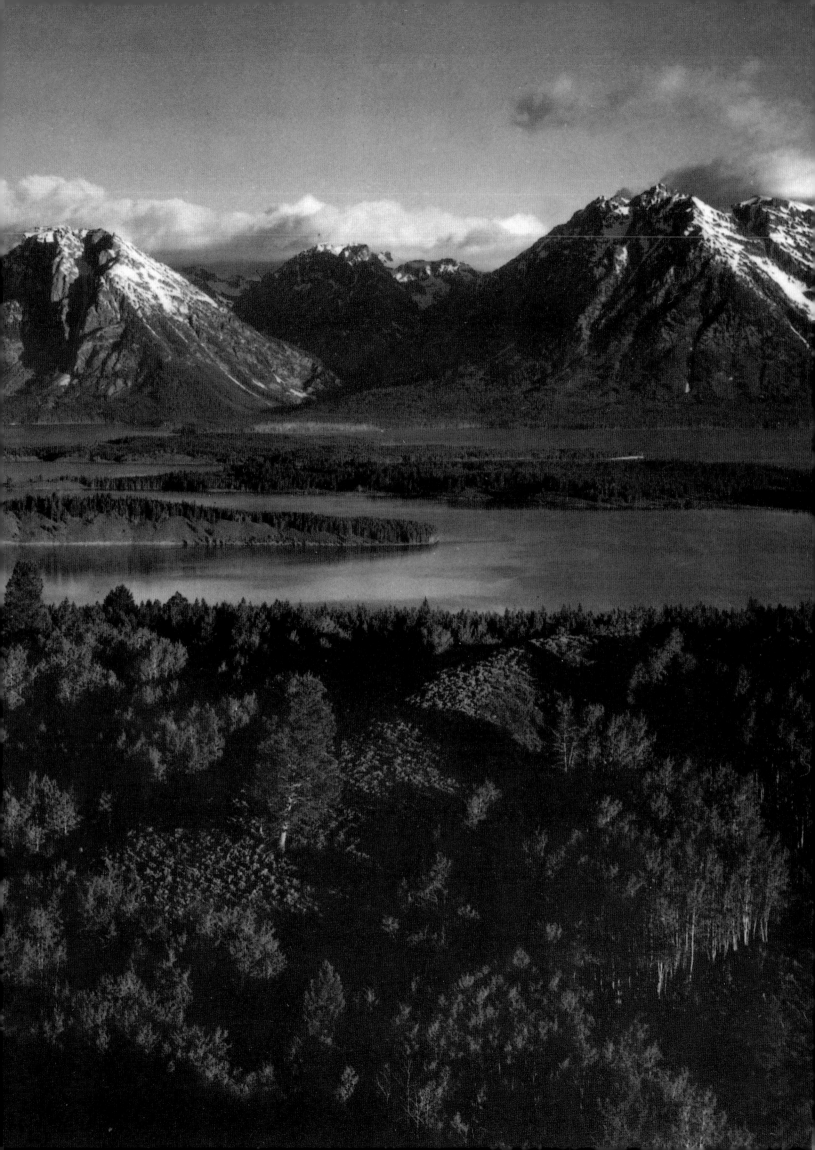

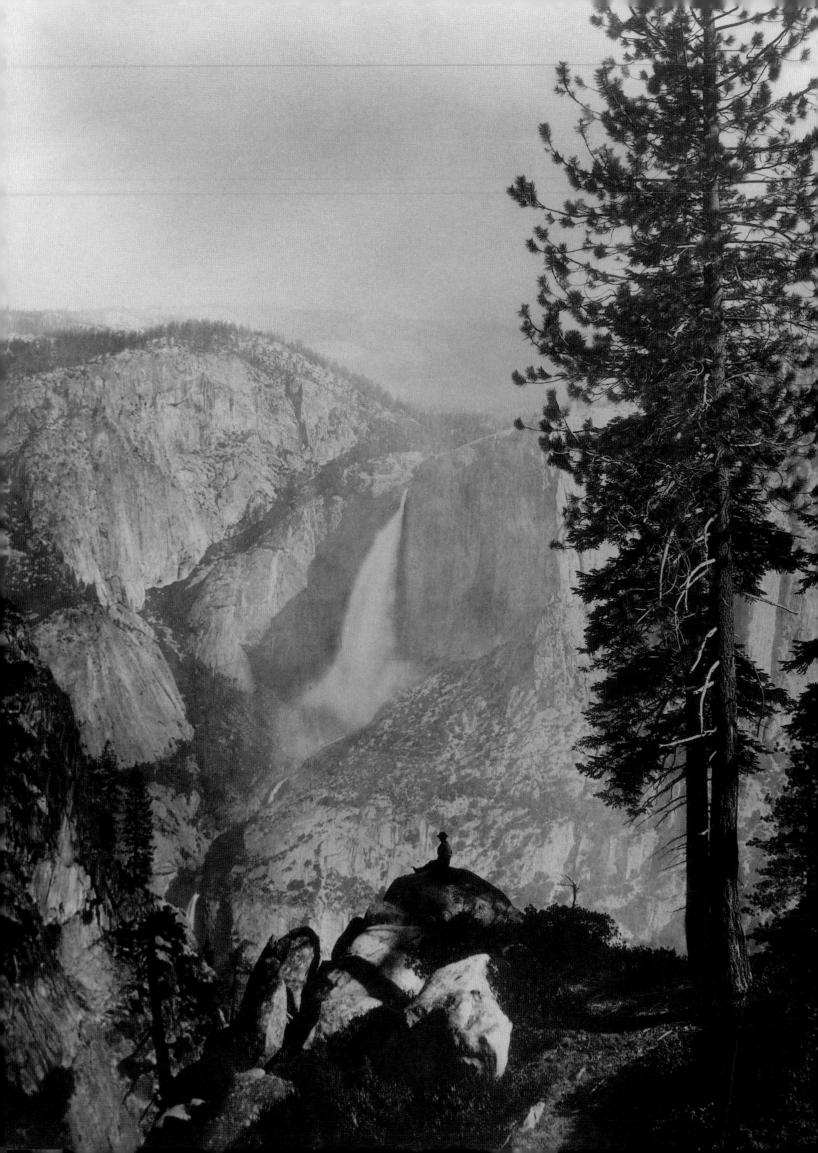

Views Aesthetic
and Spiritual

p. 58–59:
Ansel Adams
*Mount Moran and Jackson
Lake from Signal Hill*
Grand Teton National Park,
Wyoming
National Archives

Opposite:
Eadweard Muybridge
*Falls of the Yosemite from
Glacier Rock, No. 36*
Department of Special
Collections
Charles E. Young Research
Library, UCLA, Los Angeles

Ansel Adams is justly most famous for his spectacular mountain vistas. While to many contemporary viewers such a work may hold little interest beyond offering a well-composed and skillfully printed artistic depiction of a pleasing and geographically specific scene, such images once were fraught with fascinating aesthetic, religious, and even political significance in the minds of earlier generations. Adams's photographs are a direct continuation of the romantic tradition of landscape painting that originated in eighteenth-century Europe.

In 1757, preceding his career as a British statesman and political philosopher, Edmund Burke published an essay defining and describing what was to be a leading trend in the visual arts for the next 150 years. The aesthetic of the "sublime"—an appreciation of the most awesome and intense effects of nature—savored the gothic thrills of what was perceived as the irrational in nature, including such spectacular phenomena as soaring peaks, precipitous chasms, plunging waterfalls, mounting storm clouds, enveloping mists, the dramatic play of light and shadow over rugged terrain, and epic panoramas extending into infinity. In this category as well were such cataclysmic disasters as raging storms, terrifying earthquakes, and volcanic eruptions. Key to the experience of the sublime was the insignificance of man in the face of the overwhelming power and unpredictability of nature. Such a feeling could evoke a meditation on the eternal mysteries of life, death, and the sacred. Later in the nineteenth century, the meditation could also include thoughts about history, science, evolution, and nationalism. In the hands of many artists, the operatic landscape became an allegory for the omnipresence and omnipotence of the divine, a revelation of God's intentions toward humanity.

In its exaltation of the vastness and immensity of wilderness terrain, the aesthetic of the sublime landscape departed radically from the other two categories of a more cultivated landscape, the beautiful and the picturesque. As explained at the end of the eighteenth century by the British clergyman William Gilpin (not to be confused with the American territorial governor of Colorado), the beautiful or "classic" landscape was inspired by the work of seventeenth-century painter Claude Lorrain: his serene and gently rolling golden hills, like those of the pastoral countryside around Rome, evoked a

Niagara Falls in an early print.
LIBRARY OF CONGRESS

nostalgia for the poetic past of Arcadian myth. The formula of this harmonious and symmetrical idealized landscape included framing devices on both sides, either trees or outcrops of rock; a path or stream meandering from the foreground to guide the eye toward the back of the scene; figures or architectural elements for scale or cultural reference; and a vista of a far-off horizon enveloped in either a glowing light or a misty atmosphere.

On the other hand, the picturesque landscape was a tamer and more controlled version of the sublime landscape, one that was delightful rather than terrifying. The picturesque, in effect, was a beautiful landscape with a more natural informality and with a carefully composed arrangement of interesting irregular elements and contrasting textures inserted artfully in just the right position and in the correct proportion, as demonstrated in various drawing manuals. An American picturesque view appropriately consisted of an irregular foreground with rocks, dead trees, or shrubs; a middleground with a lake, winding river, or hills; and a background of mountains. Tonally, the foreground was to be dark, the middleground light, and the distance an intermediate tone, with an asymmetric element or strong diagonal linking the foreground to the background.

There were guides, as well, on how to read the symbolic language of a landscape while in a meditative state of mind. The trees and forests could be interpreted as symbols of humankind—the sapling, the mature tree, and the stump or fallen tree, all in one scene, represented the eternal cycle of life for both men and civilizations. Or splendid, towering arboreal specimens grouped together with overarching branches could be viewed as nature's version of the gothic cathedral. Waterfalls and winds were symbols of God's

omnipotence or of his eternity, or of the potential energy of the natural world. Lakes represented spiritual reflection, peacefulness, or perfection; or God's benevolent blessing. Mountains symbolized either spiritual elevation, or the grandeur and eternity of God's existence. Light could represent either emanations of a divine presence or the emanations of a single soul, while the sky was the "soul of scenery." As Thomas Paine wrote in 1794, "The word of God is the creation we behold."

Before the romantic appreciation of the untamed landscape, mountains had been regarded not only as an impediment to travel between northern Europe and the Mediterranean countries of the south, but also as visually unattractive in terms of the then-current artistic conventions. The romanticism of the sublime established mountains as a revolutionary new motif linking spirituality and art. The Swiss Alps and other European ranges became a destination for fashionable artists and travelers who set out on rigorous treks in search of the ultimate spiritual sensation. An ascent into the rarefied atmosphere at a high elevation, with its intense light, atmospheric mists and clouds, and vertiginous heights, set the stage for a state of spiritual transcendence. In effect, the climbing of rugged mountain peaks could serve as a heroic rite of initiation into a higher state of being, an approach nearer to God. This cult of the mountains, together with the aesthetic of the sublime, extended into the early decades of the twentieth century.

With its evocation of great depths of feeling about nature, the word "sublime" remained an essential concept for over a century in the American visual and literary arts. In *Notes on Virginia*, Thomas Jefferson, in describing the Natural Bridge, an unusual rock formation, wrote in 1784, "It is impossible for the emotions arising from the sublime to be felt beyond what they are here; so beautiful an arch, so elevated, so light, and springing as it were up to heaven! The rapture of the spectator is really indescribable!" John Muir, who first had climbed the Sierra Nevada in 1868, published his first and most popular book, *The Mountains of California*, in 1894. In it the word "sublime" remained essential to his vocabulary, and he framed his extraordinary ascents in terms of the spiritual experience of the sublime. Describing a trek into the High Sierra from Yosemite, he wrote, "…a rosy glow, at first scarce discernible, gradually deepened and suffused every mountain-top, flushing the glaciers and the harsh crags above them. This was the alpenglow, to me one of the most impressive of all the terrestrial manifestations of God. At the touch of this divine light, the mountains seemed to kindle to a rapt, religious consciousness, and stood hushed and waiting like devout worshipers." On his own hikes into the Sierra Nevada, Adams underwent similar spiritual experiences and then sought to re-create those moments of delight through his photographs. As he spent his early days in the mountains "becoming familiar with the spirit of wild places," his photographs evolved into "records of experiences as well as of places." Adams saw art as a vision "penetrating the illusions of reality, and photography…

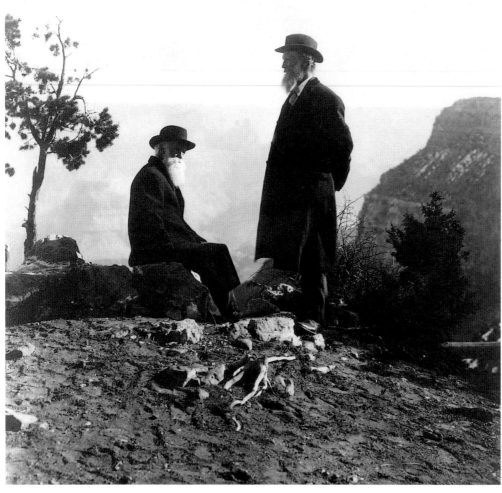

[as] one form of this vision and revelation" in that it sought to re-create that original "flash of recognition."

Before the concepts of the sublime, the beautiful, and the picturesque entered the language of America's early landscape photographers, they were adapted by the painters of the Hudson River School, so called because of their summer expeditions to New York's scenic Hudson River Valley, as well as to New Hampshire's White Mountains, the Berkshires, and the Holyoke Range along the Connecticut River Valley. In winter the artists retreated to their studios to work up dramatic landscape paintings by combining appropriate and typical details from their summer sketchbooks. English-born Thomas Cole, the first master of this school, led the way with his visionary panoramas. A more objective observer was Asher Brown Durand, who allowed the specific landscape to determine composition of his painting and the actual weather conditions to determine its light and atmospheric effects. In so doing, he and other American landscapists moved away from the fictions of the idealized English-style "beautiful" view and tried to achieve at least a certain degree of truth to nature.

Their paintings also gave expression to the ideas of transcendentalism, explored in the 1840s by New England's leading intellectuals, among them Ralph Waldo Emerson and Henry David Thoreau. Opposed to the

institutional authority of traditional religion, transcendentalism placed a high value on individual intuition and a direct relationship between the human spirit and a God who was present in all of nature.

In nineteenth-century American minds, the significance of the country's landscape soon extended beyond aesthetic and religious themes to those of national pride, particularly in the landscape paintings of the Rocky Mountain School. In many writings of the times, the United States constantly was criticized for its cultural inferiority to Europe. Americans turned to the splendors of their magnificent landscape to counter such attitudes, and the exotic natural wonders of the West were offered up as indisputable evidence of American superiority when the comparison was made with European scenery. The nation's landscape was regarded as uniquely American in that it was a pristine paradise analogous to the garden of Eden. While European culture at its most impressive was represented by architectural monuments and classical ruins, America was seen to possess equally ancient monuments in her primeval forests, awesome mountains, unspoiled lakes, and picturesque waterfalls. Furthermore, while education in the classics, world history, and literature was the necessary background for creating and appreciating the grand history and landscape paintings of Europe, the American landscape as an artistic subject was democratic in that it required of both painter and audience only a deeply felt individual experience of the beauties and dramas of nature.

This high value placed on the Western landscape as a repository of aesthetic, spiritual, and nationalist meaning helped promote the concept of protecting the most unique areas as national parks. Key, too, were the explorations by official expeditions and their detailed reports, supported by visual materials, which were submitted to officials in Washington. Another significant contributing factor was the fate of Niagara Falls. First viewed by French explorers in the late seventeenth century, this spectacular waterfall between Lake Erie and Lake Ontario soon was hailed as one of the world's greatest natural wonders. Images of Niagara as first seen by Europeans were reprinted throughout the eighteenth century in books about the New World. The reality, though, was quite different. By the early nineteenth century, commercial exploitation of the falls had let to its encirclement by a shabby assemblage of fences, souvenir stores, signs, hotels, and stables, while access by visitors to the best lookout points was available only for a substantial fee. Most European travelers, beginning with Alexis de Tocqueville in 1831, criticized the United States for allowing this disfigurement to occur. According to an 1849 British traveler, "the vilest scum of society congregate to disgust and annoy visitors from all parts of the world, plundering them and pestering them without control," leading him to the severe judgment that in failing to protect Niagara Falls, the United States lacked "patriotism, taste, and self-esteem."

Before the early nineteenth century, Niagara Falls was the only world-class attraction in the United States, but circumstances changed when the

nation began to expand westward starting with the 1803 Louisiana Purchase of territory from the Mississippi River to the eastern slopes of the Rocky Mountains. This was followed by the 1845 annexation of Texas, and the 1846 British relinquishment of its claims to the Northwest—today's Washington, Oregon, Idaho, and western Montana. Victory in the Mexican War of 1848–49 added California and most of the Southwest, including New Mexico and Arizona.

Explorers and travelers soon began to write rhapsodically about such Western attractions as the Rocky Mountains, often citing their superiority to the Swiss Alps. Indeed, advocates of this scenic nationalism assumed the stance that the ancient Sierra redwood trees, along with the unique geological phenomena of the West, were evidence of an ancient American past, one that was equal to, and even surpassed, the manmade monuments of Europe. This linking of the Western landscape to the search for a positive national identity helped win support for the preservation of the Yosemite and Yellowstone regions by their designation as national parks. Works produced by the painters of the Rocky Mountain School and by the early photographers of the West were influential in gaining support for the movement to create these national parks.

Albert Bierstadt (1830–1902), the acknowledged master of the Rocky Mountain School, also is known to have been the first photographer to take stereographs while journeying through the territory now included in Nebraska and Wyoming. Bierstadt had started his artistic career in New Bedford, Massachusetts, in 1850 and had studied abroad from 1853 to 1857 in Düsseldorf. In 1859 he obtained permission to accompany the government road survey led by Colonel Frederick Lander, which departed from Saint Joseph, Missouri, on May 5 and headed across northeastern Kansas. Bierstadt took stereographs at most important sites along the way. After the survey traveled from Fort Kearny up the Platte River to Fort Laramie, he made multiple exposures of Devil's Gate along central Wyoming's Sweetwater River. At the same time, he recorded individual Native Americans and the villages of the Sioux, Oglala Sioux, Cheyenne, and Shoshone nations. Bierstadt and a fellow artist from Boston apparently left the Lander survey near Wyoming's western border in order to sketch and to photograph the southern border of the Wind River Range of the Rockies.

By mid-September, Bierstadt was back in New Bedford and shortly thereafter set up his easel in New York's Studio Building, home to the era's leading artists, among them Frederick Church, Winslow Homer, William Merritt Chase, and Eastman Johnson. In 1860 the Bierstadt Brothers photographic gallery, established in New Bedford with Albert Bierstadt's help, issued a catalogue that included 52 of his stereographs from the Lander survey. Bierstadt used both these photographic views and his sketches in creating the series of grandiose Rocky Mountain paintings that made him famous. He found the stereographs useful in helping to depict

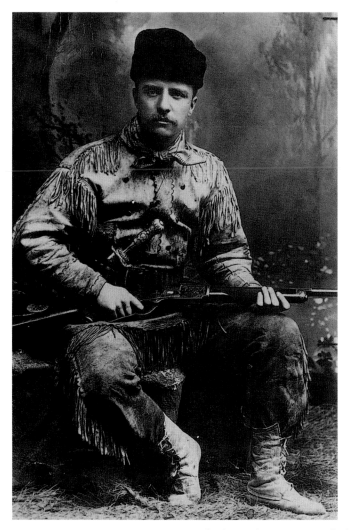

Theodore Roosevelt, as a Western outdoorsman.

the illusion of deep space for which his paintings were noted. The dramatic light effects, in a technique learned in Düsseldorf, were fully his own. On his second Western trip in 1863, Bierstadt apparently used no camera but only sketched. This time he crossed the Rocky Mountains from Denver to Salt Lake City, from there to Lake Tahoe, and then traversed the Sierra Nevada to San Francisco. On August 1, he set out for Yosemite, which was to inspire some of his greatest paintings. He was back in New York by mid-December and there he produced his 9-by-15-foot masterpiece *Domes of the Yosemite* (1867). Bierstadt spent 1871–73 in San Francisco, where he became a close friend of photographer Eadweard Muybridge and traveled with him again to Yosemite, where the two depicted some of the same scenes, each in his own medium. Reportedly, Bierstadt advised Muybridge on artistic composition and technique. Bierstadt returned to the West several times—to Colorado in 1877, to Yellowstone in 1881, and to the Northwest, Canada, and Alaska in 1889. His flamboyant style later became unfashionable and in 1889, in a devastating blow, the United States jury rejected *The Last of the Buffalo* for display at the Paris International Exposition.

Of the early Western photographers, Carleton Watkins (1829–1916) was most famous for his Yosemite views. Today art historians generally agree that he was America's greatest landscape photographer of the nineteenth century. Originally from Oneonta, New York, he first arrived in San Francisco in 1851, where he learned photography from pioneering daguerreotypist Robert Vance. After polishing his skills as a portraitist, Watkins turned to making large-sized, wet-collodion landscape views, possibly in 1856 and definitely by 1858, when three of his landscapes were used as legal evidence in a land fraud case. His first important commission for a landscape series came from explorer John C. Frémont, who planned to use images of the California Mariposa estate to procure funds for a mining operation. Watkins also produced views for other mining companies and even documented a San Francisco labor demonstration. The necessity of making wide-angle views for another legal case in 1861 led him to commission a cabinetmaker to build a camera for exposing mammoth-plate (18 x 20 inch) glass negatives.

That summer, with this equipment and a stereoscopic camera, Watkins made his first trip to Yosemite, already photographed by Charles Leander Weed

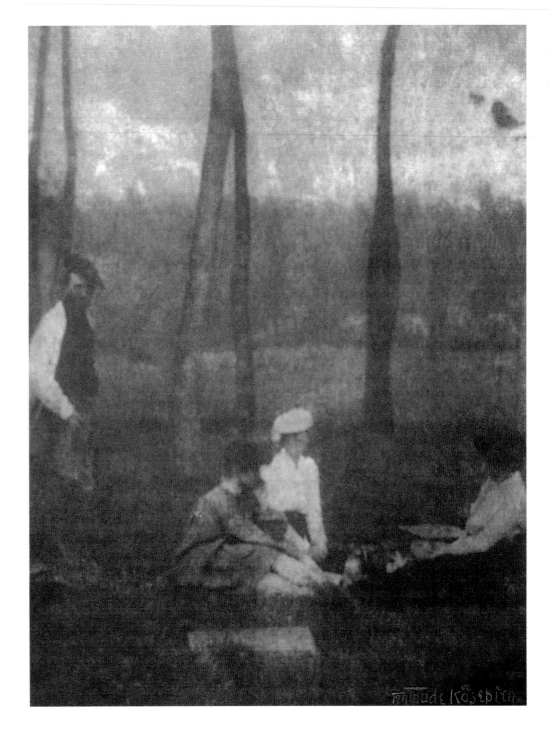

in 1859. His frequent predawn exposures and his use of a wide-angle lens on this new camera resulted in views unique for their lyrical artistry. These works were exhibited the next year in New York and were brought to the attention of Ralph Waldo Emerson, Oliver Wendell Homes, and Josiah Dwight Whitney. A number of politicians, as well, were impressed enough by these images to support the 1864 federal establishment of Yosemite as a California state park. All of this publicity helped cement Watkins's reputation as a leading landscape photographer.

He returned to Yosemite in 1865 with even finer equipment and also visited the Giant Sequoias of the Mariposa Grove. In 1866 he made a series of smaller-format Yosemite views for Whitney's *The Yosemite Book*. Ever-widening

appreciation for Watkins's artistic skill did not guarantee commercial success though, particularly since various East Coast publishers pirated his work.

An 1867 trip to Oregon and back resulted in the series *Watkins' Pacific Coast Views*, which ranged from mammoth-plate images to stereographs of such scenes as Mount Hood, the Columbia River Valley, and the extinct volcanos of the Coast Range. Beginning in 1869, he made views for the Central Pacific Railroad, in 1870 for the King expedition to northern California, and in 1873 of Utah landmarks. Following financial setbacks in the mid-1870s, he rephotographed most of his best subjects, including Yosemite, for *Watkins' New Series*. He also started a new series of southern California *Mission Views*, revisited the Northwest, and then traveled to Arizona.

During the 1880s, Watkins remained busy photographing Arizona, southern California, the Northwest, Idaho, Montana, and Yellowstone. By 1885 he had covered the entire Pacific Coast from Alaska to Mexico. The 1906 San Francisco earthquake destroyed Watkins's studio, and this gifted and prolific artist spent his last days in an insane asylum.

Equally energetic in pursuing his work as a landscapist was Eadweard Muybridge (1830–1904), an English-born photographer who arrived in New York in 1851. While an East Coast printer's representative, he learned daguerreotypy, and by late 1855 he had arrived in San Francisco to open a bookshop. After his first 1860 excursion to Yosemite, he returned to England, apparently to master the techniques of large-format photography. In 1867 he was back in San Francisco again operating as a landscape and cityscape photographer under the professional title of "Helios." For the series of stereographs *San Francisco Views*, he traversed the city in his horse-drawn "Flying Studio" to capture maritime views, street scenes, and artistic studies of moonlight. He returned to Yosemite on his first professional journey with a stereoscopic camera and a small-view camera to photograph the Calaveras Big Tree Grove, and then what he considered Yosemite's very best views under the most favorable light conditions. He returned home with 114 stereographs and 72 full-plate landscapes, and printed up many of these views using picturesque clouds from other exposures. His 1868 series, *Scenery of the Yosemite Valley*, was praised for his composite cloud effects, skillful composition, and unusual vantage points. He later expanded this Yosemite series to include 160 stereographs and 100 mounted photographs.

In 1868 he traveled to Alaska to photograph the new territory's military posts and harbors. En route, he also photographed the British Columbia shoreline and the coastal Indians. The images from this trip were marketed as both photographs and stereographs. After completing other government commissions, he returned in 1872 to Yosemite to complete a new series of views, including subjects he had photographed previously, as well as the high country and the Mariposa Grove. This expedition produced 379 stereographs, 36 full-plate views, and 45 large views, many of them more poetic in mood than his 1867 images.

The year 1873 was a busy one, as Muybridge covered the Modoc Indian War and traveled to Oregon to make stereographs for his *Pacific Northwest Scenes* series; in October he made large views of San Rafael and Mount Tamalpais in the San Francisco Bay area. After killing his wife's lover in 1874, and his 1875 acquittal, he left on a long photographic tour of Central America that resulted in a series of 260 images. In 1877 he completed several 360-degree panoramas of San Francisco, followed in 1878 by a mammoth-plate panorama of 13 remarkably detailed pictures. The year before that, he had resumed the animal-motion project that was to consume the rest of his days. In 1893 he relocated his experimentation to Philadelphia, and in the following year returned to England for good.

While the lyrical landscape photographs of Watkins and Muybridge, along with Bierstadt's magnificent paintings, helped to ensure Yosemite's designation as a state park and then as a national park in 1890, the first Western area to be granted national-park status, in 1872, was the primeval Yellowstone region of the northwestern Montana Territory. Its earliest explorers noted Yellowstone's "majestic display of natural architecture" and compared a geyser crater to "a miniature model of the Coliseum," descriptions that specifically ranked America's natural monuments as equal to those of Europe. The official visual documentarians of the 1871 Hayden survey of Yellowstone were painter Thomas Moran and frontier photographer William Henry Jackson. Yellowstone's unique phenomena—the geyser basins, hot spring terraces, canyon of the Yellowstone River, and its falls— were recorded by Moran in sketches and watercolors and by Jackson in detailed photographs. To support the campaign to designate Yellowstone a national park, Moran's watercolor sketches were exhibited prominently together with Jackson's photographs in the halls of the Capitol building. As the second great master of the Rocky Mountain School, Moran used his sketches along with Jackson's photographs to create the 7-by-12-foot painting *The Grand Canyon of the Yellowstone*. It was purchased in 1872 by the government for $10,000 and installed in the Senate lobby.

In 1873 Moran accompanied John Powell's Colorado River expedition and later used his field studies to paint *The Chasm of the Colorado*, also purchased by the government for placement in the Capitol to celebrate the West's natural wonders as a source of national pride. When the Hayden survey returned to the West in 1873, this time to investigate the Rocky Mountain region of Colorado, Jackson made the first photograph of a series of *The Mountain of the Holy Cross*. This iconic view, retouched by Jackson to accentuate its symbolic content, became a popular wall adornment in Victorian parlors and chapels for decades to come. In that it implied a visible revelation of God's blessing on the United States, this image combined the aesthetic, spiritual, and nationalistic themes of nineteenth-century American landscape photography.

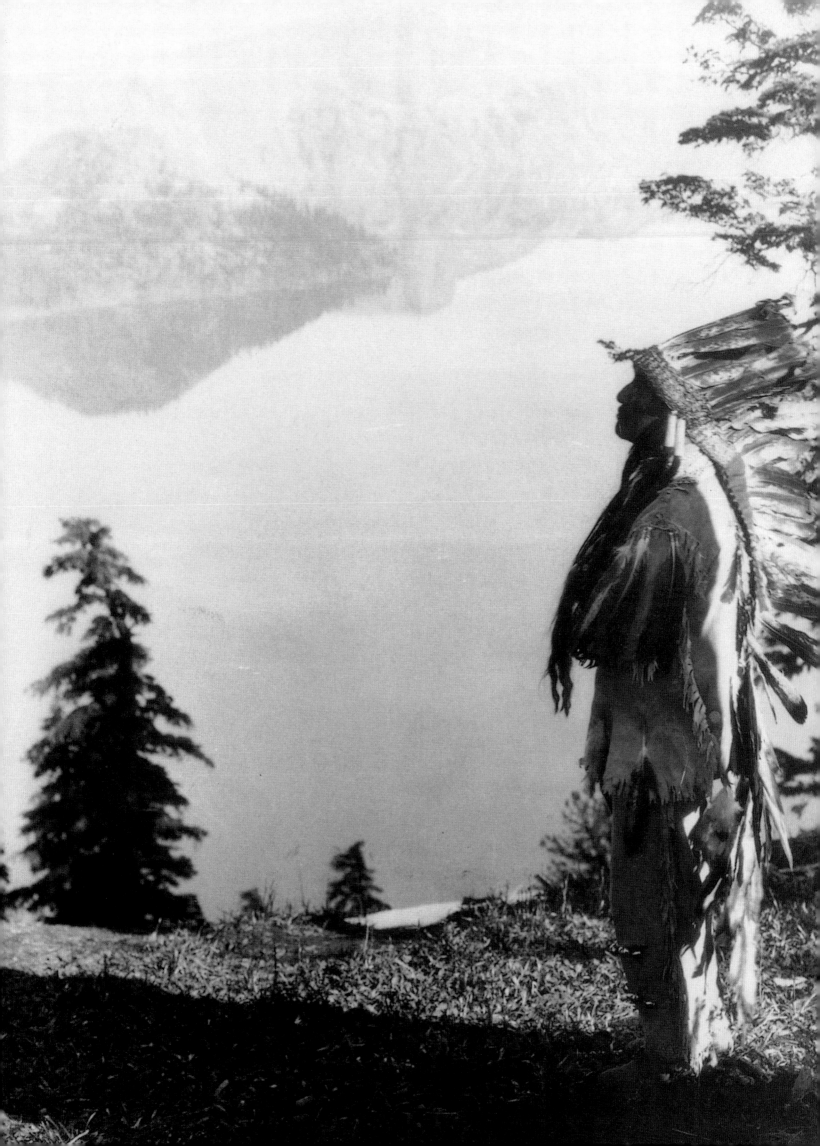

Ansel Adams
Evening, McDonald Lake
Glacier National Park, Montana

Ansel Adams
Grand Canyon National Park, Arizona

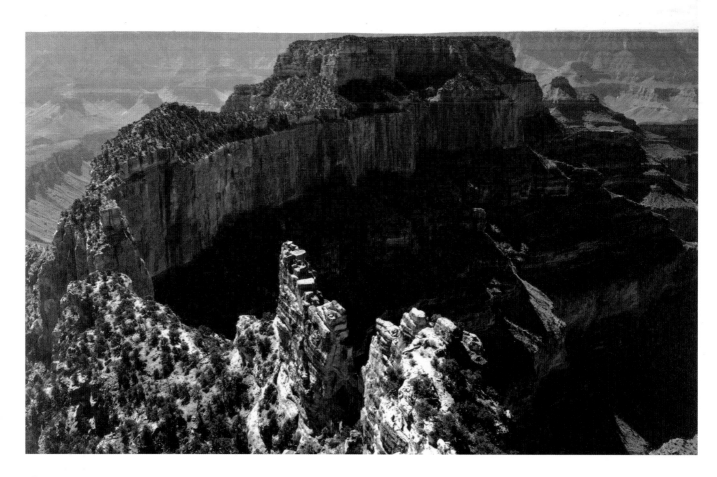

Above:
Ansel Adams
Grand Canyon National Park, Arizona
NATIONAL ARCHIVES

Opposite:
Ansel Adams
Grand Canyon from North Rim
NATIONAL ARCHIVES

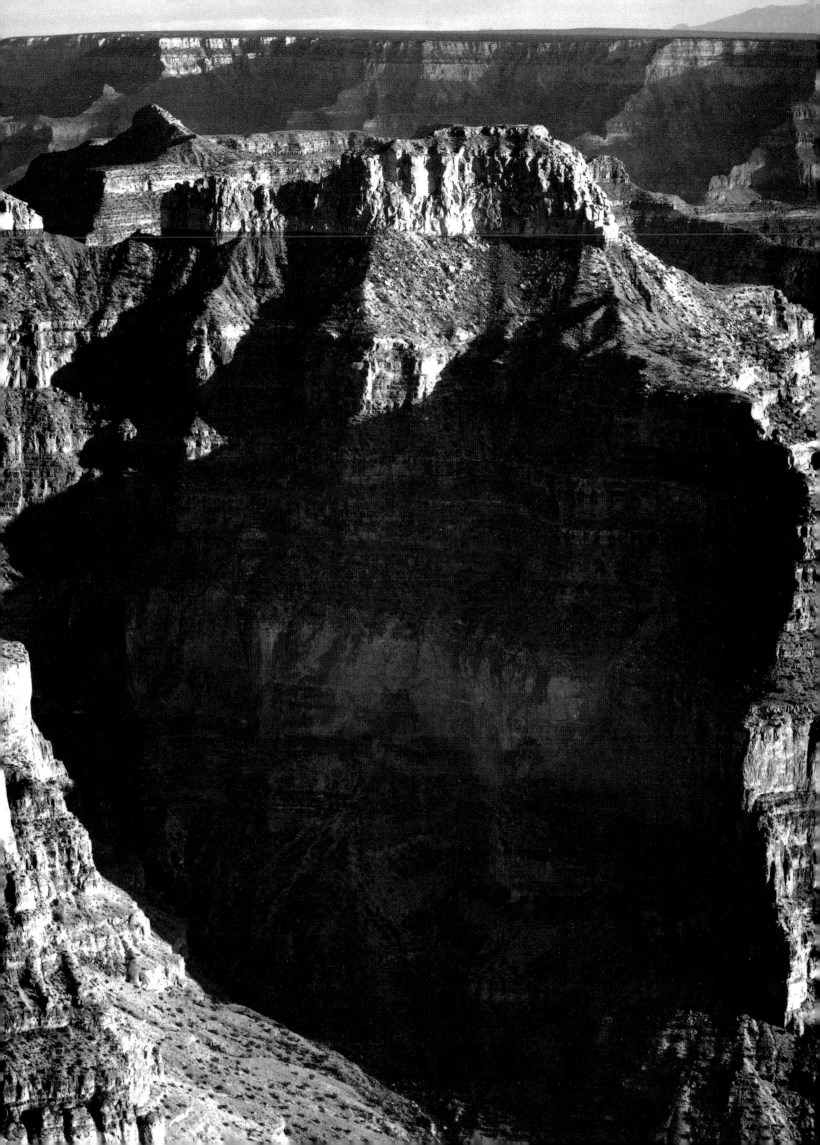

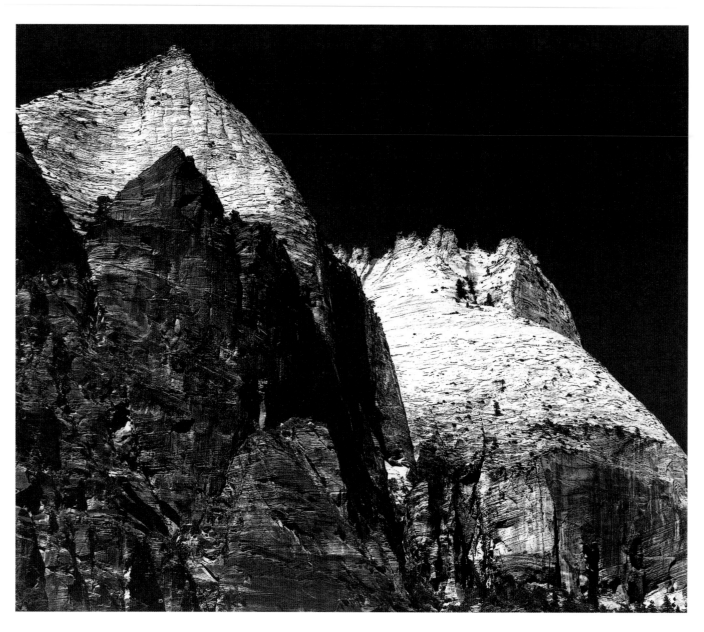

Ansel Adams
Zion National Park, Utah

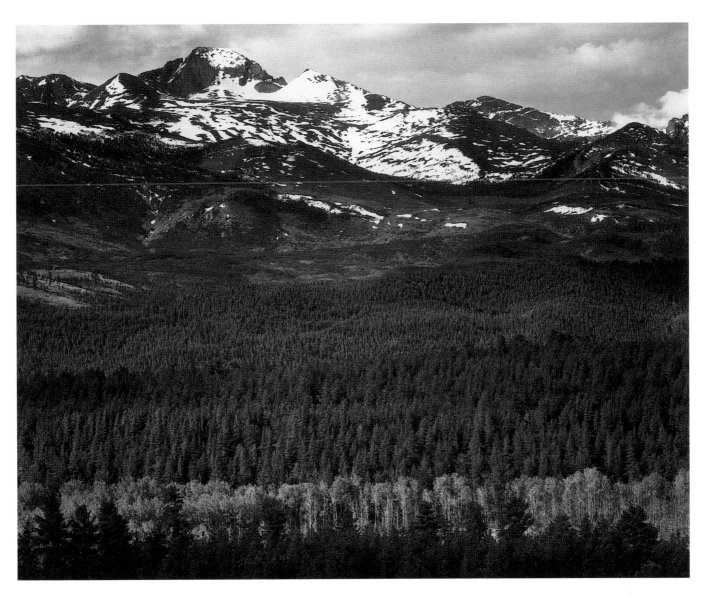

Ansel Adams
Long's Peak from Road
Rocky Mountain National Park, Colorado
National Archives

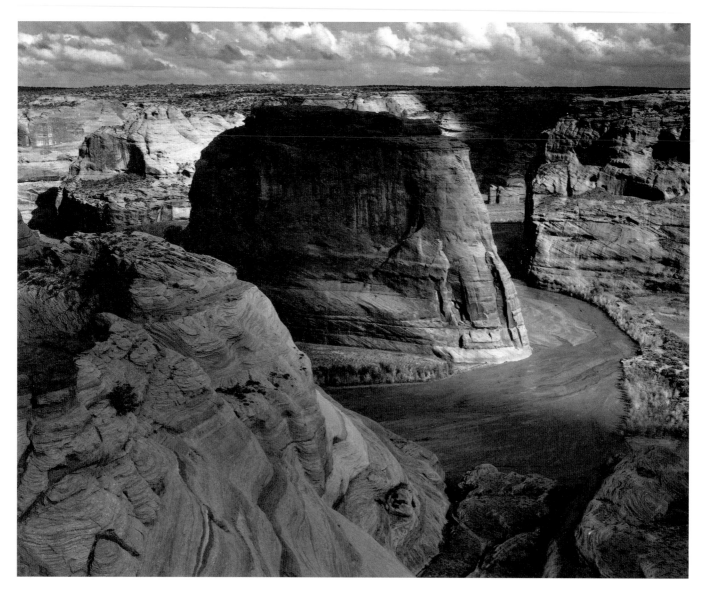

Ansel Adams
Canyon de Chelly, Arizona

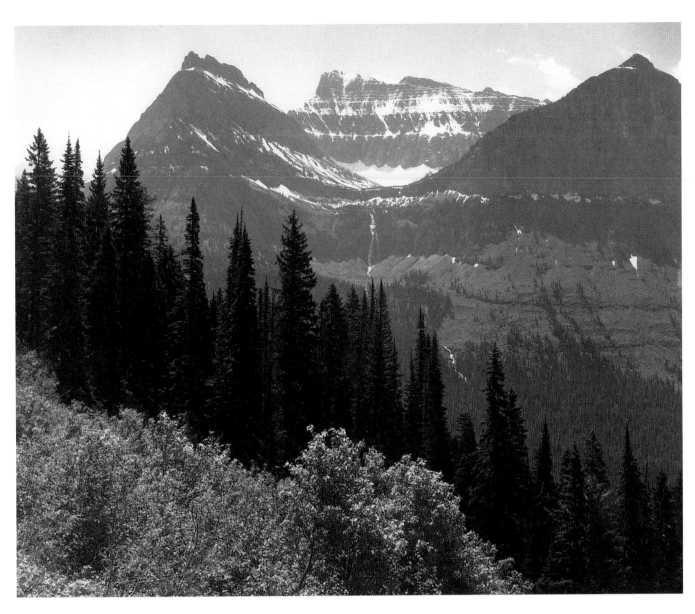

Ansel Adams
In Glacier National Park, Colorado
National Archives

p. 80–81:
Ansel Adams
Tetons from Signal Mountain
Grand Teton National Park, Wyoming
National Archives

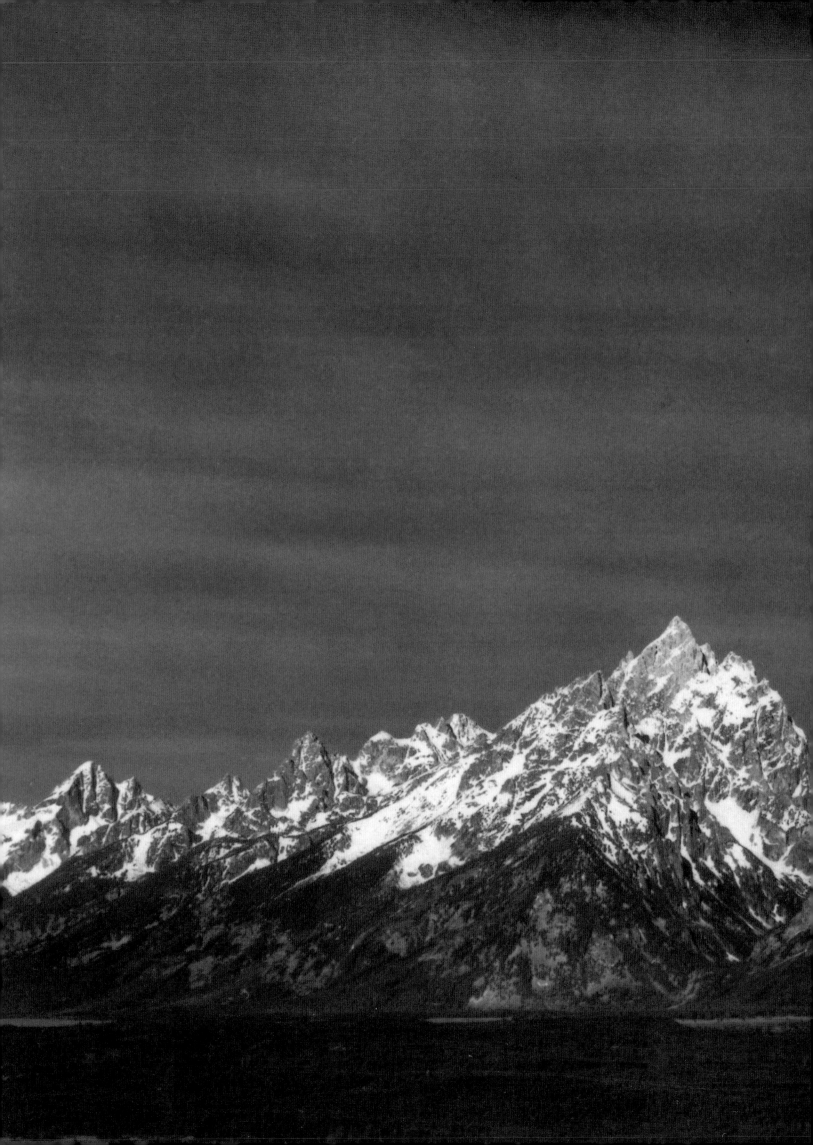

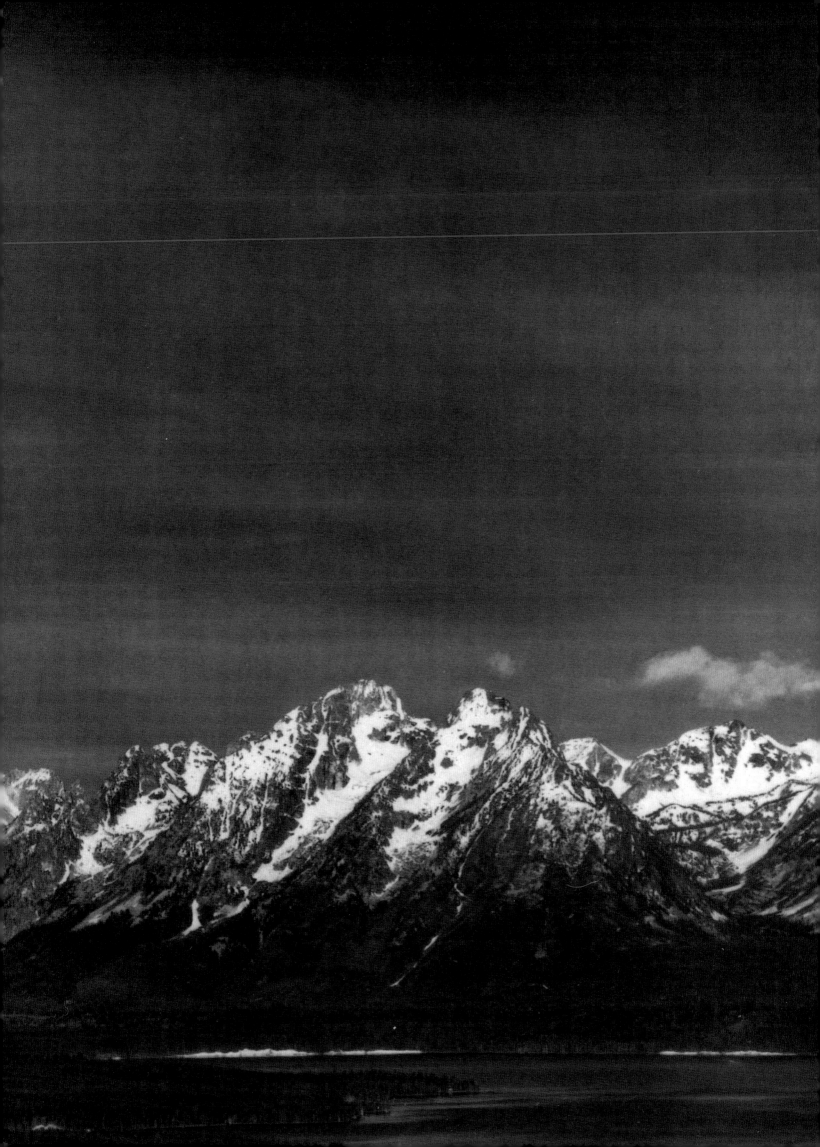

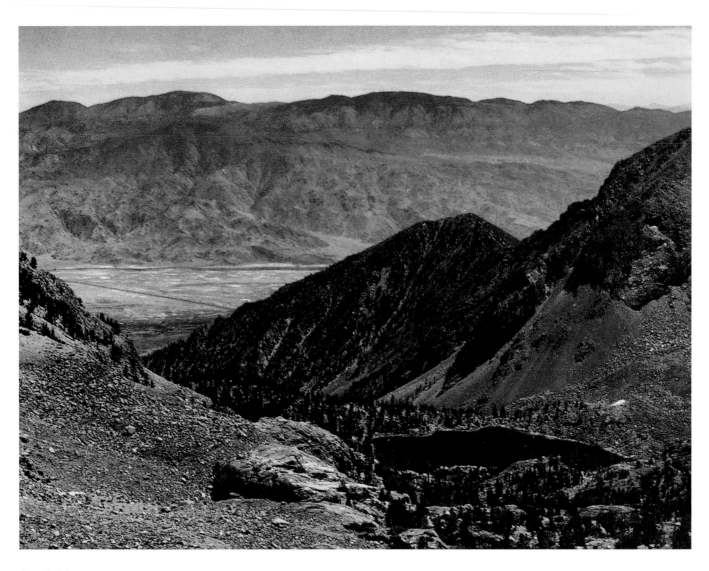

Ansel Adams
Owens Valley from Sawmill Pass
Kings River Canyon, California

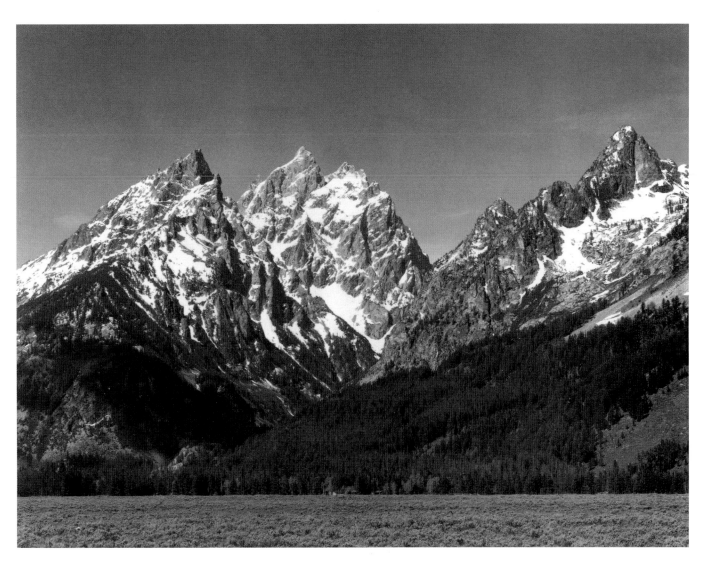

Ansel Adams
Grand Teton
Grand Teton National Park, Wyoming

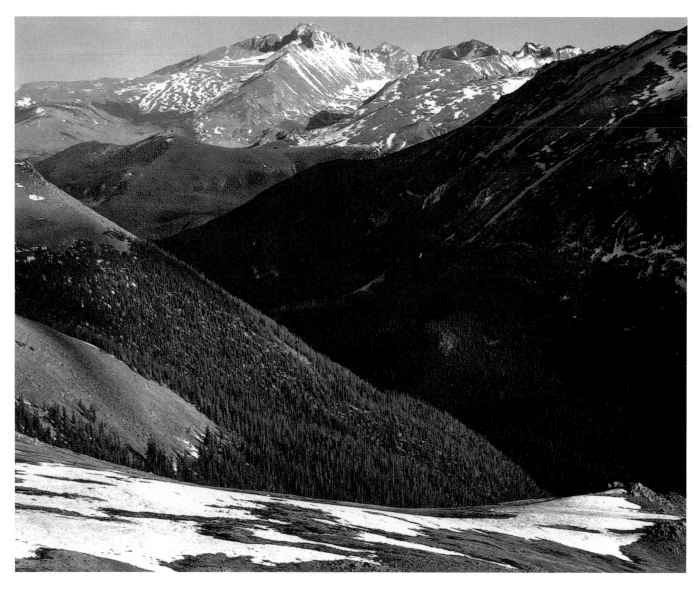

Above:
Ansel Adams
Long's Peak
Rocky Mountain National Park, Colorado
National Archives

Opposite:
Ansel Adams
In Rocky Mountain National Park, Colorado
National Archives

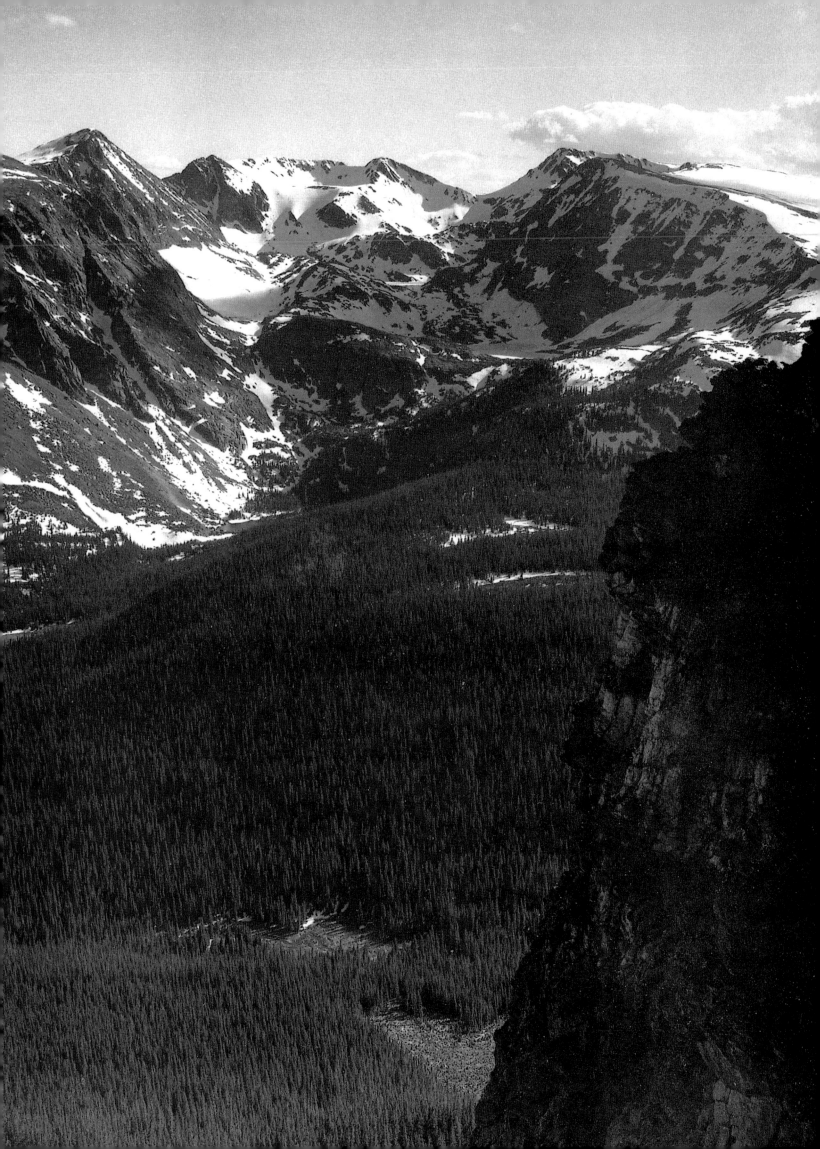

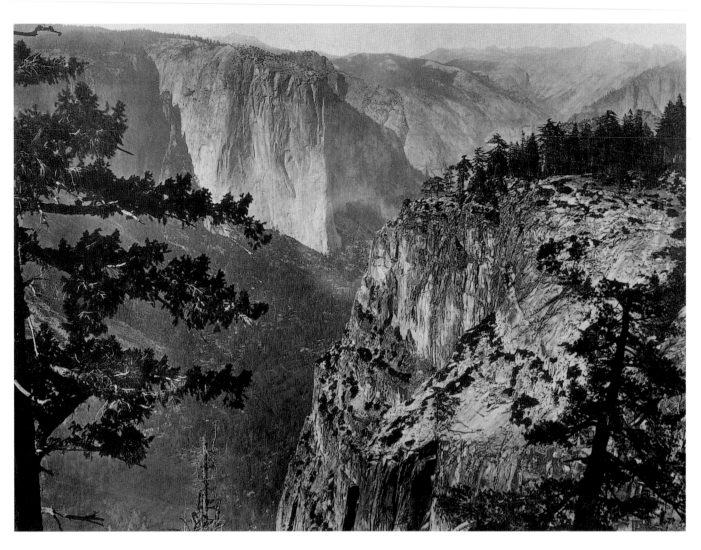

Carleton E. Watkins
First View of the Yosemite Valley,
from Mariposa Trail. c. 1866

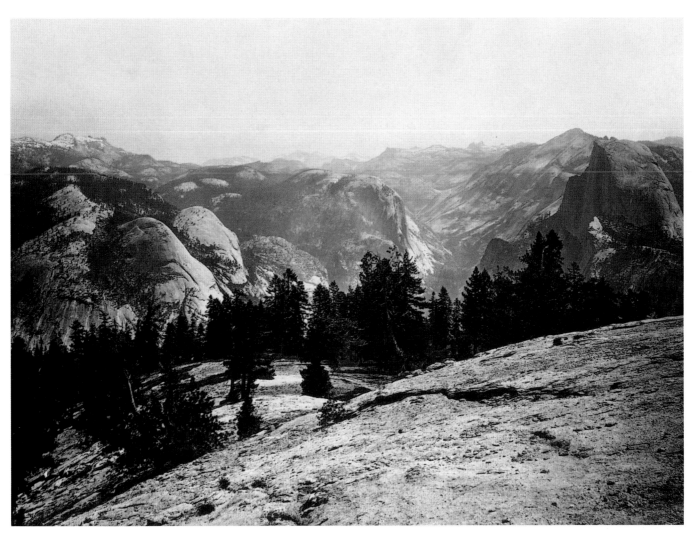

Carleton E. Watkins
The Domes from Sentinel Dome, Yosemite,
No. 94. 1866
RARE BOOK DEPARTMENT, HISTORICAL PHOTOGRAPHS
THE HUNTINGTON LIBRARY, SAN MARINO, CALIFORNIA

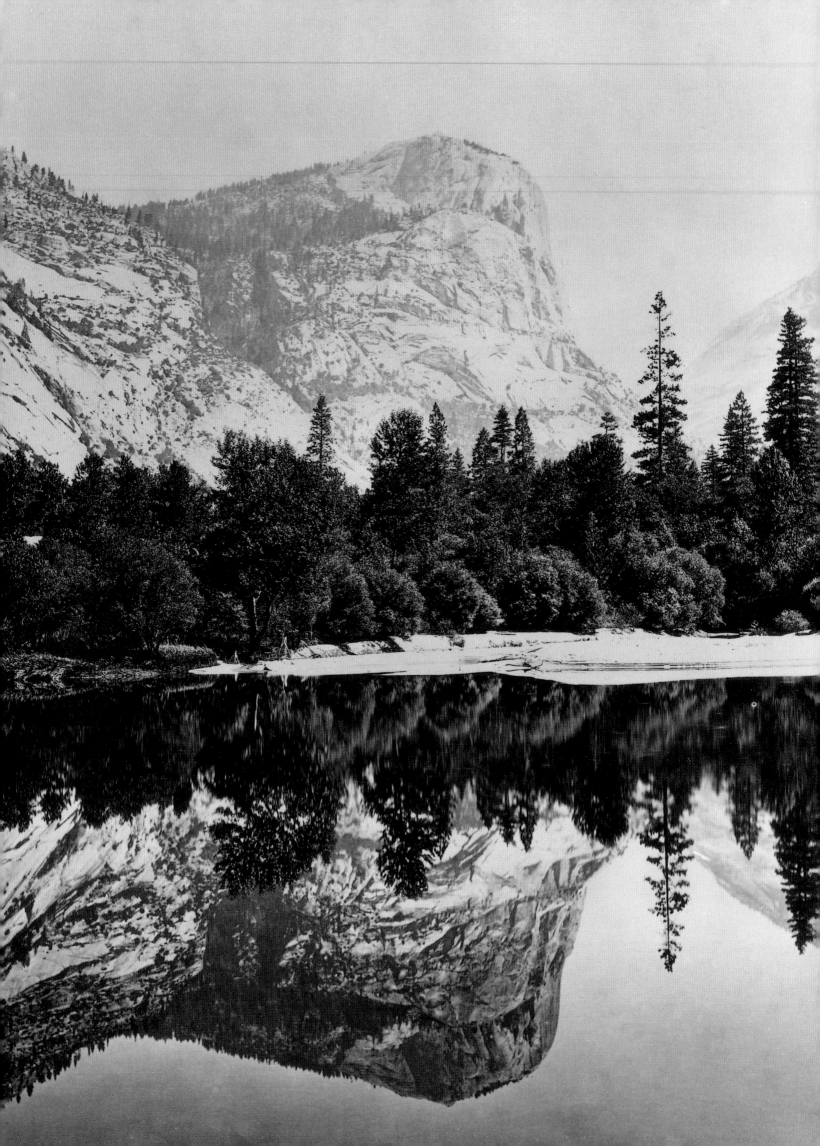

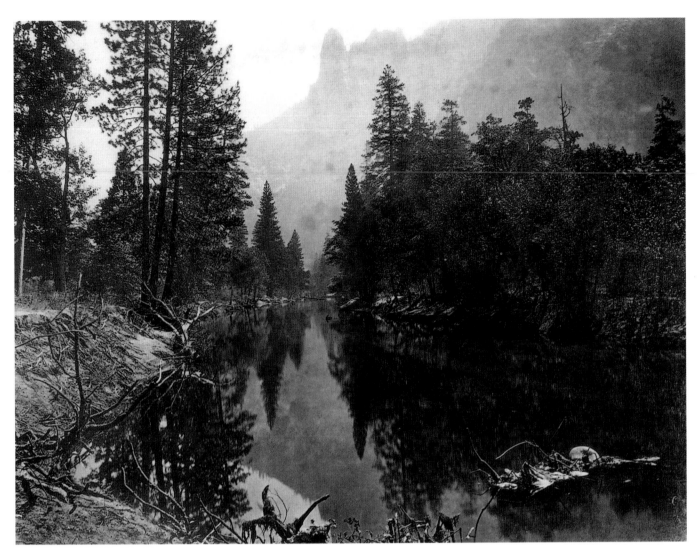

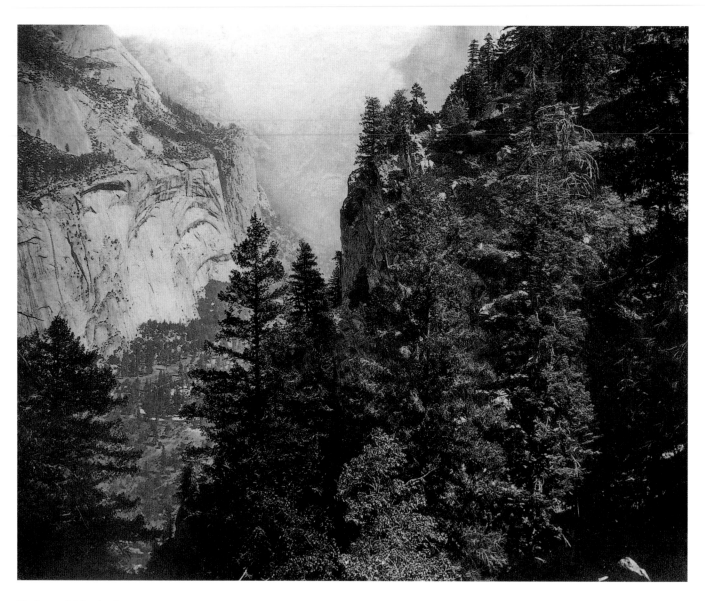

Eadweard Muybridge
Tenaya Canyon, Valley of the Yosemite,
No. 35. 1872
Department of Special Collections
Charles E. Young Research Library, UCLA,
Los Angeles

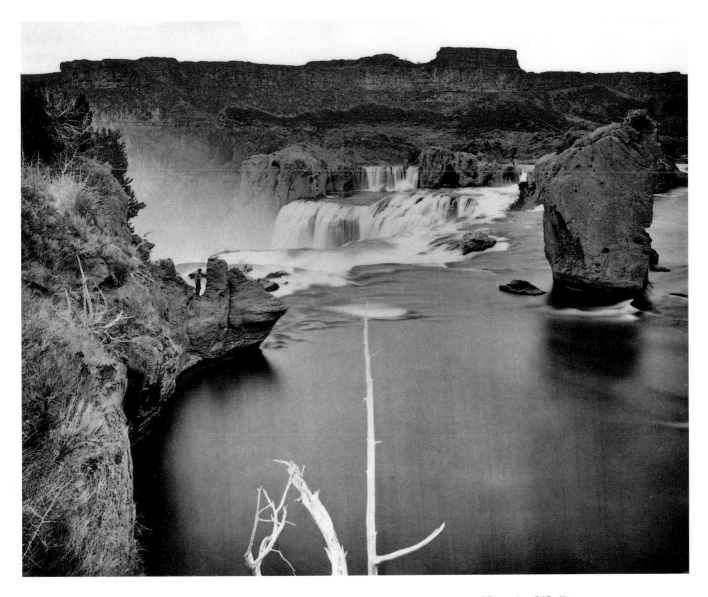

Timothy O'Sullivan
Shoshone Falls, Snake River, Idaho
(Wheeler Survey)

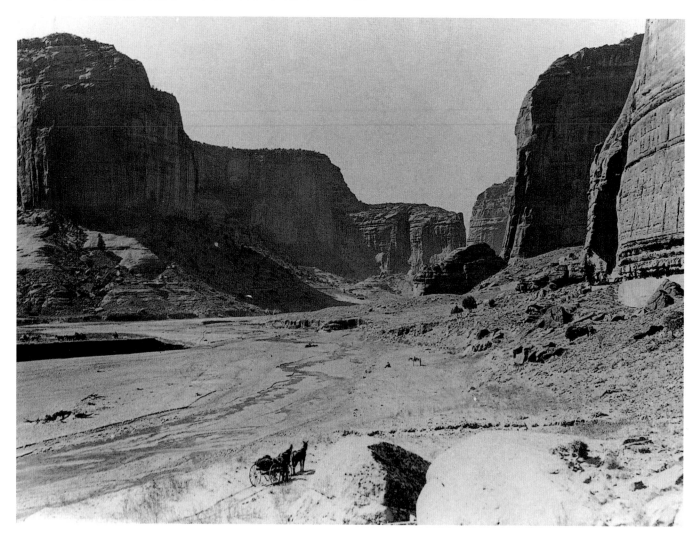

Above:
John K. Hillers
View from Face Rock, Canyon de Chelly,
Arizona. 1882
Photo Archives, Museum of New Mexico, Santa Fe
NEG. NO. 110980

Opposite:
John K. Hillers
Reflected Cliff, Green River, Ladore Canyon, Utah
Photo Archives, Museum of New Mexico, Santa Fe
NEG. NO. 113719

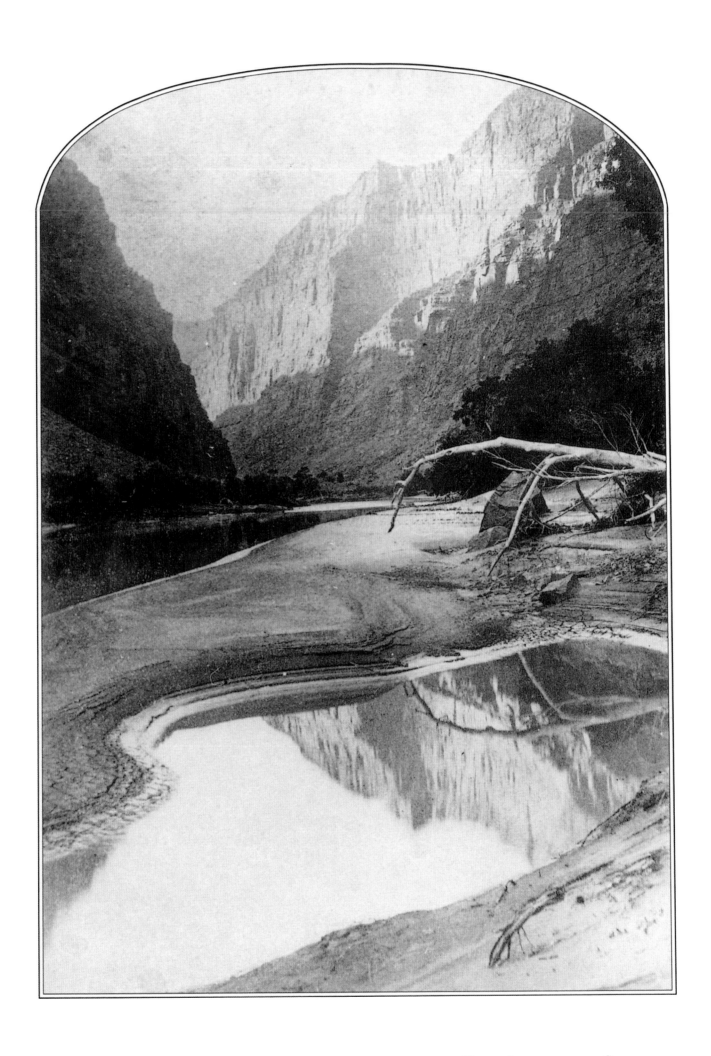

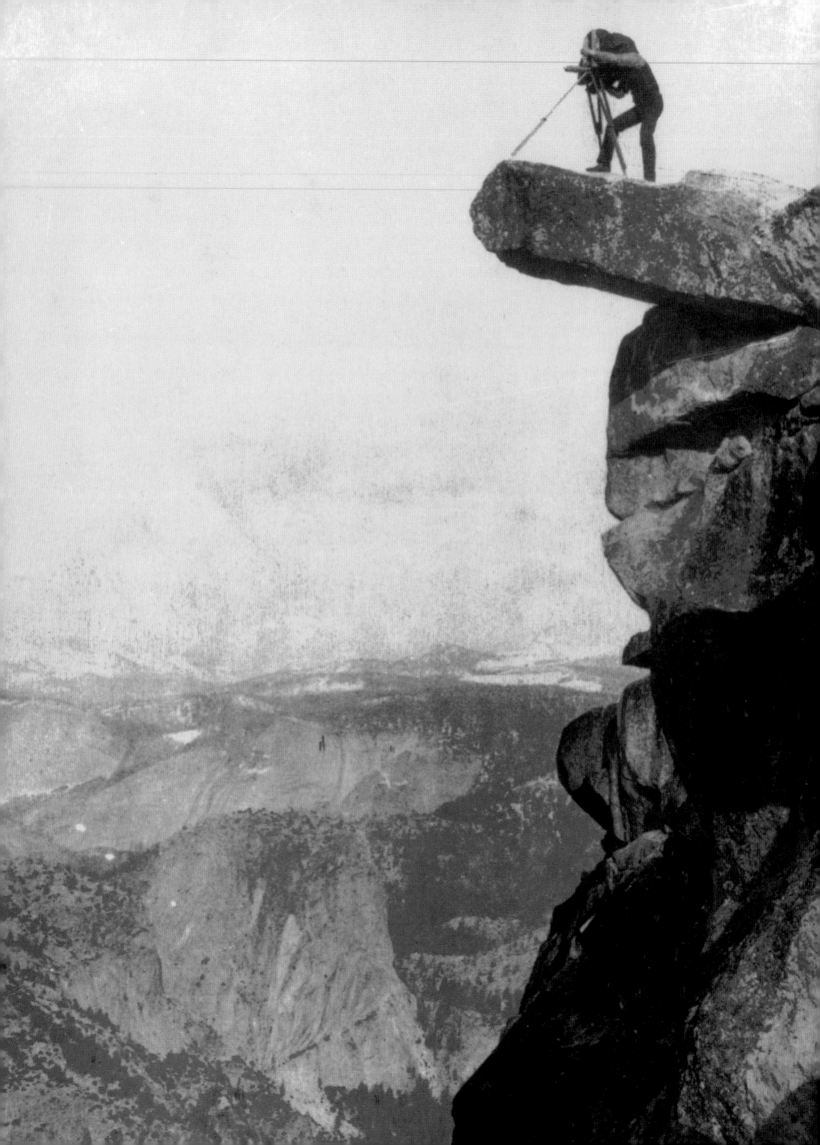

SURVEYS
AND SCIENCE

From its earliest days, photography was considered the perfect scientific tool. Decades before it recorded the geology and archaeology of the West, it was used to document botanical specimens, the phases of the moon, and the wounds of Civil War soldiers. An important task of the surveys and expeditions to the West, aside from exploring the terrain and mapping the topography, was the collection of scientific information of all kinds about these new lands. The nineteenth century was a great era of growth and development in the natural sciences, which previously had been part of natural history and philosophy. From these beginnings arose the specialties of botany, zoology, geology, astronomy, meteorology, paleontology, archaeology, and ethnology. The opportunity to join expeditions was highly valued by scientists. On a trek into the Western wilderness one might find hitherto unknown specimens and even species. The opportunity to collect, classify, and study Western fossils, rocks, plants, animals, and artifacts was an incomparable experience, one that created reputations. For those unable to venture into the field themselves, photographs of the West's scientific marvels were a more than adequate substitute. For example, Harvard University's Asa Gray, a leading nineteenth-century botanist, eagerly studied the photographic tree portraits, labeled with their Latin names, made by Carleton Watkins.

Of all these scientific fields, geology emerged as the most exciting in that it became the focus of intense religious and scientific controversies about the origin of the Earth. While uniformitarians believed that mountains and other landforms grew slowly from natural forces operating regularly over eons, catastrophists held that sudden violent cataclysms were responsible for changes to the terrain.

Adams's detailed photographs of the unique and ancient landforms of the West, particularly in the Sierra Nevada, provide an accurate record of the region's geologic history and of the glacial processes that shaped it. Glaciers were the result of annual layers of snowfall which were compressed by the weight of new layers to eventually form massive and dynamic bodies of ice. His images of rounded rocks and boulders, of the deposits and ridges (also known as moraines) of rocky debris, of domes and spires, and of gouged, striated, and fractured rock faces all are evidence of the movement and action

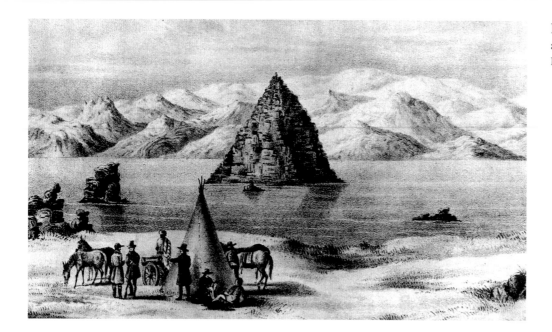

Frémont, the Pathfinder, at Pyramid Lake.
NATIONAL ARCHIVES

of glaciers. Glaciers also carved out the bowl-shaped valleys with steep walls and their tributary or hanging valleys from which waterfalls descended. Yosemite Valley is a prime example of this process. Scorning scientific documentation as his intent, Adams stated, "The grand lift of the Tetons is more than a mechanistic fold and faulting of the earth's crust; it becomes a primal gesture of the earth beneath a greater sky."

Only two pre-Civil War expeditions to the West made use of photography. In his 1853 *Cosmos*, the great German naturalist and explorer Alexander Humboldt had called for the use of photography in documenting expeditions. For his fifth expedition west to investigate a possible railroad route along the 38th parallel, John C. Frémont hired daguerreotypist Solomon Carvalho (1815–97), who exposed hundreds of plates as the party crossed Kansas, Colorado, and Utah from September 1853 to February 1854. Of the images, Frémont's wife stated that "almost all of the plates were beautifully clear and realized the wish of Humboldt for 'truth to nature.'" Unfortunately, these daguerreotypes were lost some time after Frémont worked with Mathew Brady to transfer them to glass-plate negatives. A group of artists also made paintings and engravings from Carvalho's images in preparation for Frémont's expedition report, which never was completed. Some of the engravings later appeared in his 1887 *Memoirs*. In 1859 painter Albert Bierstadt made over 100 stereographs while accompanying the Lander federal wagon-route survey across Kansas, Nebraska, and Wyoming.

After the Civil War, the four major official expeditions of the 1860s and '70s to the West were devoted mainly to an investigation of scientific matters. The Geological Survey of the Territories, led by naturalist and geology professor Ferdinand V. Hayden to Montana, Wyoming, and Idaho in 1867, with photographer William Henry Jackson along, found some 44 new organisms, ranging from a moth to a dinosaur fossil. Geologist Clarence King, in his 1867 Geological Exploration of the Fortieth Parallel, used the

services of photographer Timothy O'Sullivan (and those of Carleton Watkins and Andrew J. Russell on other projects). King later organized and became the first head of the U.S. Geological Survey. Geologist and ethnologist John Wesley Powell employed John K. Hillers on two Colorado expeditions of 1869 and 1871, and continued to use his services when he became the first head of the Bureau of American Ethnology. (Later, he succeeded King as head of the U.S. Geological Survey.)

The army Geographical Surveys West of the 100th Meridian were led by Lieutenant George Wheeler, who also employed O'Sullivan to document areas in the Southwest. From 1869 to '79, Wheeler mapped the region's mountain ranges, determined the elevation of some 400 peaks, and collected some 61,000 specimens.

Timothy O'Sullivan (1840–82) arrived in the West in the vanguard of photographers hired to document the government surveys and scientific expeditions that resumed after the war ended. He had become an accomplished cameraman by documenting the Civil War, first with Mathew Brady's crew and then under Alexander Gardner. In 1867 he joined Clarence King's expedition and during the next two years photographed unique geological formations and other scenes of interest in the 100-mile-wide stretch of wilderness along the proposed route of the Central Pacific Railroad, which extended from Virginia City, at Nevada's western border, some 900 miles eastward across Utah to Denver. In a series of extraordinary photographs notable for their startling realism and unconventional composition, he documented the mine shafts of the Comstock Lode; the tufa formations of Pyramid Lake; the arid Humboldt and Carson sinks; the Ruby, Wasatch, and Uinta Mountains; Great Salt Lake basin; Shoshone Falls; and the Green River. For hundreds of these photographs, he successfully exposed mammoth-plate glass negatives—a considerable achievement when operating in rough terrain.

After an 1870 hiatus during which he accompanied an American naval survey to Panama to search for a possible canal route across the Isthmus, O'Sullivan came back to the West and joined Wheeler's survey in 1871. While in Nevada and Utah, he recorded images of Owens Valley, Death Valley, and the Grand Canyon of the Colorado River. He then rejoined the King survey in Utah for a while and returned to the Green River Valley. On another expedition for Wheeler, he traveled in 1873 to the region to investigate the Canyon de Chelly, and the pueblos of Zuñi and Magia. He returned to the Southwest again in 1874–75 to document the indigenous cultures, including those of the Mojave and Navajo. O'Sullivan's photographs of the peoples of the Southwest are notable for their straightforward and unsentimental quality, the preferred approach for ethnographic documentation.

He then traveled back to Washington to develop and print a selection of his photographs for the Wheeler survey album. There he worked for the new U.S. Geological Survey, established in 1879, and in 1880 became the Treasury

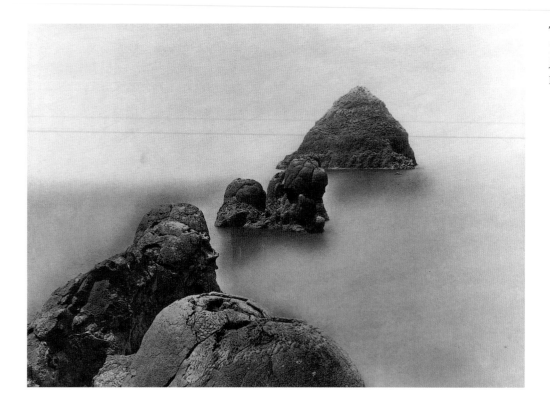

Department photographer for a brief period. He had to resign when he developed tuberculosis, and he died not long after, still a relatively young man but one whose photographic achievements were truly remarkable.

The career of survey and frontier photographer William Henry Jackson (1843–1942) was extraordinary for its breadth and length. He worked for close to 80 years, periodically in the service of the federal government, beginning with his 1863 enlistment as a Union volunteer in the Civil War, followed by his years as a survey photographer, and ending with his late-1930s New Deal commission by the Works Progress Administration. This was to complete four large paintings recalling the 1870s surveys—those led by Hayden to Yellowstone, by Wheeler to the Southwest, by Powell to the Grand Canyon of the Colorado River, and by King to the Sierra Nevada. After successfully finishing this assignment, he was hired to paint six more oils and more than forty watercolors of scenes from the national parks. In a 1940 exhibition, the Interior Department displayed a selection of his 1870s survey photographs along with his newly installed survey murals.

Originally from Keesville, New York, where he had worked as a photo retouching artist, Jackson arrived in Omaha, Nebraska, in 1867 and established a studio as the base for his fieldwork on a series depicting the region's Native Americans and their villages. On an 1869 field trip westward on the Union Pacific Railroad to Promontory Point, Utah, he refined his skills as a photographic landscapist. (As an artistically inclined youth, he had studied Chapman's 1847 *American Drawing Book*, which described the composition of ideal landscapes.) In 1871 he joined the Hayden survey, an association that he maintained until 1878. For his survey work as official photographer, he photographed Yellowstone, the Grand Tetons, the Wind

River range, the Colorado Rockies, southwestern Colorado's Ute reservation, and the Mesa Verde region. However, his 1877 work on the archaeological ruins of the Southwest was lost because of technical problems.

Hayden assigned Jackson to organize the survey's exhibit at Philadelphia's 1876 Centennial Exposition. The display included scientific specimens, ethnological artifacts, and a clay model of the ancient cliff-house dwellings near Mesa Verde, which Jackson had discovered and photographed in 1875–76. Most impressive was the selection of many of his finest landscapes, a number of which he enlarged even more and transferred to transparent glass plates. Also on view at the exposition were the expedition photographs of his competitors Timothy O'Sullivan, William Bell, and John K. Hillers, but Jackson's astutely presented images reaped most of the critical acclaim.

After leaving the Hayden survey, he founded in Denver what became a profitable company to market photographs of Western landscapes nationwide. In 1892 he journeyed along the Santa Fe Railroad route with Thomas Moran and in the following year photographed the World's Columbian Exposition in Chicago for architect Daniel Burnham. After an 1894–96 world tour, he moved his commercial operation to the Detroit Photographic Company, a mass marketer of popular views. While many of Jackson's spectacular views were radically reduced in size and cropped for use as postcards, thus destroying much of their artistic power, a selected body of his work was marketed in its original format. Jackson took his last professional photographs in 1924, after which he turned to painting and to assembling his memoir, which encompassed a remarkable era of Western exploration.

Landscape photographer Carleton Watkins also completed various survey assignments. In 1865 he became official photographer for the California State Geological Survey, and the following year he documented Yosemite's valleys and high country for geologist Josiah Dwight Whitney, appointed the agency's first director in 1860. In July 1867 he sailed with Whitney to Portland, Oregon, to document the extinct volcanos of the Coast Range. He spent six weeks in 1870 photographing the northern California Sierra Nevada around Mount Shasta and Mount Lassen for Clarence King's expedition to the region. On this trip, he made what may have been the first photograph of a living glacier with *Commencement of the Whitney Glacier, Summit of Mt. Shasta*. The 1879 U.S. Geodetic Survey led by George Davidson to the Sierra Nevada hired Watkins to photograph Mount Lola and Round Top, and two years later he documented the Yolo Base Line Survey for Davidson near Davis, California. The result of this project was the 40-view series *Summits of the Sierra*.

As did Watkins, Eadweard Muybridge took on assignments for surveys of various kinds. In August 1868, he sailed north up the coast on General Henry W. Halleck's Alaska expedition to document maritime and army facilities for the U.S. Military Division of the Pacific. In 1871, hired by the

Lighthouse Board, he photographed all lighthouses from Washington Territory to San Diego. During the 1873 Modoc Indian War, he produced for the Army Engineers a reconnaissance survey of northern California's Lava Beds. In 1875 the Pacific Mail Steamship Company sent him on a lengthy tour through Central America in order to renew interest in the Atlantic-to-Pacific route across the Panama Isthmus, which had been eclipsed by completion of the transcontinental railroad in the United States.

But it was with his photographic experiments, which he then translated into new technologies, that Muybridge made his greatest impact in the scientific realm. His 1877 attempt to promote the use of photography for copying written documents failed, but earlier that year he had resumed work on his 1872–73 project for capturing the mechanics of a horse's pace. He had been commissioned to do so by California governor Leland Stanford, who was interested in determining whether all four of a horse's hooves were in the air at any one time during a trot. Muybridge had been able to prove this by taking a series of photographs with a single camera of Stanford's horse "Occidental." With Stanford's continued sponsorship and the use of his new Palo Alto Farm in 1878–79, Muybridge installed a battery of specially adapted cameras placed 21 inches apart. Their shutters were tripped by the passage of the horse. With his 1878 series *The Horse in Motion*, Muybridge showed that the conventional equine flying gallop long depicted by artists was a fiction. He went on to record the paces of numerous animals and of human beings as well, moving his experiments in 1883 to Philadelphia's University of Pennsylvania. He used these images to design the Zoöpraxiscope, which involved the rotation of sequential photographs on a disk to produce a short motion-picture loop. This device illustrated his many lectures on animal locomotion, but the first viable motion-picture projector, which Muybridge anticipated, was Edison's Vitascope of 1896.

After completing his two explorations of the Colorado River, John Wesley Powell was appointed in 1879 as head of the new Bureau of American Ethnology (BAE), associated with the Smithsonian Institution. This official attempt to formalize and apply scientific standards to the study of human cultures arose from the relatively recent development of the discipline of cultural anthropology, of which ethnology, archaeology, and linguistics were the main branches. Of course, this was not the first systematic collection of information about America's indigenous groups. From the days of the conquistadors in the 1500s, explorers assembling the required reports for the Spanish royal government kept copious records of their encounters with Indians in Florida, the South, and the Southwest, describing in detail their appearance, their dwellings, their hunting and agricultural methods, and their beliefs and rituals. In Canada, the Great Lakes region, and the Mississippi River Valley, French missionaries and others gathered a voluminous body of writings about the first inhabitants of those areas.

Nor was the new nation of the United States remiss in seeking out such

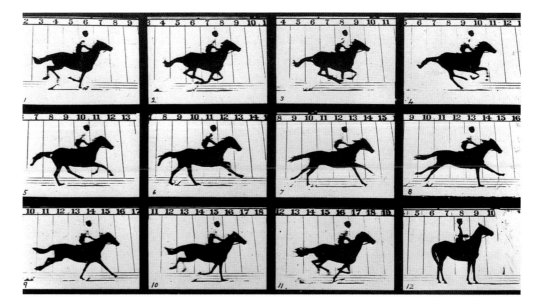

documentation. When President Thomas Jefferson sent Meriwether Lewis and William Clark on their epic journey across the Louisiana Territory, he included in his detailed instructions to Lewis orders to gather information about, among other things, "Their language, traditions, monuments; Their ordinary occupations in agriculture, fishing, hunting, war, arts, and the implements for these; Their food, clothing, and domestic accommodations;… Peculiarities in their laws, customs, and dispositions." Lewis returned with notes about such aspects of Indian life as the weapons and horse gear of the Shoshone, the houses of the Chinooks, and the social status of women and elders. Thus, some 350 years after the advent of Europeans, a considerable archive already existed about those who had arrived before them.

In 1879 Powell sent out the first BAE expedition to Zuñi Pueblo. The group was headed by Colonel James Stevenson and included a young Frank Hamilton Cushing, as well as Stevenson's wife Matilda Coxe Stevenson. John K. Hillers (1843–1925), a Civil War veteran who devoted some 20 years to documenting official surveys, was the photographer. In 1871 he had been taken on as a boatman for the second Powell Colorado River exploration. He learned his craft from the expedition photographers, Edward O. Beaman and James Fennemore, and became head photographer in 1872, when they departed. He also received instruction briefly from Carleton Watkins in San Francisco in 1873. After Powell was made head of the BAE, and served concurrently as director of the U.S. Geological Survey (USGS) from 1881 on, he continued to rely on Hillers's expertise. In 1872–74 Hillers had photographed the Colorado River region and Arizona's Hopi people, to whom he returned in 1876. His 1875 photographs of the displaced nations of the Indian Territory (Oklahoma) brought him acclaim at the 1876 Philadelphia Centennial display. From 1879 on, he returned repeatedly to the Southwest to photograph at Zuñi, Hopi, Laguna, Acoma, Cochiti, Santo Domingo, Santa Clara, and Ildefonso pueblos, and elsewhere for the BAE. In 1885 he became head of the photographic

laboratory of the USGS and BAE in Washington, D.C., where he also made portraits of Indian delegates. In 1892 he conducted field trips to Yosemite and the Kings Canyon area of California's Sierra Nevada.

One of Hillers's most intriguing subjects was the Zuñi *berdache* We'wha—a man who led the life of a woman. We'wha arrived in Washington in late December 1885 for a six-month stay as the guest of Matilda Coxe Stevenson. He was welcomed socially in the nation's capital and by the press, who believed him to be a famous Zuñi princess or priestess. His visit ended in an audience with President Grover Cleveland, to whom he presented a gift. It was during this stay that We'wha posed for Hillers in a series of 62 photographs demonstrating the steps of Zuñi weaving techniques. Also an accomplished potter, he was among the first Zuñi to produce for sale the Southwestern ceramics and textiles that eventually came to be esteemed as valuable works of art.

The fact that *berdaches* had an accepted and even important role, sometimes as shamans, in many North American Indian cultures was a difficult and even abhorrent concept for most nineteenth-century non-native Americans, who viewed these cultures through the filter of their own prejudices. This was also the case with the era's ethnologists, who supported an evolutionary theory of cultural development, beginning with a savage state and moving through progressively higher stages to culminate in a superior civilization characterized by Victorian social, economic, religious, and moral values. The divergence of native peoples from such norms was seen as evidence of their still primitive and childlike state. This condescending attitude frequently led to abuses in fieldwork by ethnologists who often used intimidation or deception to obtain information their subjects were reluctant to share. Ethnologists unearthed the graves of ancestors, insensitively published details and photographs of sacred rituals, and carried off so many artifacts that the ability to conduct ceremonies was seriously impaired. The scientists justified these actions by asserting that they were preserving for posterity the culture of a "vanishing race." If anything, their high-handed methods contributed to that process—the erosion of Native American culture. Little wonder, then, that when these intrusive Anglos, including ethnographic photographers, approached the Indians, they often turned and fled. Images of their departure reinforced the ideology of the vanishing race, especially when the captions explicitly alluded to it. This evolutionary type of ethnology finally slowed to a halt by 1910. Since it ignored Charles Darwin's central idea of adaptation, it was unable to produce new or useful knowledge about the indigenous cultures.

Edward Curtis's *The North American Indian* is often disparaged for its romantic depiction of the vanishing race and of the noble savage, as well as for his "artistic" re-enactment of rituals. Certainly his work is not considered ethnographically authentic, even though he stated that this was his intent.

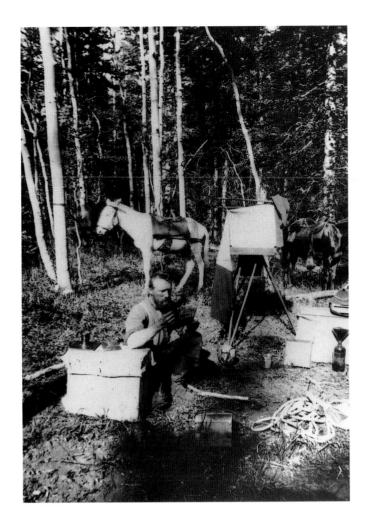

John K. Hillers
Hillers at Work, Powell Survey. c. 1872
NATIONAL ARCHIVES

Only in his later photographs did Curtis sometimes allow Indians to be seen as his contemporaries rather than as actors portraying their ancestors as Curtis imagined them. Yet his immense body of images includes photographs, particularly when stripped of their sometimes patronizing titles, that possess an aura of objectivity and seem to provide invaluable ethnological information about the ritual apparel, body adornment, and masks of specific groups, as well as documentation about domestic structures, methods of gathering and processing foodstuffs, the making of artifacts, and types of transportation. Nevertheless, such images can be deceptive. When some subjects refused to don sacred ritual apparel for Curtis's portrayal, he is known to have come up with a persuasive re-creation of mask and costume. Nor was he the only transgressor. While on his survey, Powell had "authentic" clothing made for Utes and Paiutes photographed by Hillers, and he later added these costumes, together with their inappropriate feather bonnets, to the Smithsonian Institution collection.

Curtis was introduced to scientific ideas when his participation as an official photographer for the Harriman expedition exposed the Seattle society portraitist to the leading minds of the day. Financed and organized by railroad tycoon Edward Harriman, the shipboard expedition sailed in 1899 north from Seattle along the Alaskan coastline and back, making some 50 stops en route so that the passengers (among whom were scientists from all disciplines, including the naturalist-conservationists John Muir and John Burroughs) could gather botanical and entomological specimens; obtain information about birds, small mammals, and marine life; and make geological observations. They also visited native villages, from one of which they typically carried off a cache of Tlingit sacred objects. Discoveries and observations made by participants later filled a 13-volume report.

With his photographs of Native Americans, Ansel Adams had no pretensions of gathering ethnographic data. Yet the artistic quality of his detailed photographs of archaeological ruins and of pueblo peoples, taken during the early 1940s for the Mural Project, do convey a sense of the Southwest's indigenous tribes. These images record a moment in time of an ancient culture that has persisted into the twentieth century, and whose peoples have survived by adaptation to changing circumstances while still retaining their traditional values. In Adams's observations, pueblo architecture is at one with the surrounding natural environment.

Above:
William Henry Jackson
Hayden Survey at Noon Meal, Red Buttes,
Wyoming Territory. 1870
NATIONAL ARCHIVES

Opposite:
Timothy O'Sullivan
Canyon de Chelly. 1873
(Wheeler Expedition)
NATIONAL ARCHIVES

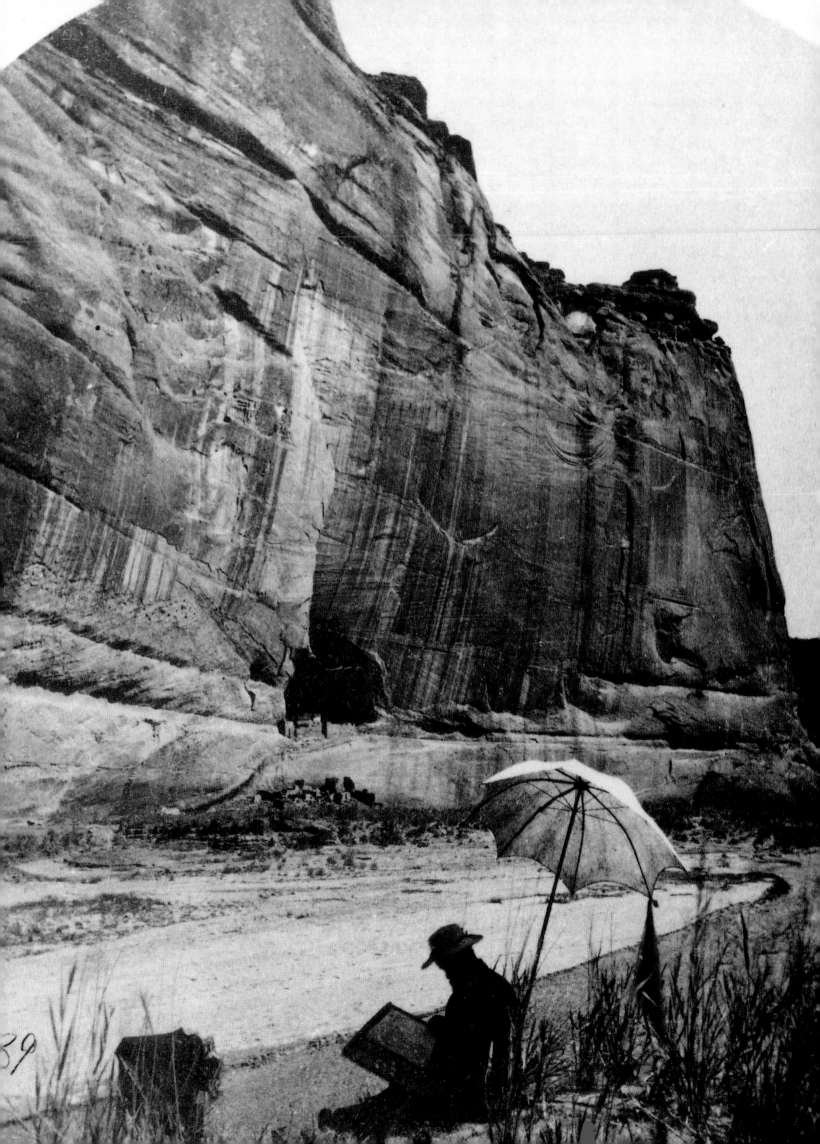

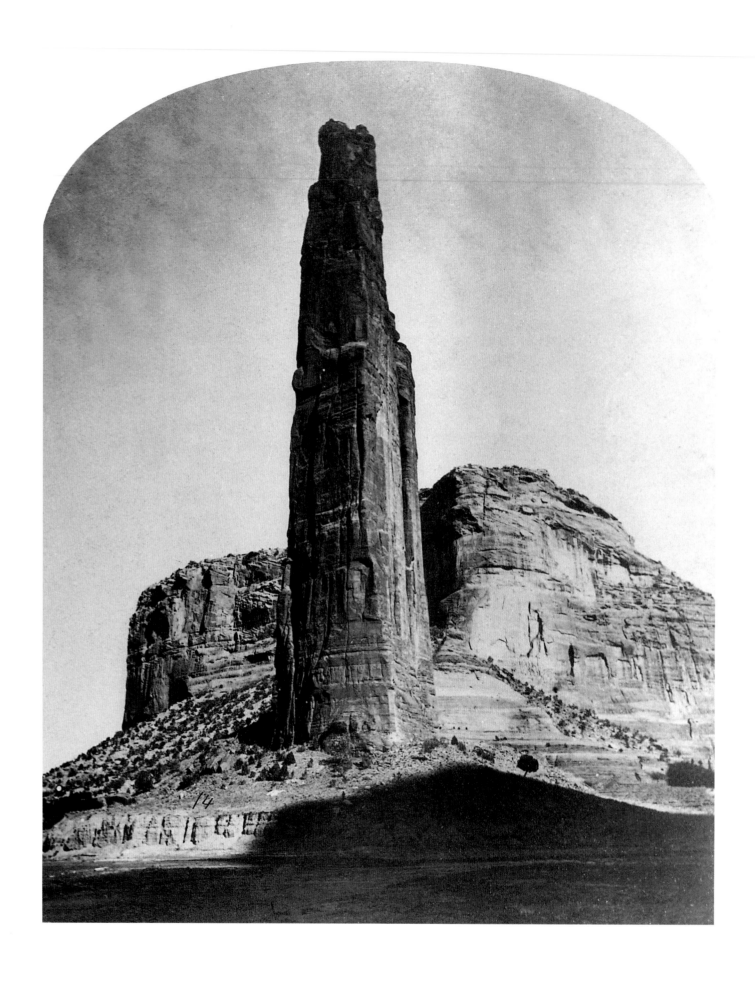

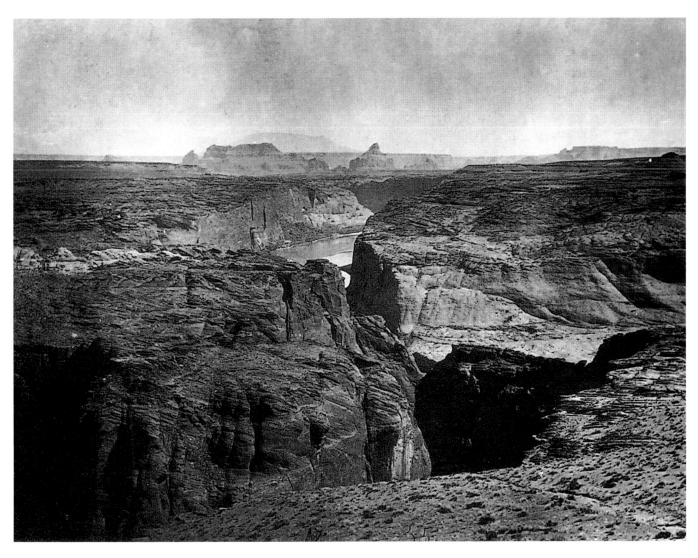

Opposite:
Timothy O'Sullivan
Explorer's Column. 1873
(Spider Rock, Canyon de Chelly,
Arizona)
PHOTO ARCHIVES, MUSEUM OF NEW MEXICO,
SANTA FE
NEG. NO. 40199

Above:
Timothy O'Sullivan
*Canyon of the Colorado River, near the
Mouth of the San Juan River, Arizona.*
c. 1873
PHOTO ARCHIVES, MUSEUM OF NEW MEXICO,
SANTA FE
NEG. NO. 143871

William Henry Jackson
North from Berthoud Pass
YALE COLLECTION OF WESTERN AMERICANA,
BEINECKE RARE BOOK & MANUSCRIPT LIBRARY

William Henry Jackson
Crater of the Lone Star Geyser, Yellowstone. 1872
Photo Archives, Museum of New Mexico, Santa Fe
NEG. NO. 53166

William Henry Jackson
Moraines on Clear Creek, Valley of the
Arkansas, Colorado. 1873
Yale Collection of Western Americana,
Beinecke Rare Book & Manuscript Library

William Henry Jackson
Mammoth Hot Springs, Yellowstone. 1872
Photo Archives, Museum of New Mexico,
Santa Fe

NEG. NO. 53163

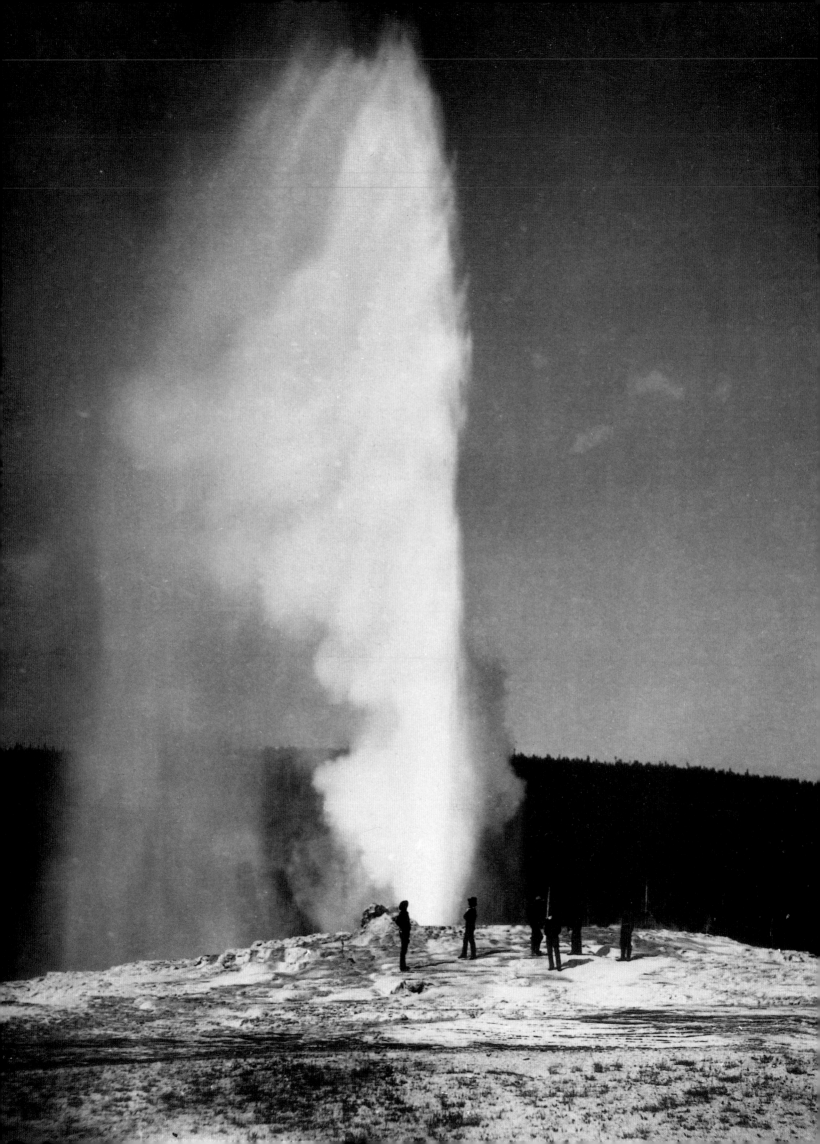

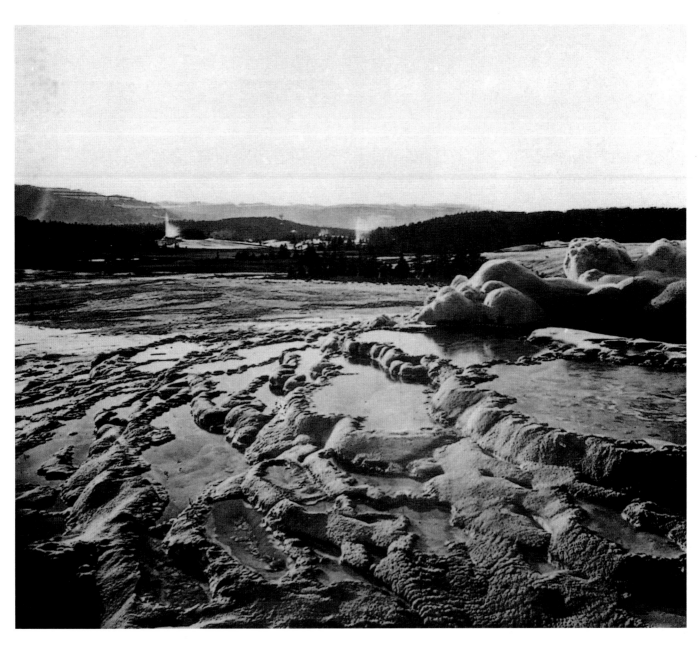

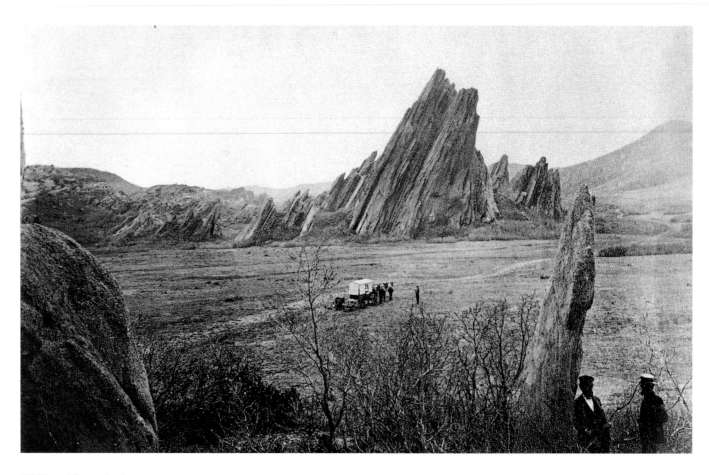

William Henry Jackson
Rocks below Platte Canyon, Colorado. 1870
ACADEMY OF NATURAL SCIENCES, PHILADELPHIA

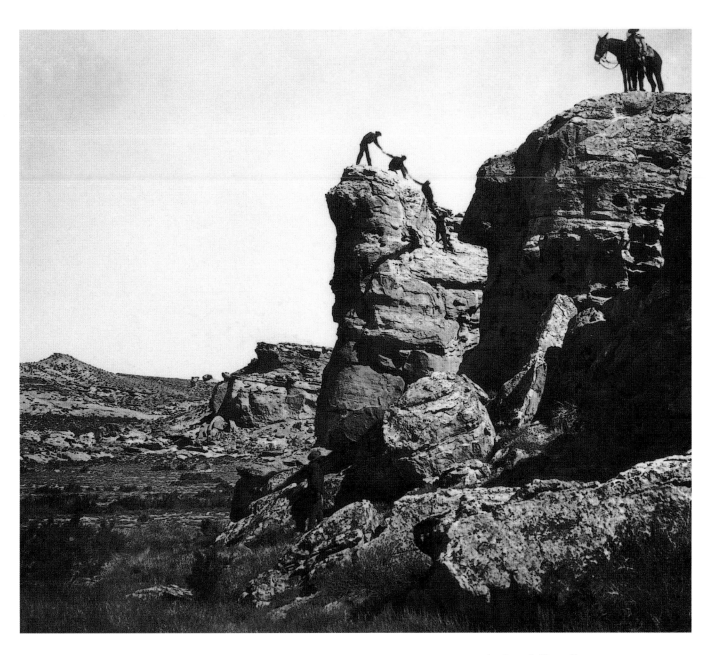

Andrew J. Russell
High Bluff, Black Buttes, Wyoming.
1867–68
Yale Collection of Western Americana,
Beinecke Rare Book & Manuscript Library

Above:
Andrew J. Russell
Skull Rock, Sherman Station, Laramie
Mountains, Wyoming
PHOTO ARCHIVES, MUSEUM OF NEW MEXICO, SANTA FE
NEG. NO. 109641

Opposite:
Andrew J. Russell
Serrated Rocks or Devil's Slide, Weber Canyon,
Utah
PHOTO ARCHIVES, MUSEUM OF NEW MEXICO, SANTA FE
NEG. NO. 109647

Ansel Adams
Jupiter Terrace, Fountain Geyser Pool
Yellowstone National Park, Wyoming

Above:
Ansel Adams
The Fishing Cone, Yellowstone Lake
Yellowstone National Park, Wyoming
National Archives

p. 122:
Ansel Adams
Formations, along Trail in the Big Room,
beyond the Temple of the Sun
Carlsbad Caverns National Park,
New Mexico
National Archives

p. 123:
Ansel Adams
The Giant Dome, Largest Stalagmite
Thus Far Discovered
Carlsbad Caverns National Park,
New Mexico
National Archives

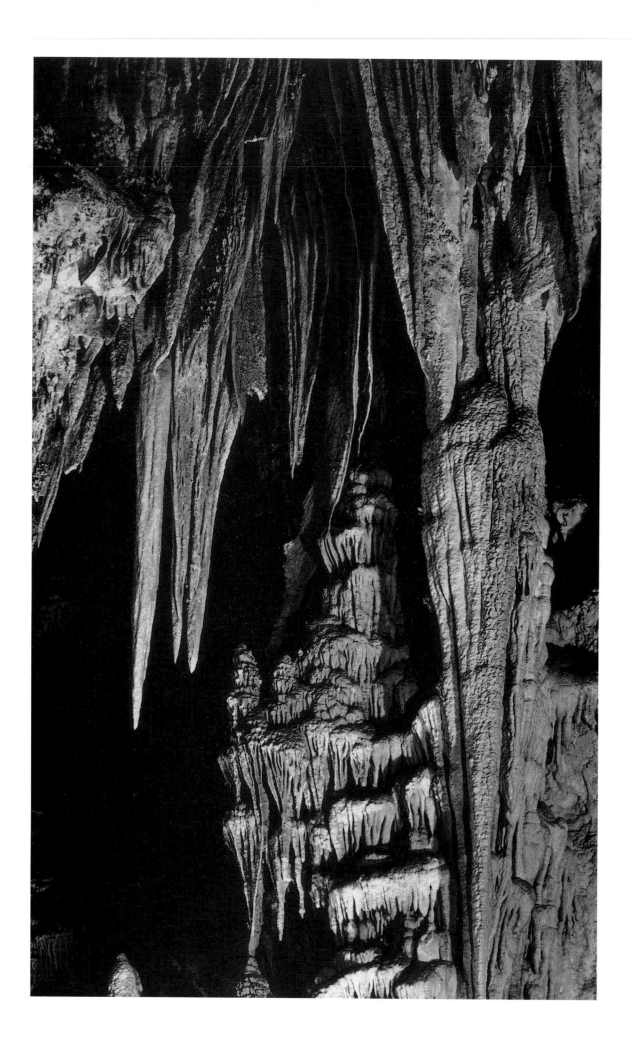

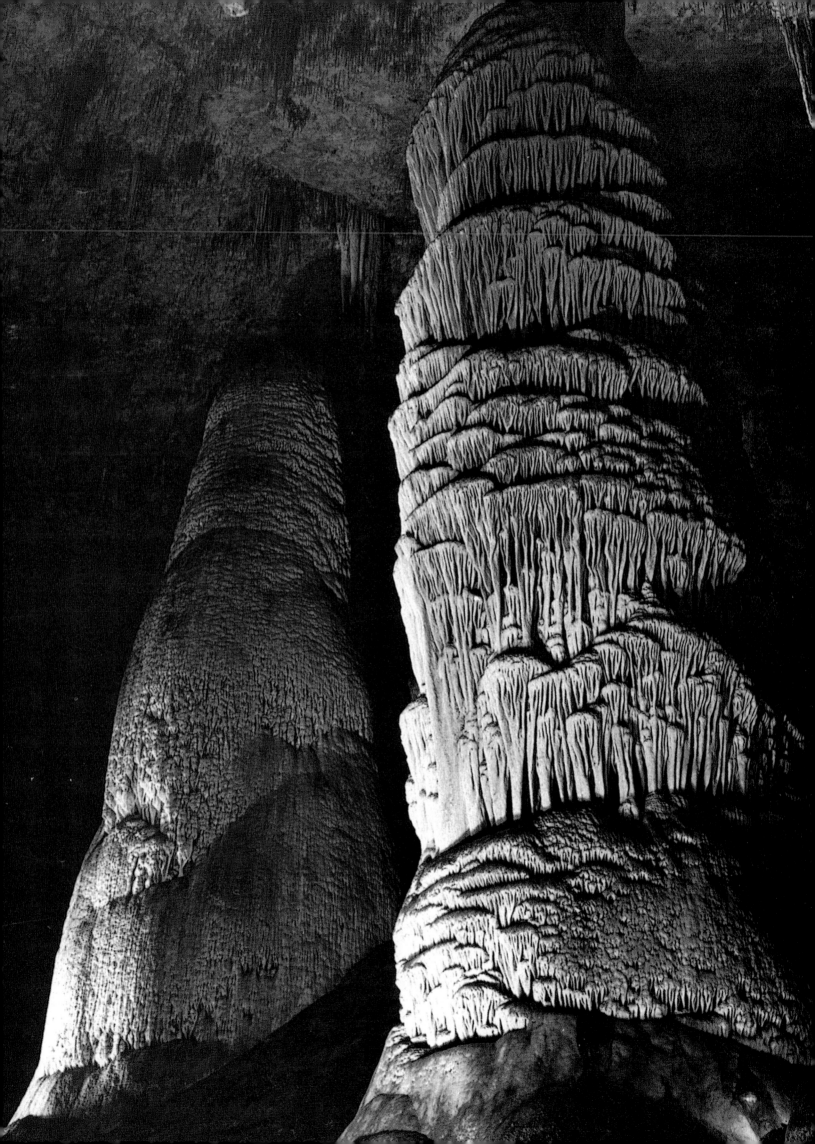

Carleton E. Watkins
Grizzly Giant, Mariposa Grove, Yosemite
Photo Archives, Museum of New Mexico,
Santa Fe
neg. no. 113899

Edward S. Curtis
Hasen Harvest—Qahitika

John K. Hillers
First Terrace of Zuñi, New Mexico. 1879
NATIONAL ARCHIVES

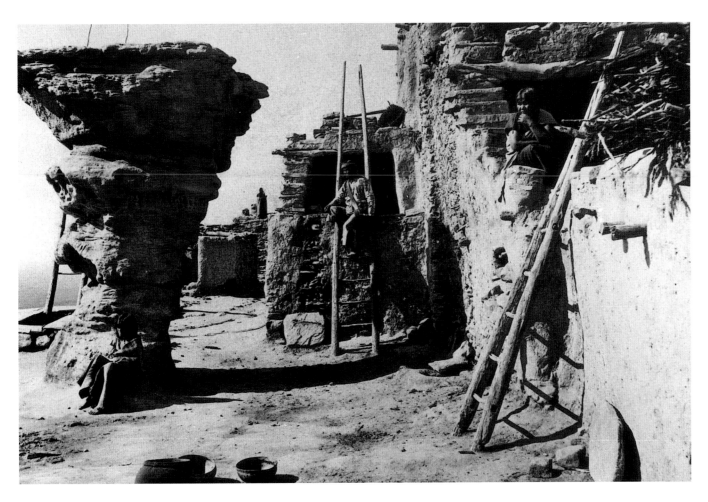

John K. Hillers
Dancers' Rock, Walpi, Arizona. 1879

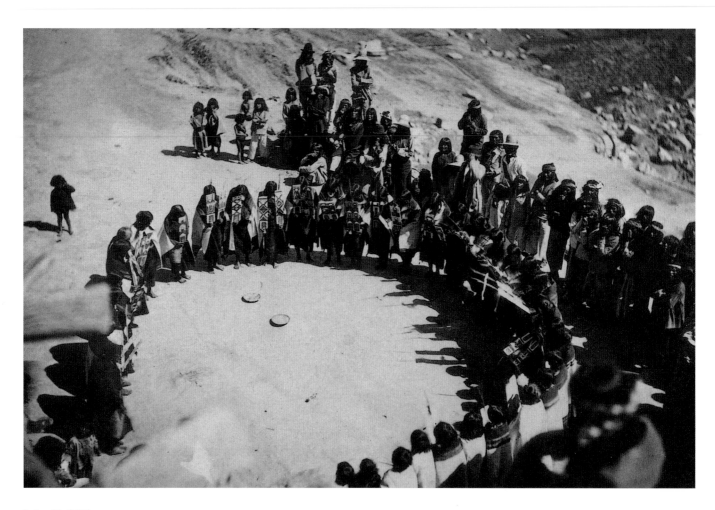

John K. Hillers
Hopi Women's Dance, Oraibi, Arizona. 1879
National Archives

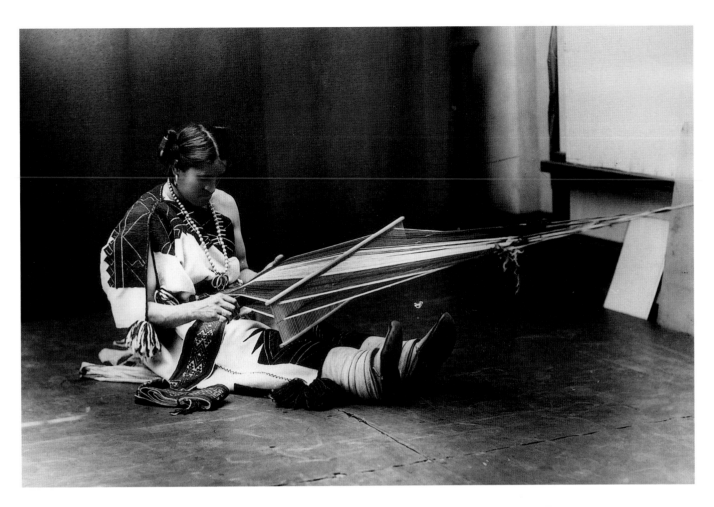

John K. Hillers
We'wha, Weaving a Belt on a Waist Loom.
1879
National Archives

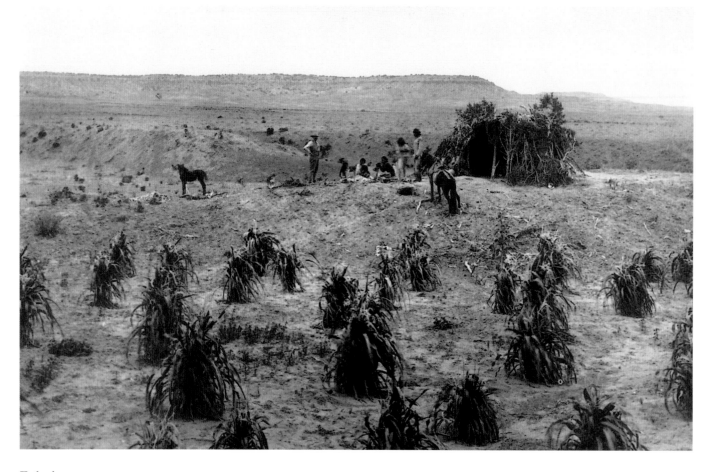

F. A. Ames
Navaho Hogan and Corn Field, near
Holbrook, Arizona. 1889
NATIONAL ARCHIVES

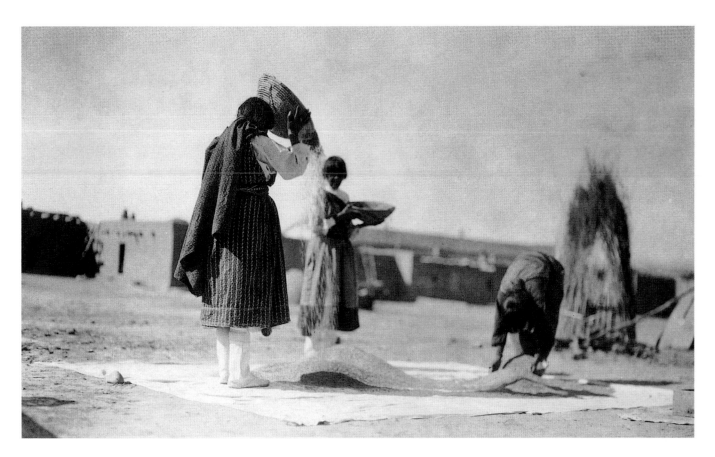

Above:
Edward S. Curtis
Winnowing Wheat — San Juan
LIBRARY OF CONGRESS

p. 132:
Edward S. Curtis
Drilling Ivory, King Island
LIBRARY OF CONGRESS

p. 133:
Edward S. Curtis
Fishing in Front of a Platform
LIBRARY OF CONGRESS

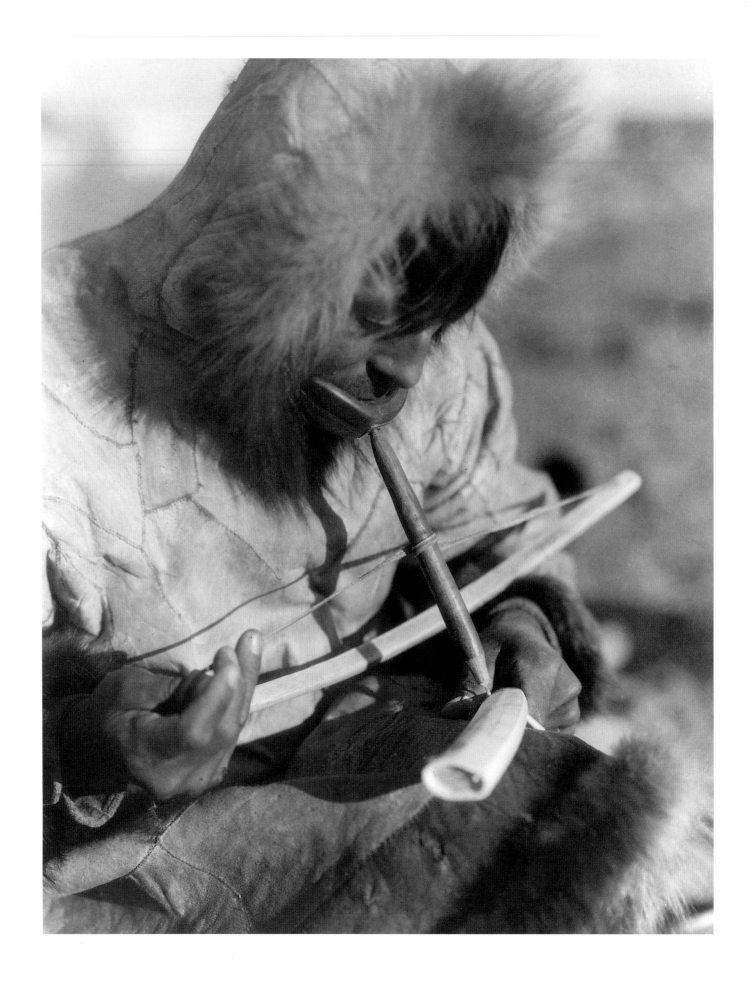

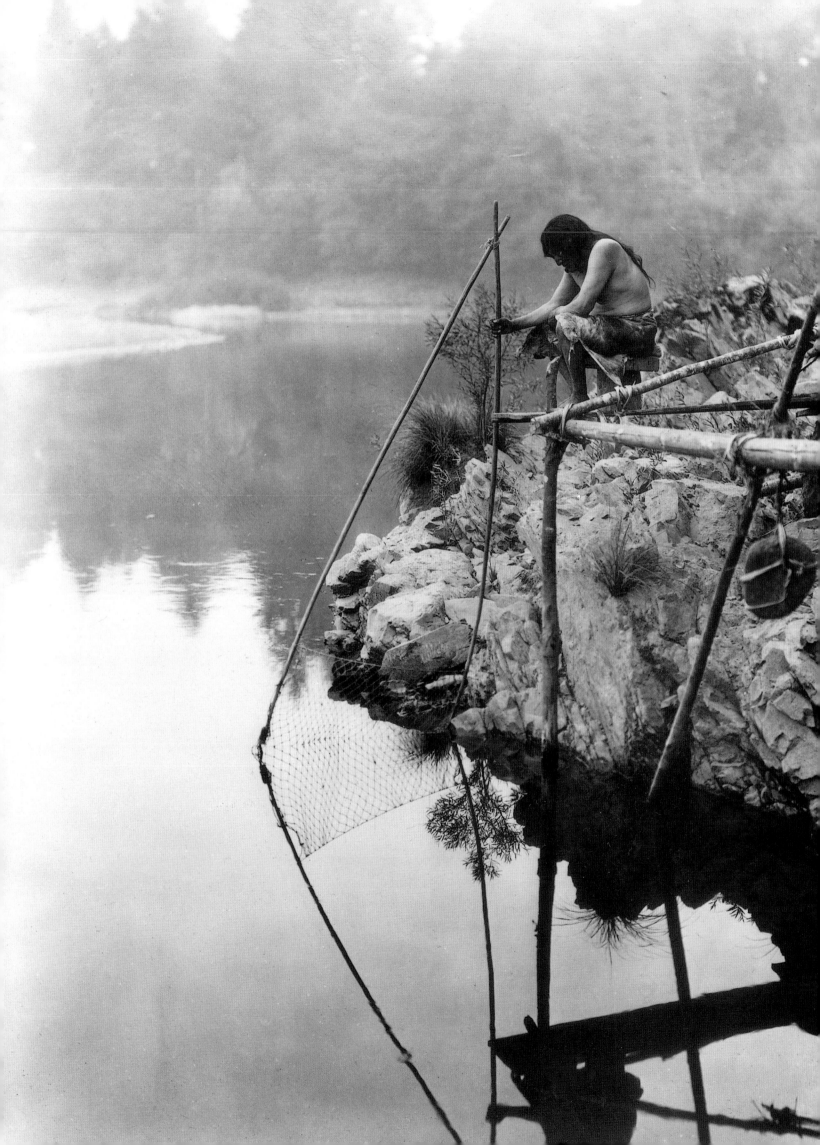

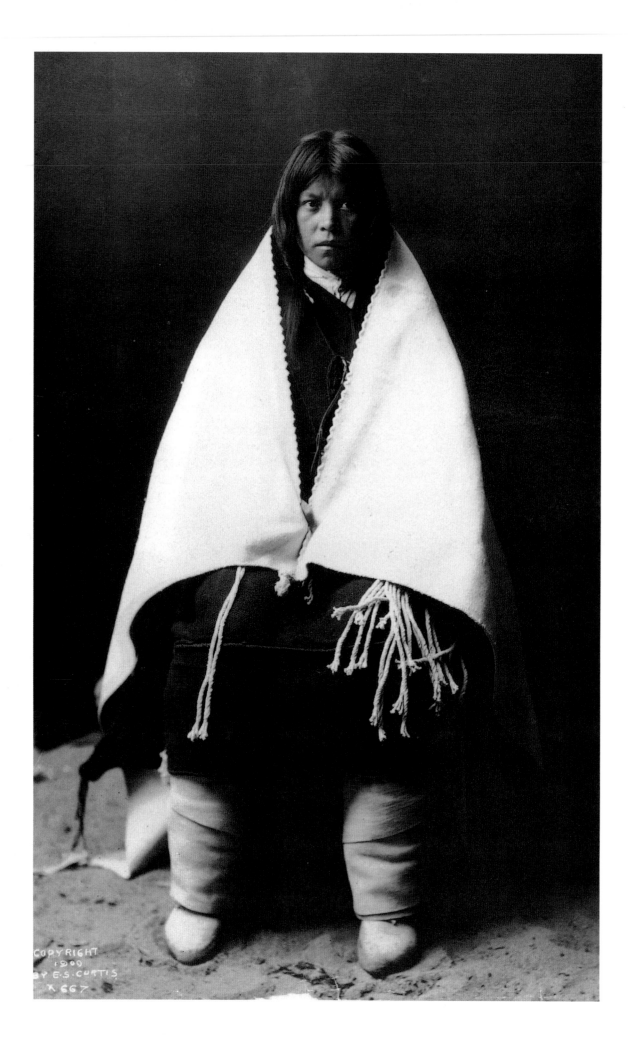

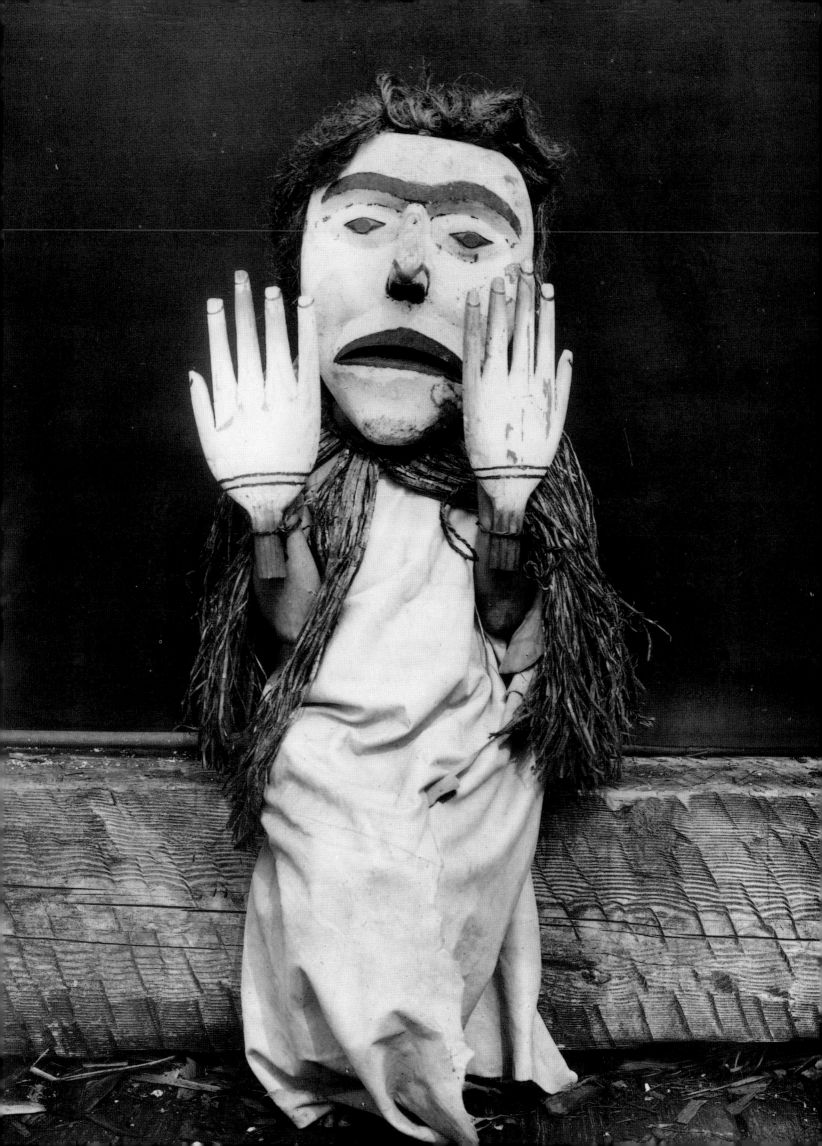

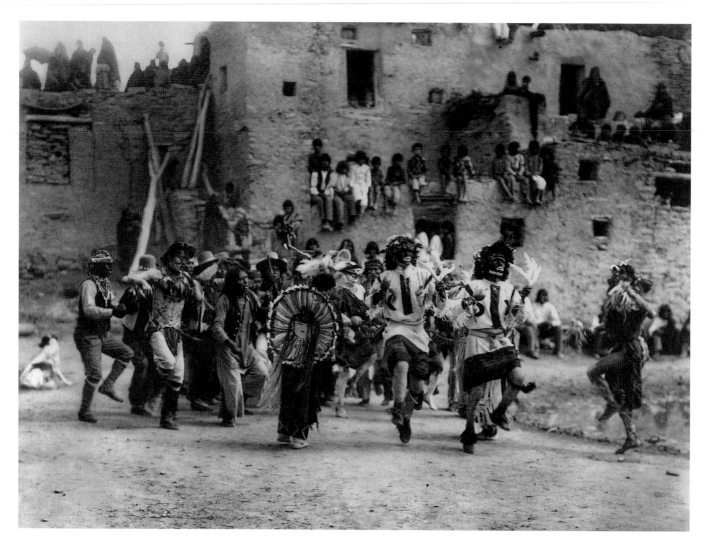

Above:
Edward S. Curtis
Buffalo Dance at Hano
LIBRARY OF CONGRESS

p. 134:
Edward S. Curtis
Hopi Bridal Costume
LIBRARY OF CONGRESS

p. 135:
Edward S. Curtis
Nuhlimkilaka—Koskimo
LIBRARY OF CONGRESS

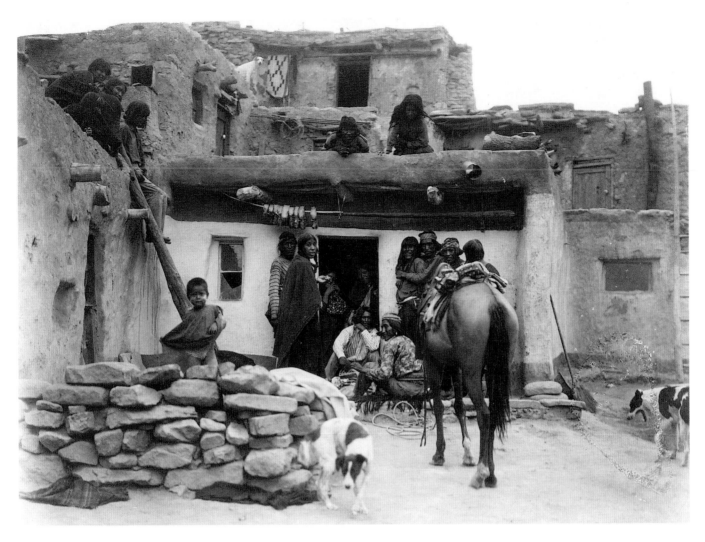

Edward S. Curtis
A Visitor

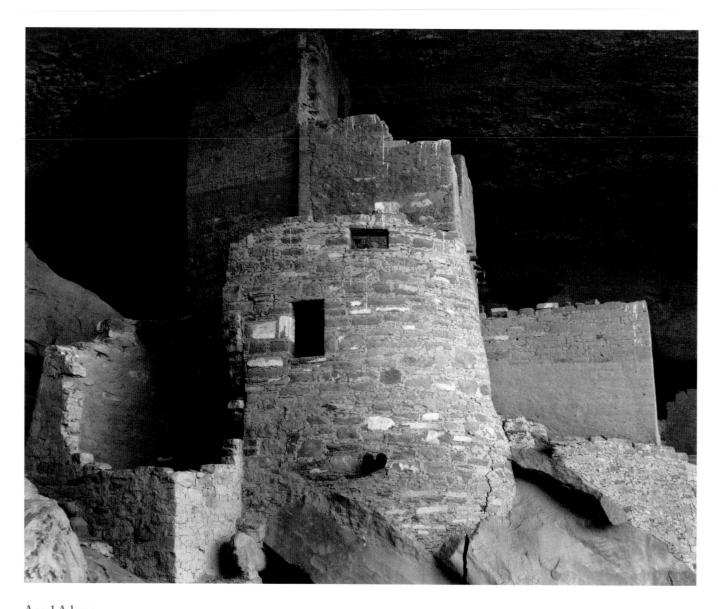

Ansel Adams
Cliff Palace
Mesa Verde National Park, Colorado

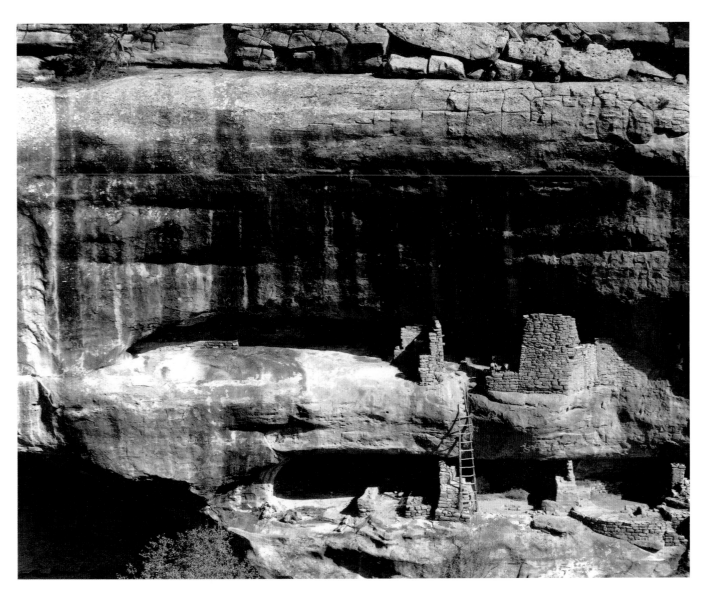

Ansel Adams
Mesa Verde National Park, Colorado

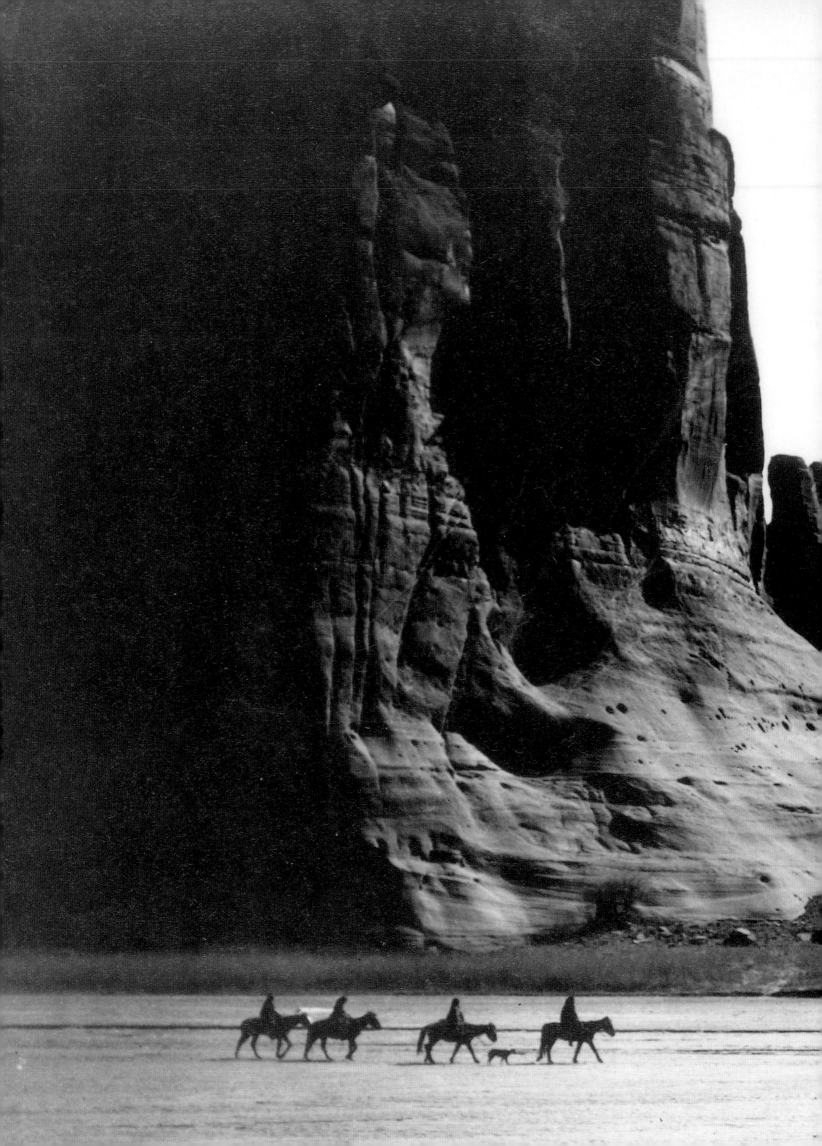

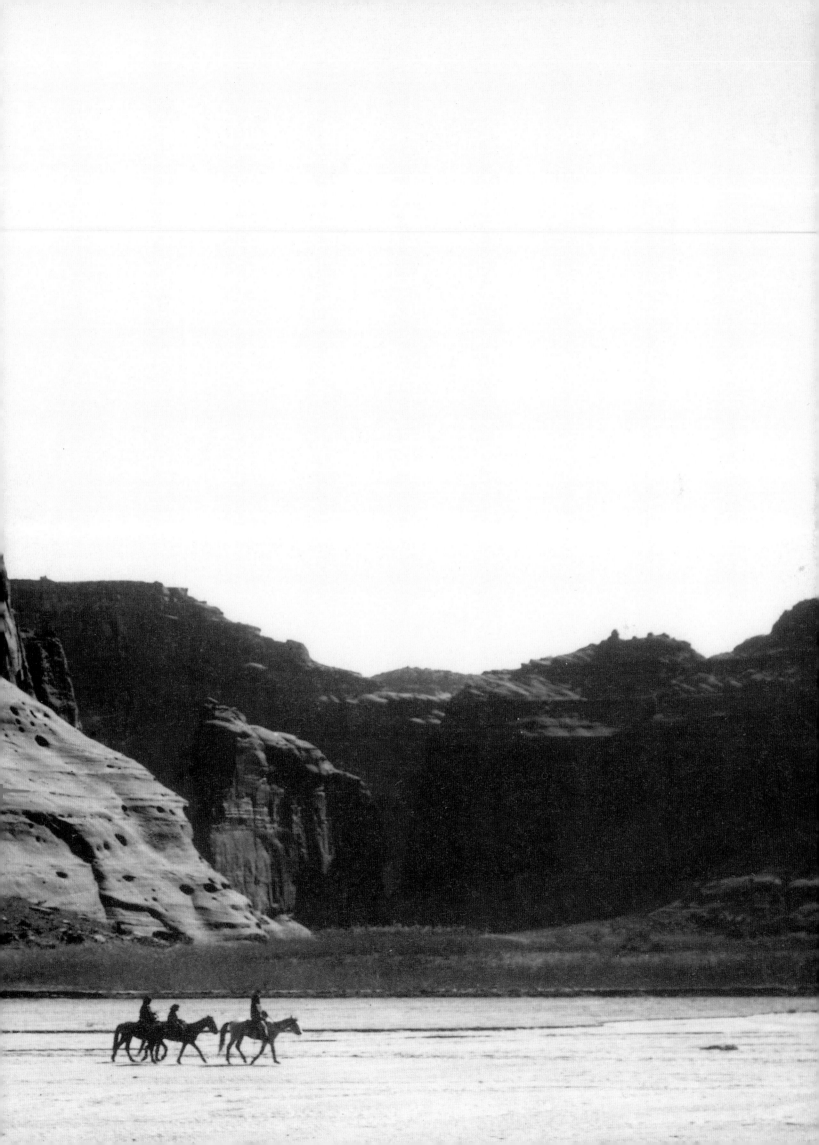

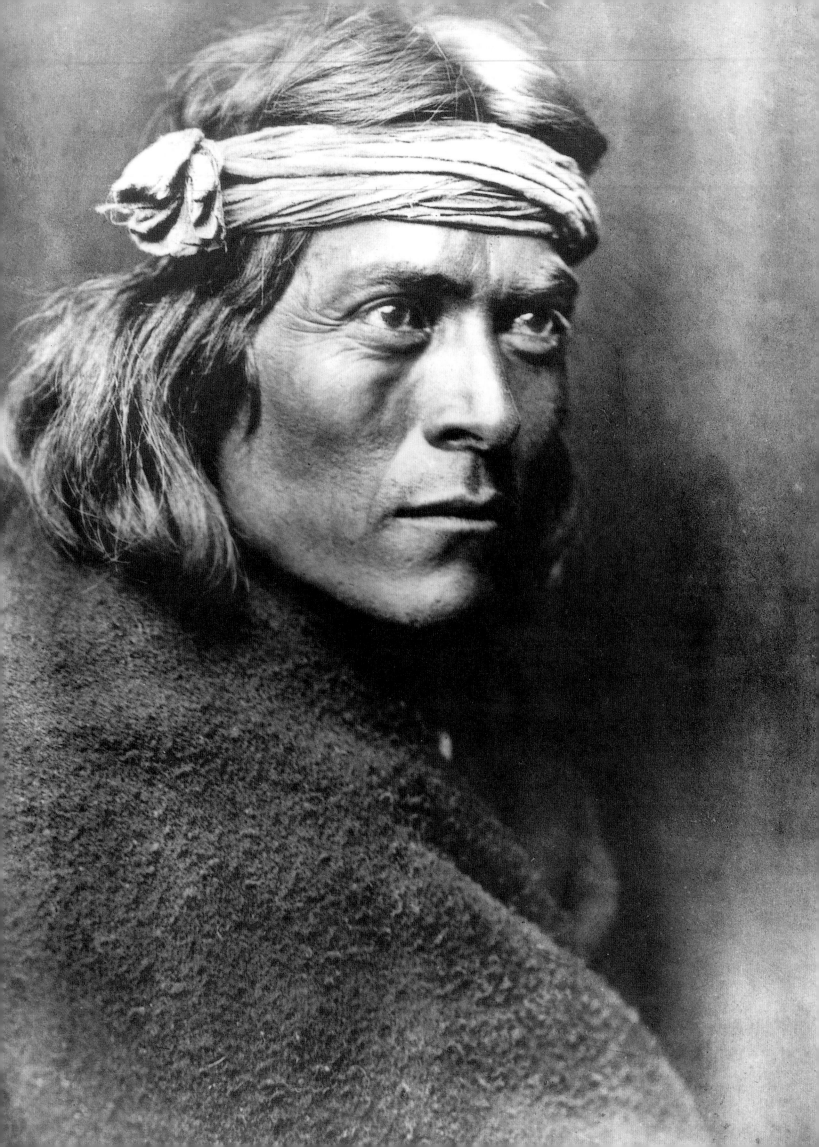

SHADOW CATCHERS

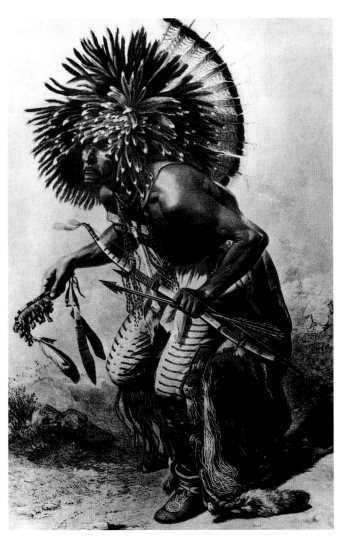

The frontier photographers, called shadow catchers by the Indians, produced a body of work on native life that was widely appreciated in their era, but which has become the focus of considerable controversy in more recent times. Most controversial of all are the romantic Indian portraits and ceremonial re-enactments by Edward S. Curtis (1868–1952). He was not the only photographer to commit the offenses of misrepresentation—of posing his subjects, providing them with clothing and props, and manipulating the exposure, negative, and print—in order to create artistic and timeless images that expressed and perpetuated his own and societal stereotypes of the "noble savage" and the "vanishing race." Perhaps what draws most criticism is that he did this under the guise of ethnographic accuracy.

What has made Curtis a prime target is that today he undoubtedly is the best known of the late-nineteenth and early-twentieth-century Indian photographers, especially after his work re-emerged in the late 1960s and early 1970s to become part of the mass culture. (Indeed, the commercialization of Curtis's work in the form of postcards, calendars, and posters is equaled only by the similar marketing of Ansel Adams's work.) Curtis's romanticized Indian portraits appealed to a generation of rebellious youths who projected onto them a universal spirituality lacking in their own contemporary world of materialism. His appealing and nostalgic re-creation of a past that never existed for most of the nation's Indians made it easy for many others to ignore the harsh realities of reservation life, the grave injustices perpetuated by the government against the native peoples, and the fact that they had not vanished but had changed over time, as had other Americans.

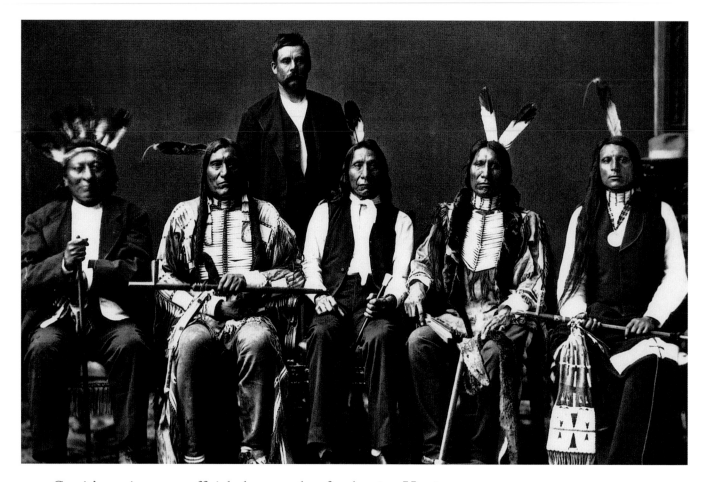

Curtis's service as an official photographer for the 1899 Harriman expedition inspired him to produce his own visual documentation of the nation's Indians. This project was aided by an enthusiastic President Theodore Roosevelt, who enlisted the financial sponsorship of J. Pierpont Morgan. From 1903 to 1930, Curtis traveled with his crew to more than 80 tribes west of the Mississippi River to photograph some 40,000 subjects. The result was his 20-volume opus *The North American Indian*, which incorporated more than 2,200 photographs reproduced as photogravures. Curtis carefully shaped the understanding of these images with the use of extended didactic captions. That for *The Vanishing Race—Navaho* states, "The thought which this picture is meant to convey is that the Indians as a race, already shorn of their tribal strength and stripped of their primitive dress, are passing into the darkness of an unknown future. Feeling that the picture expresses so much of the thought that inspired the entire work, the author has chosen it as the first of the series."

In seeking to assemble an extensive inventory of the American Indian, and in appending a didactic narrative text to the images, Curtis was following a well-established tradition. The first promoter of an educational "Indian Gallery" of the "vanishing race" was Commissioner of Indian Affairs Thomas McKenney. In 1821 he began to commission from painter Charles Bird King portraits of Indian delegates to Washington and to treaty councils. From 1836 to 1841, he issued these works as lithographic reproductions in the three-part portfolio *History of the Indian Tribes of North America*. During the 1830s, painter George Catlin traveled

p. 143:
Karl Bodmer's painting of Pehriska-Ruhpa, Hidatsa Indian, 1833–34.
NATIONAL ARCHIVES.

Above:
Oglala Sioux delegation: from left, Red Dog, Little Wound, Red Cloud, American Horse, and Red Shirt; before 1876.
NATIONAL ARCHIVES.

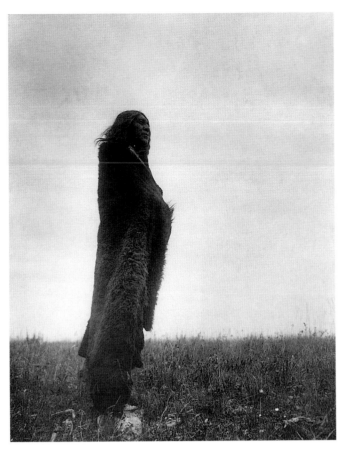

Above:
Edward S. Curtis
Crying to the Spirits
LIBRARY OF CONGRESS

Right:
I. G. Davidson
Blacksmithing at the Indian
Training School, Forest
Grove, Oregon, 1882.
NATIONAL ARCHIVES.

through the Midwest and the Great Plains to make sketches for his own Indian Gallery. He showed the works at home and abroad. Beginning in the early 1840s, painter and daguerreotypist John Mix Stanley (1814–72) spent over a decade creating his North American Indian Gallery, most of which was destroyed by an 1865 fire at the Smithsonian Institution. The 1869 Smithsonian catalogue of 301 photographic Indian portraits in its collection later was incorporated into William Henry Jackson's *Descriptive Catalogue of Photographs of North American Indians*, published in 1877 as part of the Hayden survey. Jackson's text praised those tribes that had taken on Anglo ways of education and agriculture. Biographical sketches of "good" and "bad" Indians (those who had adapted and those who had rebelled) promoted the process of acculturation sought by the federal government. This acculturation was enforced by sending native children away to boarding schools far from home.

In the late nineteenth century, the marketing of Indian portraits provided a brisk business for photographers. This is not to imply that the subjects were the victims of yet another form of exploitation, in that first their lands and now their images were stolen. Most demanded a posing fee, as did the Indians portrayed by Curtis. They collaborated, to some degree, in the creation of their own photographic images. Some even controlled the marketing of these images. When the Hunkpapa Sioux chief Sitting Bull joined Buffalo Bill's Wild West Show in 1885, he sought the exclusive right to sell his portrait, and he agreed to pose for a fee with visitors to the show. Apache warrior Geronimo (Goyathlay) also found his stay at the 1904

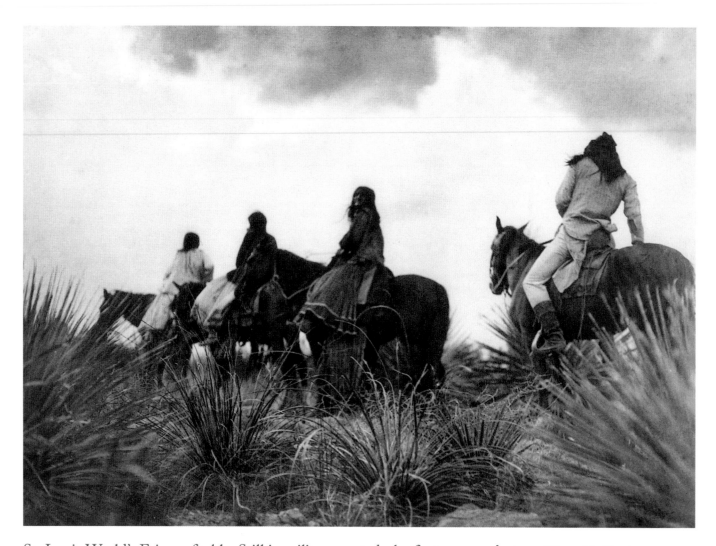

Edward S. Curtis
The Storm

St. Louis World's Fair profitable. Still in military custody, he first appeared at fairs in Omaha and Buffalo. While he may have been featured at St. Louis as a symbol of the conquered savage, posing with the small bows and arrows he crafted as souvenirs, he was pleased to earn two dollars a day from selling his portraits and signing his name. He returned to Oklahoma with more money than he had ever had before.

"Indian celebrities" also were a profitable line for photographer William Stinson Soule (1836–1908), a New Englander and Civil War veteran who spent less than a decade out West, from around 1867 to 1876. By 1869 he had made his way to Fort Sill, Oklahoma Territory, where he may have been hired by the army to document the fort's construction. At his gallery there, he made studio portraits of the notable Indians who came to the fort; he marketed these pictures back East until the 1890s. He also ventured into the surrounding area to photograph the villages of the Comanche, Arapaho, Kiowa, Wichita, and Caddo people.

The career of Ben Wittick (1845–1903), who worked with several partners, points out the problem of correctly attributing a photograph to its maker. Following his 1878 move to Santa Fe and an initial partnership with W.P. Bliss, he established a Santa Fe studio in 1880 with R.W. Russell. They later moved their operation to Albuquerque, ending this partnership in 1884. While Wittick

photographed out in the field for the Atlantic and Pacific Railway (renamed the Atchison, Topeka, and Santa Fe), and in 1882 for James Stevenson's Grand Canyon expedition, on which he documented Havasupai Indians, Russell made the studio portraits. Therefore, such portraits attributed to Wittick may actually have been Russell's work. With later studios at Gallup and at Fort Wingate, Wittick traveled all over the Southwest, with visits to Zuñi Pueblo and to the Hopi, who permitted him to photograph their snake dance ceremony in 1880. (Apparently, he died from the bite of a rattlesnake that he had captured for the Hopi.) During the 1880s–90s he produced great numbers of stereographs, lantern slides, and large prints of the Indian country of New Mexico and Arizona.

In 1895 the Hopi snake dance inspired Pasadena, California, book dealer Adam Clark Vroman (1856–1916) to become a Southwestern photographer. He produced images respectful of Hopi traditional life and ceremonies, and he also photographed the southern Navajo and the Indians of the Yosemite Valley.

The Southwest also exercised a strong attraction on Laura Gilpin (1891–1976), recognized as one of the first female landscape photographers of the West. Her work is tied to that of Curtis in that artistry governed her photographic depiction of pueblo life. Born in Colorado and distantly related to William Henry Jackson, she attended school in the East and went on to New York's Clarence H. White School of Photography in 1916–17. Her talent for soft-focus pictorialist portraits and for making platinum prints allowed her to establish a career as a professional photographer in the West, serving

Walter D. Wilcox
Johnnie Saux, a Quinaielt, holding a dog salmon, Taholah, Washington, 1936. NATIONAL ARCHIVES.

commercial, architectural, and tourism clients. Beginning in the 1920s, she made camping trips in Colorado and to New Mexico, where she moved in 1946. Selections of her Southwestern photographs were published in the books *The Pueblo: A Camera Chronicle* (1941), *The Rio Grande: River of Destiny* (1949), and *The Enduring Navaho* (1968).

Ansel Adams also found the Southwest a magical place. After his first 1927 visit he returned many times. While spectacular scenery was his forte, he also found the region's ancient ruins and traditional pueblo villages seductive subject matter. Probably his single most famous image is *Moonrise, Hernandez, New Mexico* (1941), taken while he was working on the Mural Project. His Mural Project photographs of stonework archaeological remains and of weathered adobe buildings, which echo the materials and forms of the surrounding mesas and mountains, convey his sense of the harmonious and spiritual connections of the Southwestern peoples to their natural surroundings.

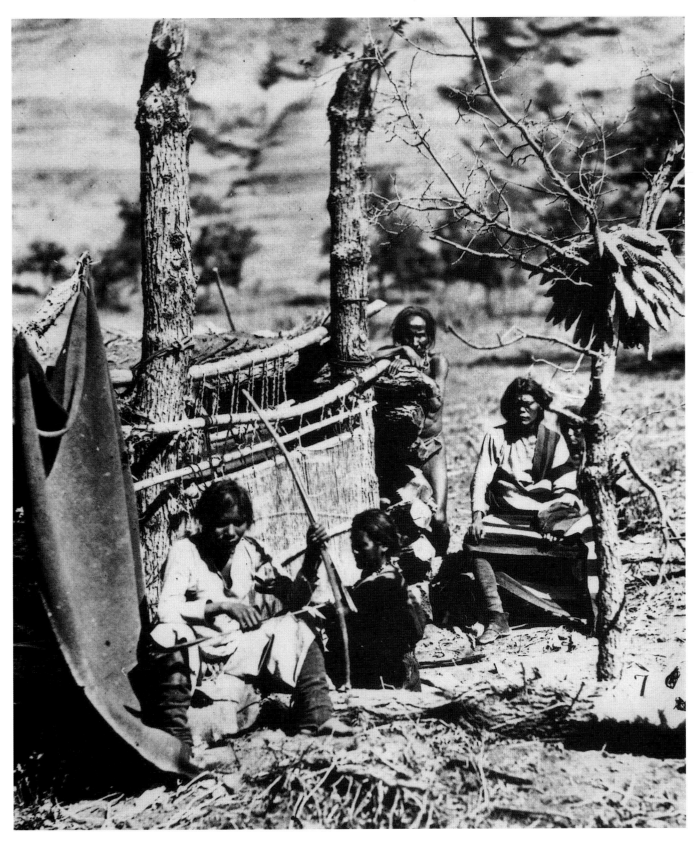

Opposite:
Timothy O'Sullivan
Two Mohave Braves. 1871
NATIONAL ARCHIVES

Above:
Timothy O'Sullivan
Aboriginal Life among the Navaho
Indians. 1873
NATIONAL ARCHIVES

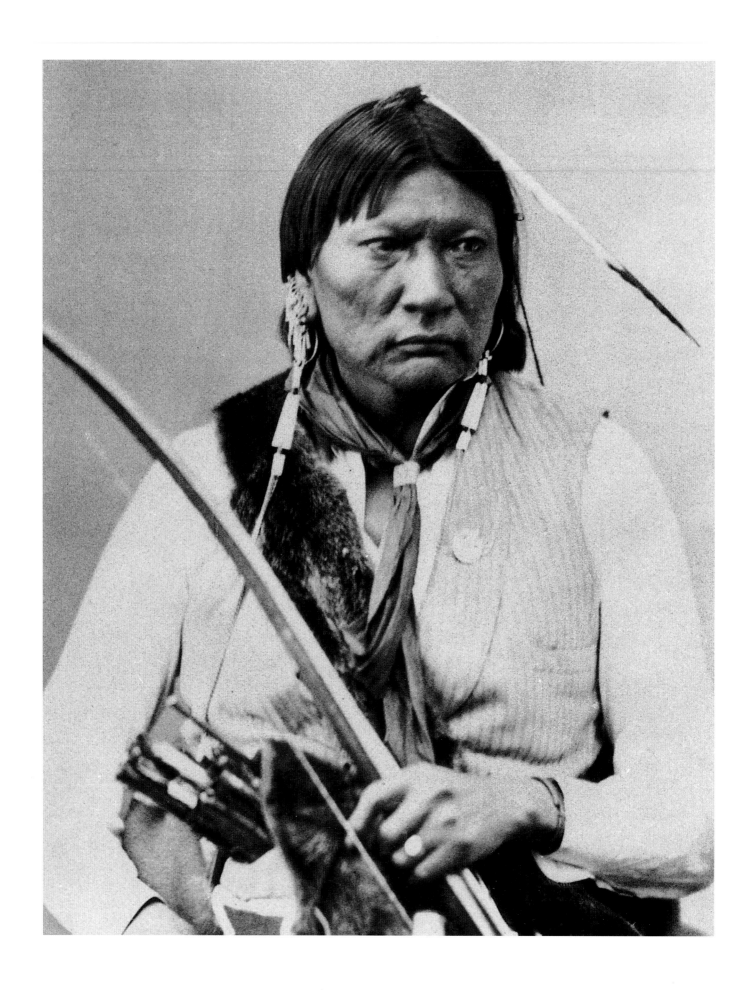

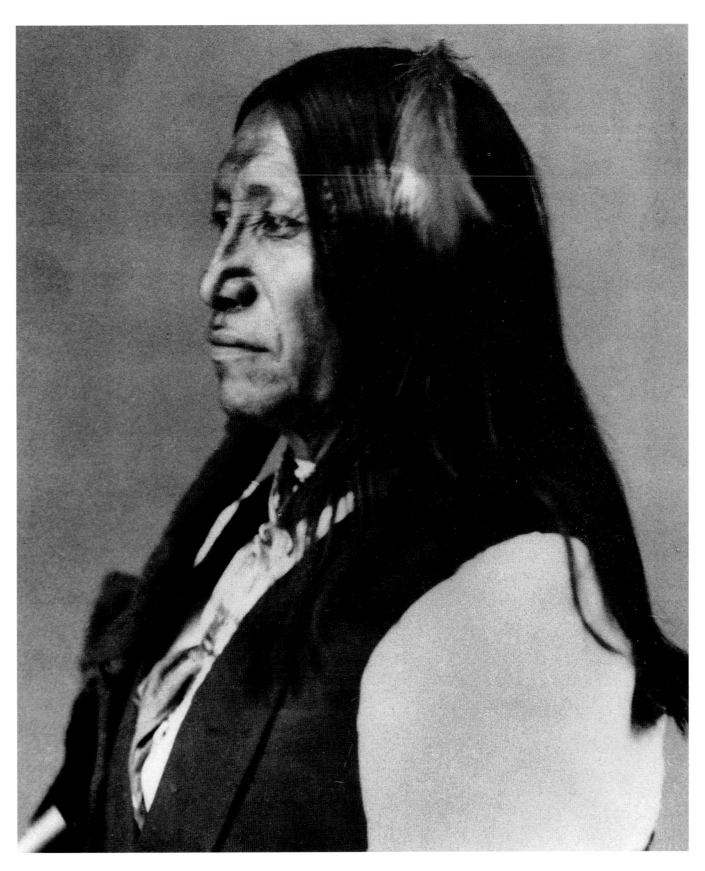

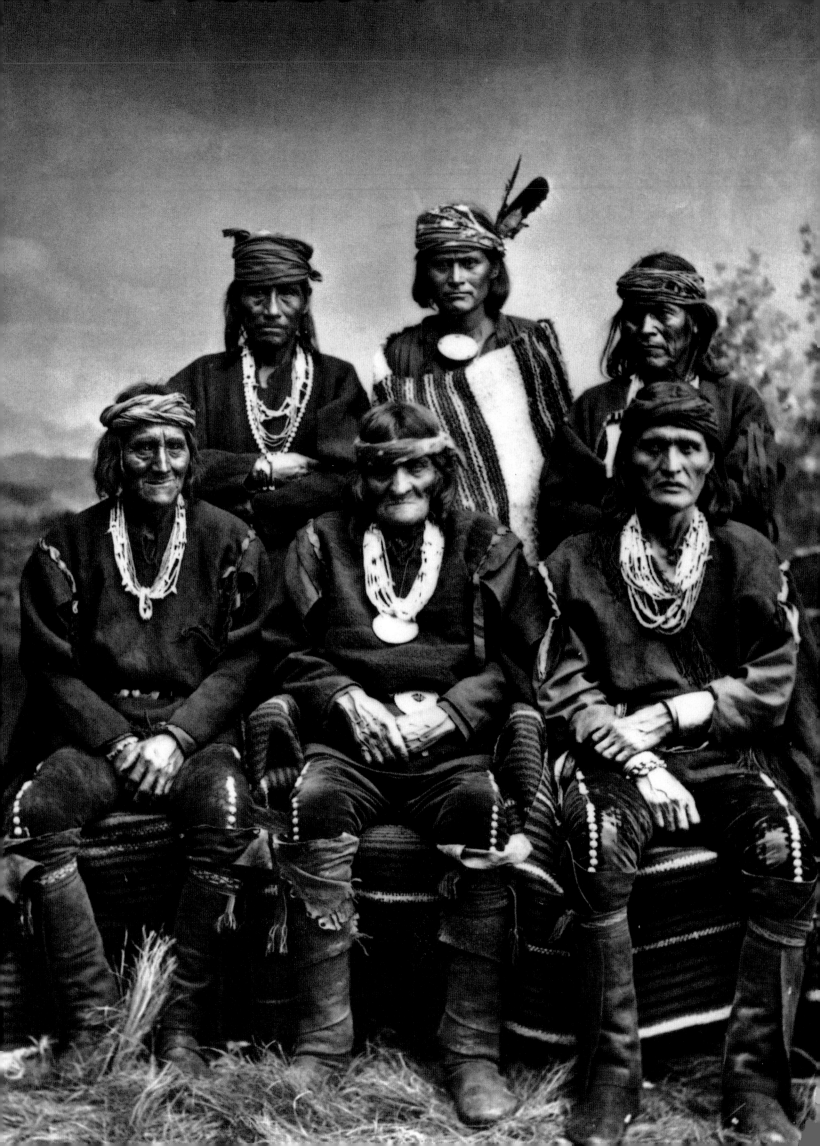

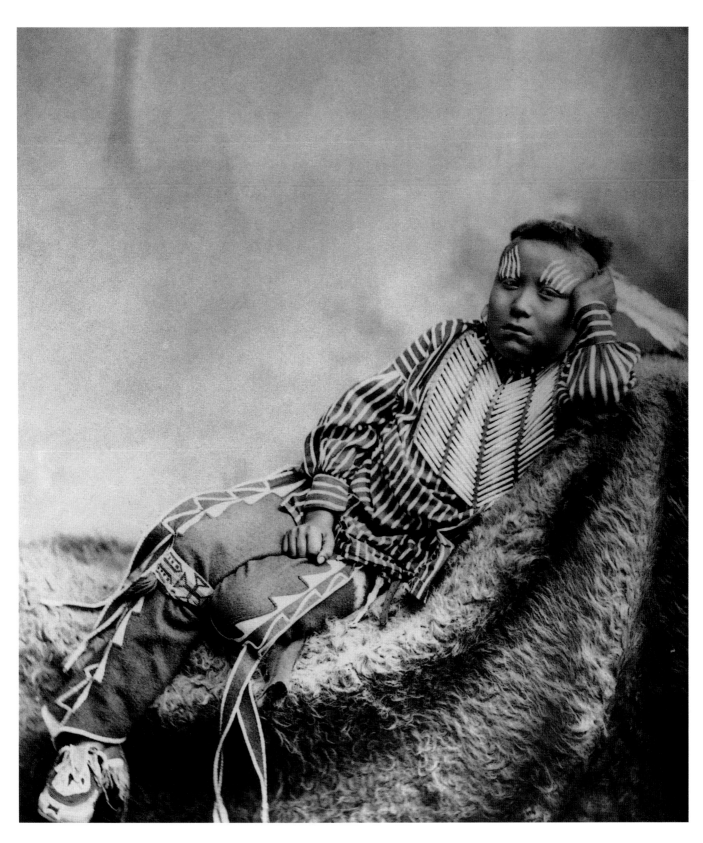

Opposite:
John K. Hillers
Six Zuñi Men. 1879
NATIONAL ARCHIVES

Above:
William Stinson Soule
*Lone Bear (Tar-lo), a Kiowa Dressed
as an Osage.* 1868–74
NATIONAL ARCHIVES

SHADOW CATCHERS 153

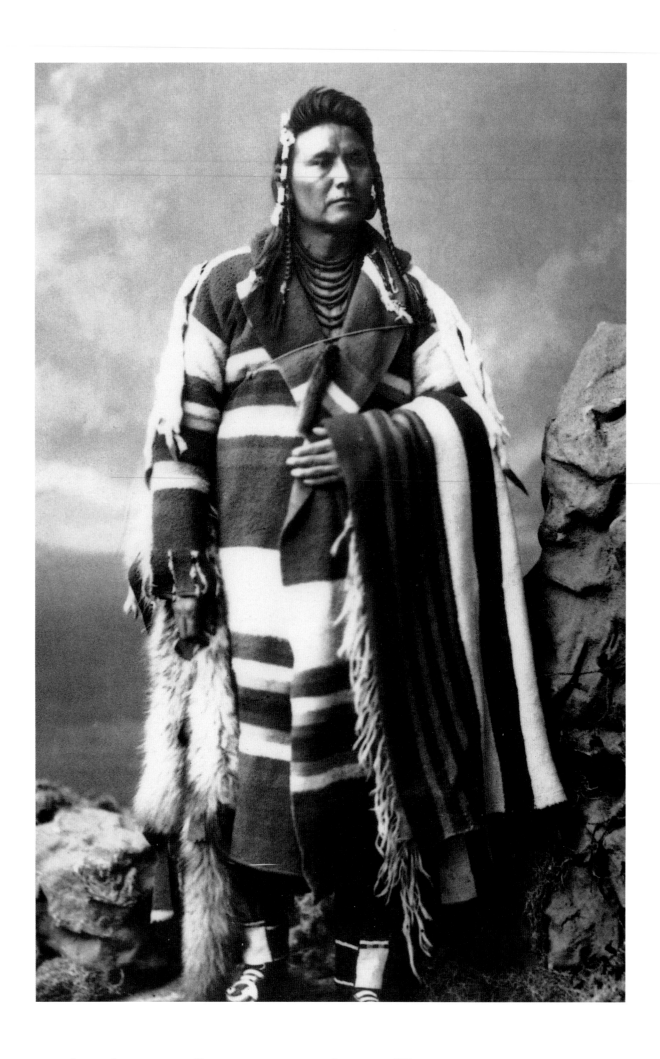

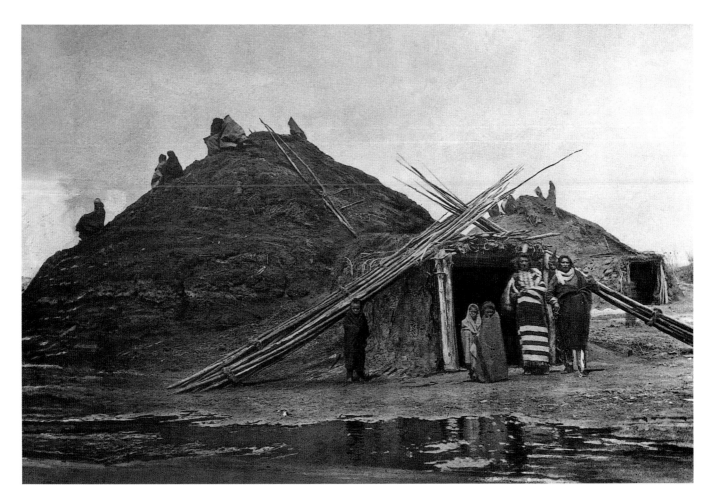

Opposite:
William Henry Jackson
Joseph (Hinmaton-Yalatkit), Nez Percé
Chief. Before 1877
NATIONAL ARCHIVES

Above:
William Henry Jackson
Pawnee Lodges at Loup, Nebraska. 1873
NATIONAL ARCHIVES

p. 156:
William Stinson Soule
Chief Powder Face of the Arapaho. 1868–74
PHOTO ARCHIVES, MUSEUM OF NEW MEXICO, SANTA FE
NEG. NO. 58648

p. 157:
William Stinson Soule
White Bear (Sa-tan-ta), a Kiowa Chief.
1869–74
NATIONAL ARCHIVES

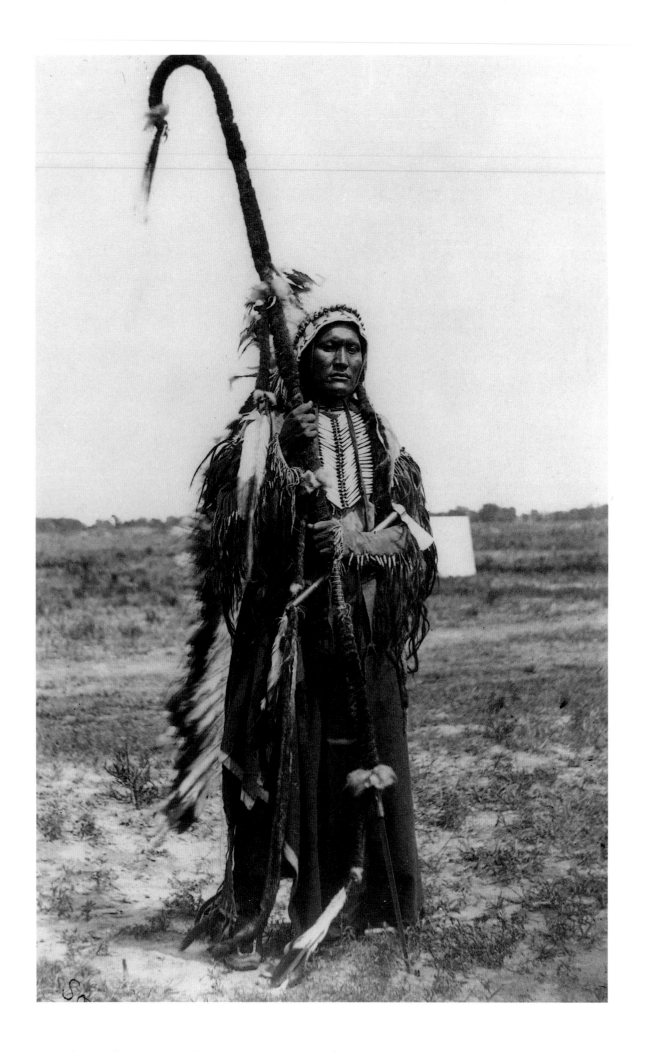

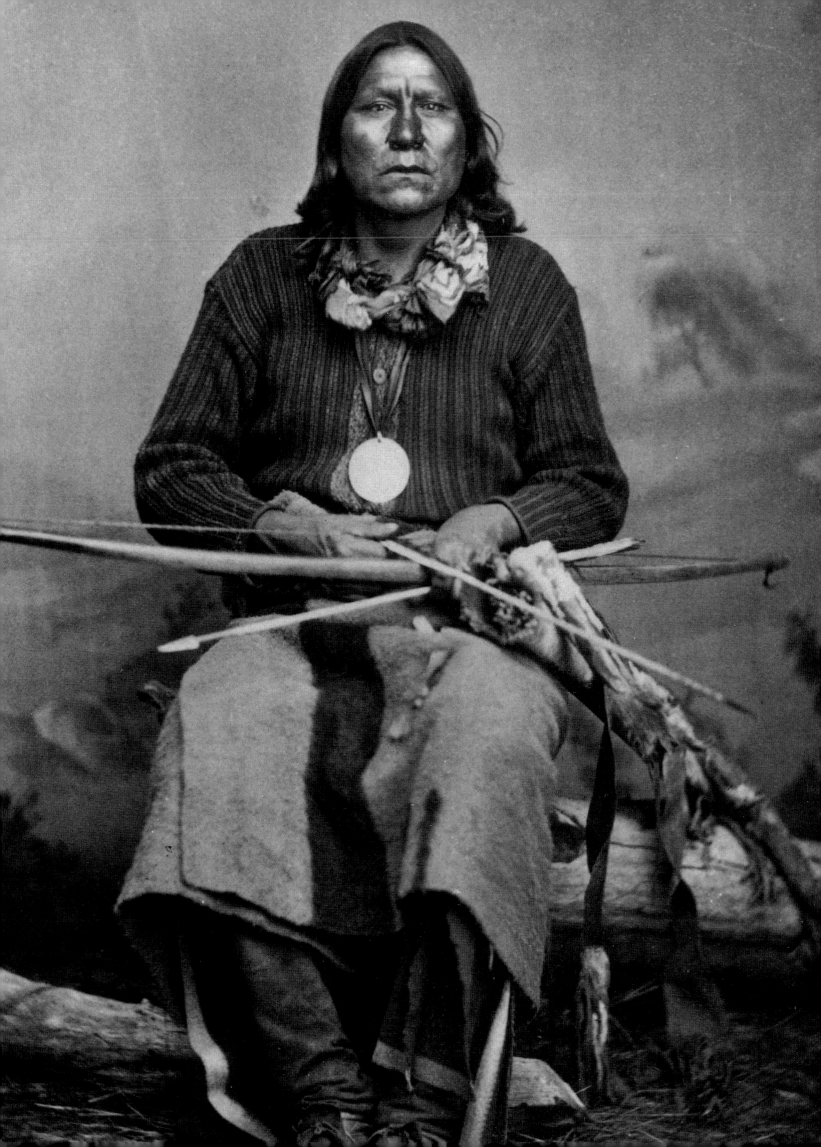

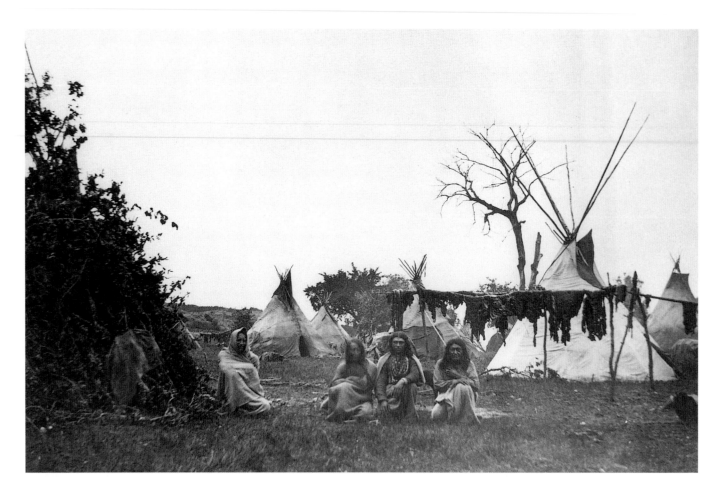

Above:
William Stinson Soule
*Arapaho Camp, with Buffalo Meat
Drying, near Fort Dodge, Kansas.* 1870
NATIONAL ARCHIVES

Opposite:
Ben Wittick
*Peaches (Tsoe), a White Mountain Apache
Scout.* c. 1885
NATIONAL ARCHIVES

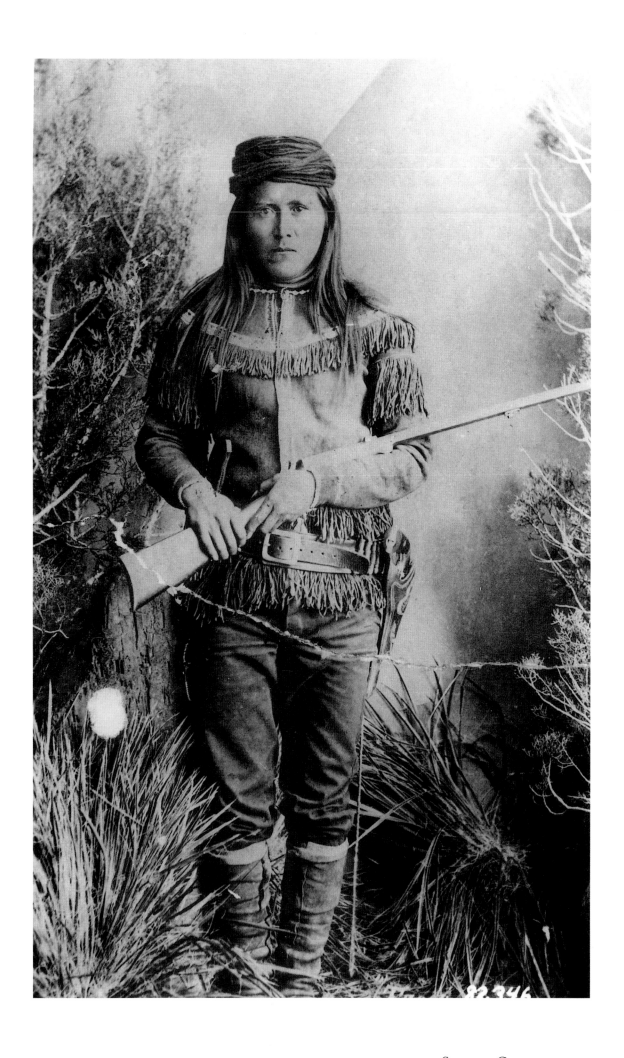

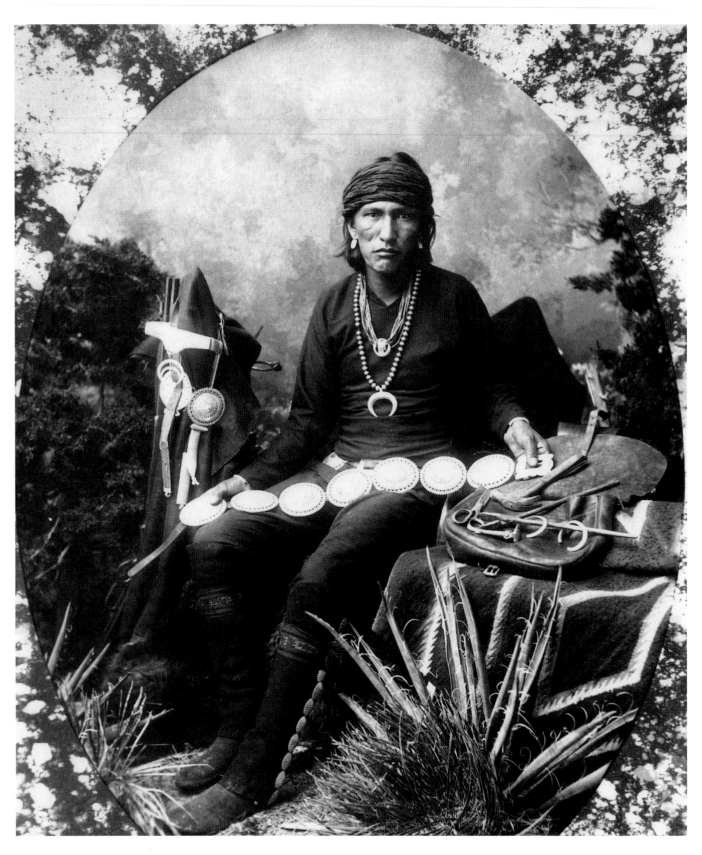

Above:
Ben Wittick
Navaho Silversmith. c. 1880
NATIONAL ARCHIVES

Opposite:
Ben Wittick
*Man and Woman of Laguna Pueblo,
New Mexico*
NATIONAL ARCHIVES

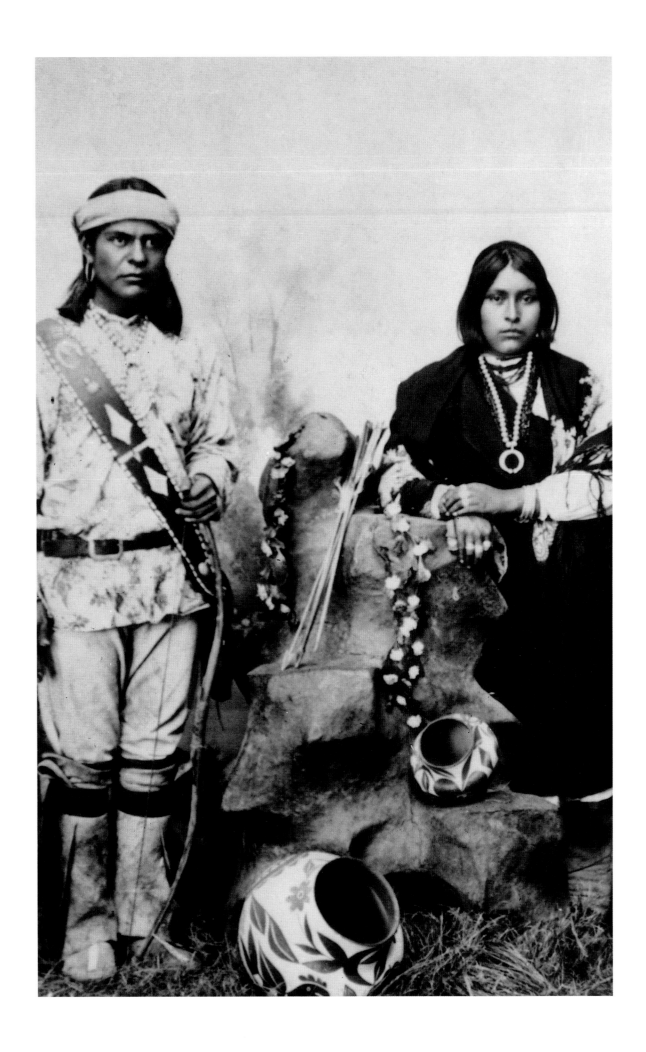

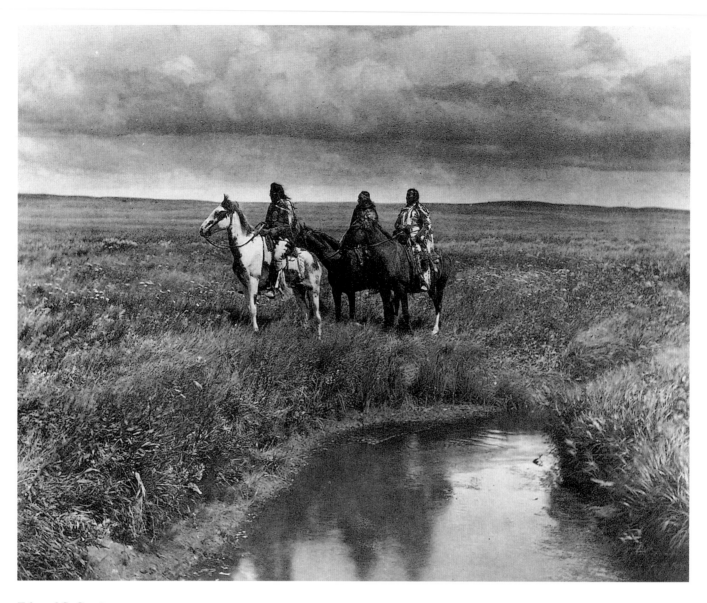

Edward S. Curtis
Three Chiefs—Piegan. 1900

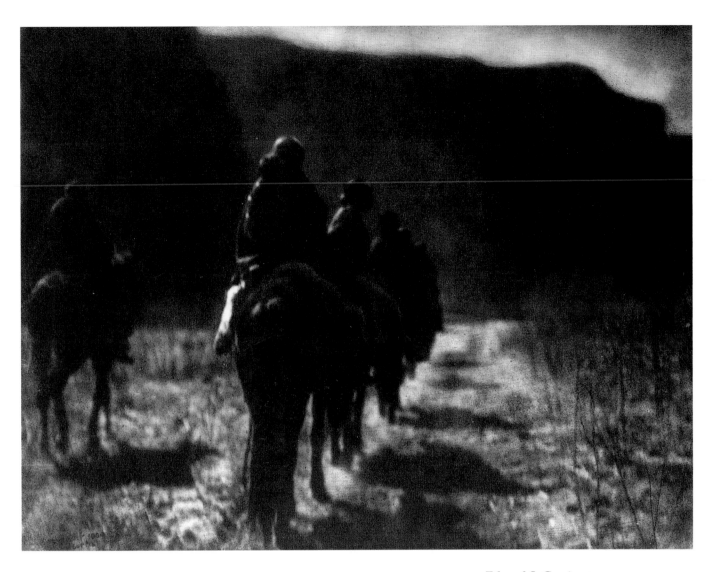

Edward S. Curtis
The Vanishing Race—Navaho

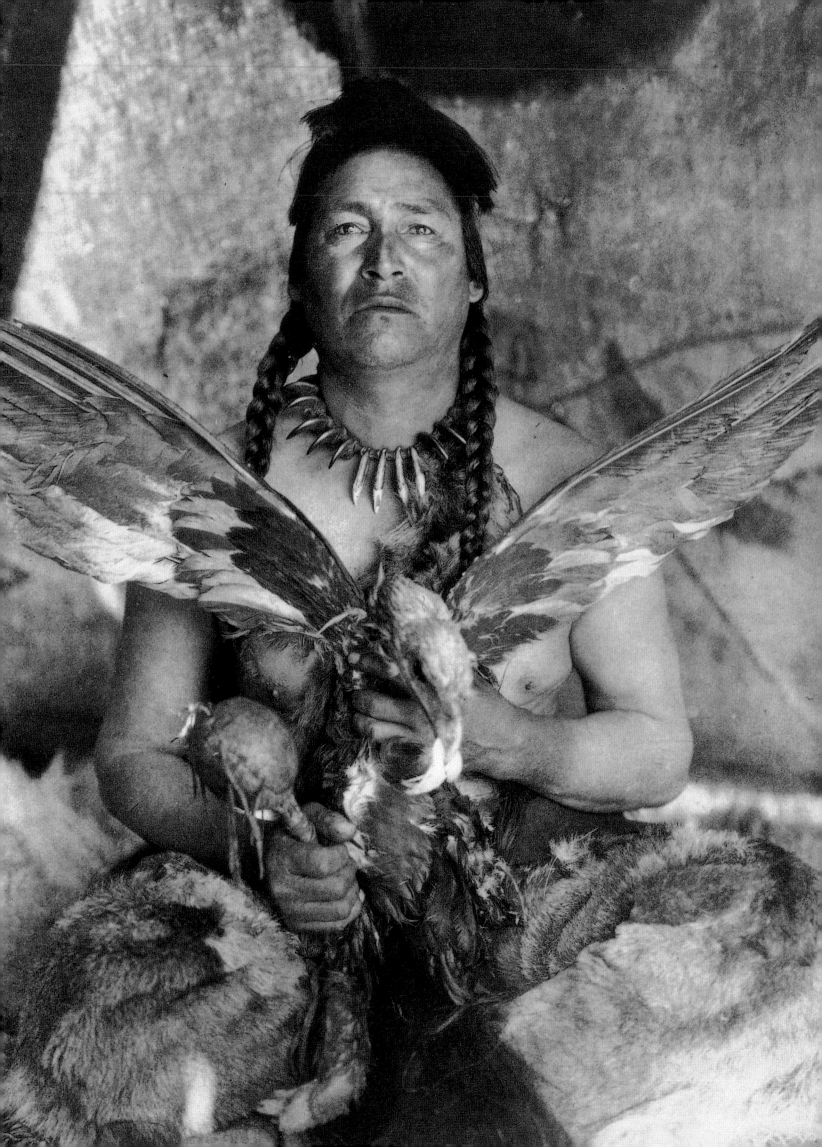

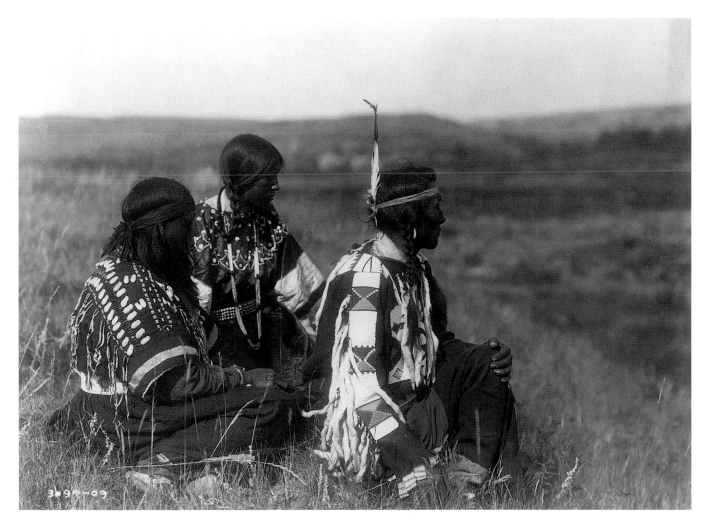

Opposite:
Edward S. Curtis
*Placating the Spirit of a Slain Eagle—
Assiniboin*
LIBRARY OF CONGRESS

Above:
Edward S. Curtis
Overlooking the Camp—Piegan
LIBRARY OF CONGRESS

p. 166:
Edward S. Curtis
Buffalo Dancer
LIBRARY OF CONGRESS

p. 167:
Edward S. Curtis
Singing to the Snakes—Shipalovi
LIBRARY OF CONGRESS

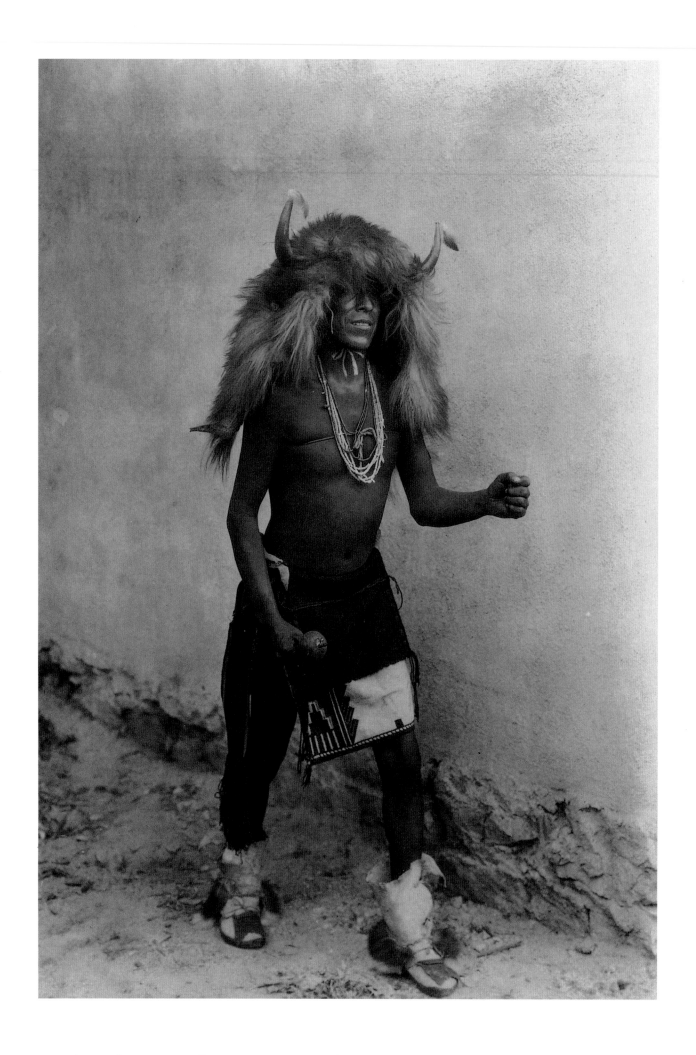

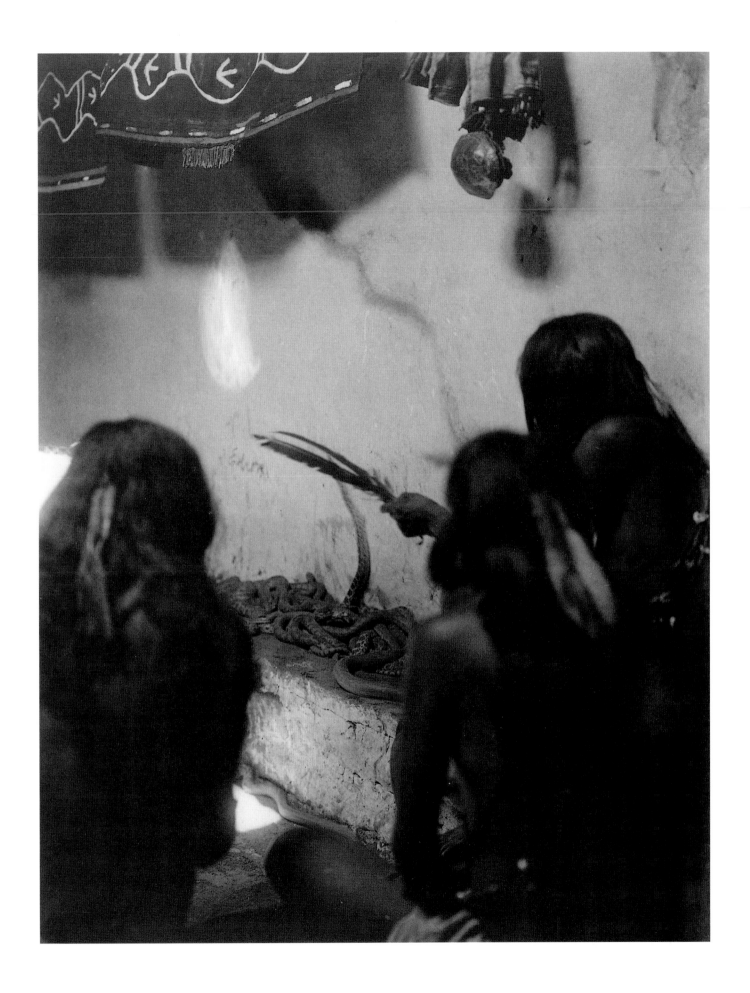

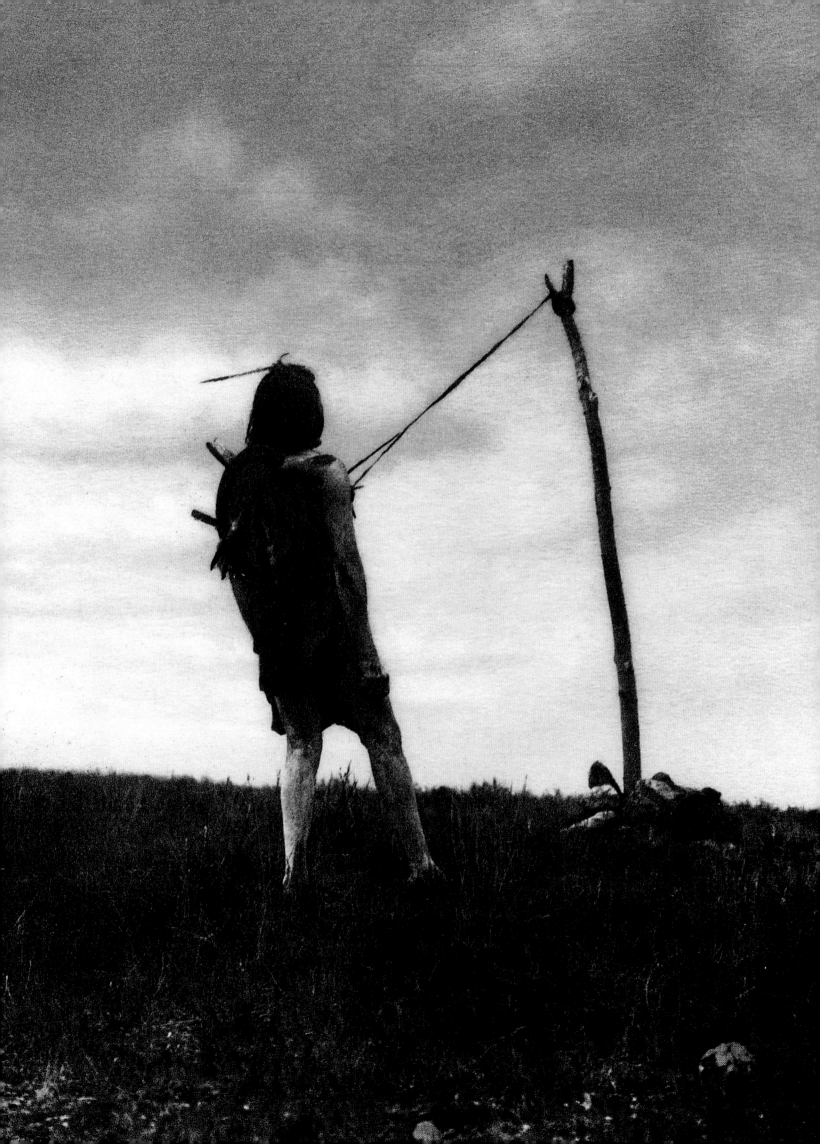

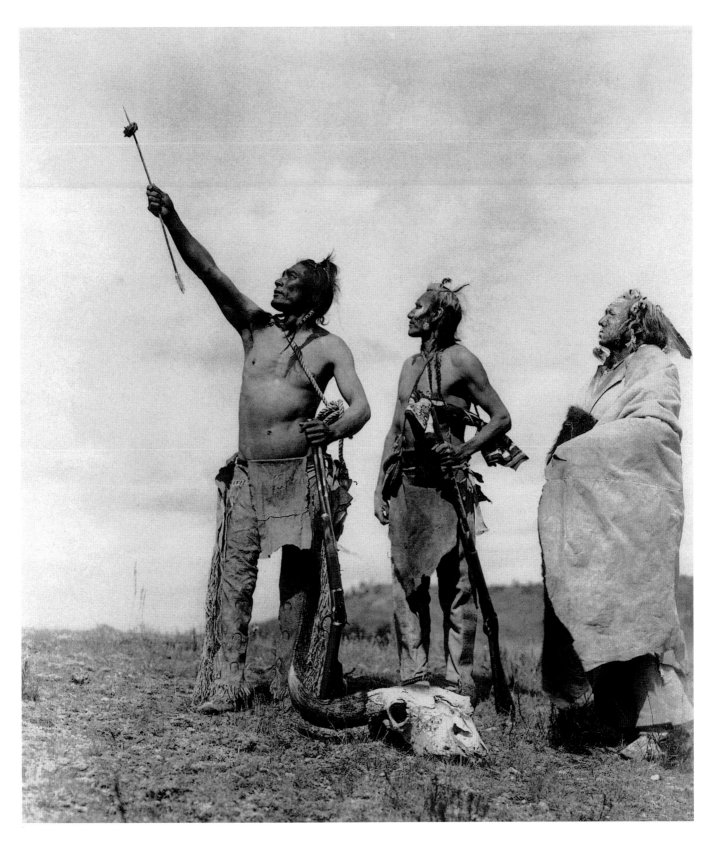

Opposite:
Edward S. Curtis
For Strength and Visions
Library of Congress

Above:
Edward S. Curtis
The Oath—Apsaroke
Library of Congress

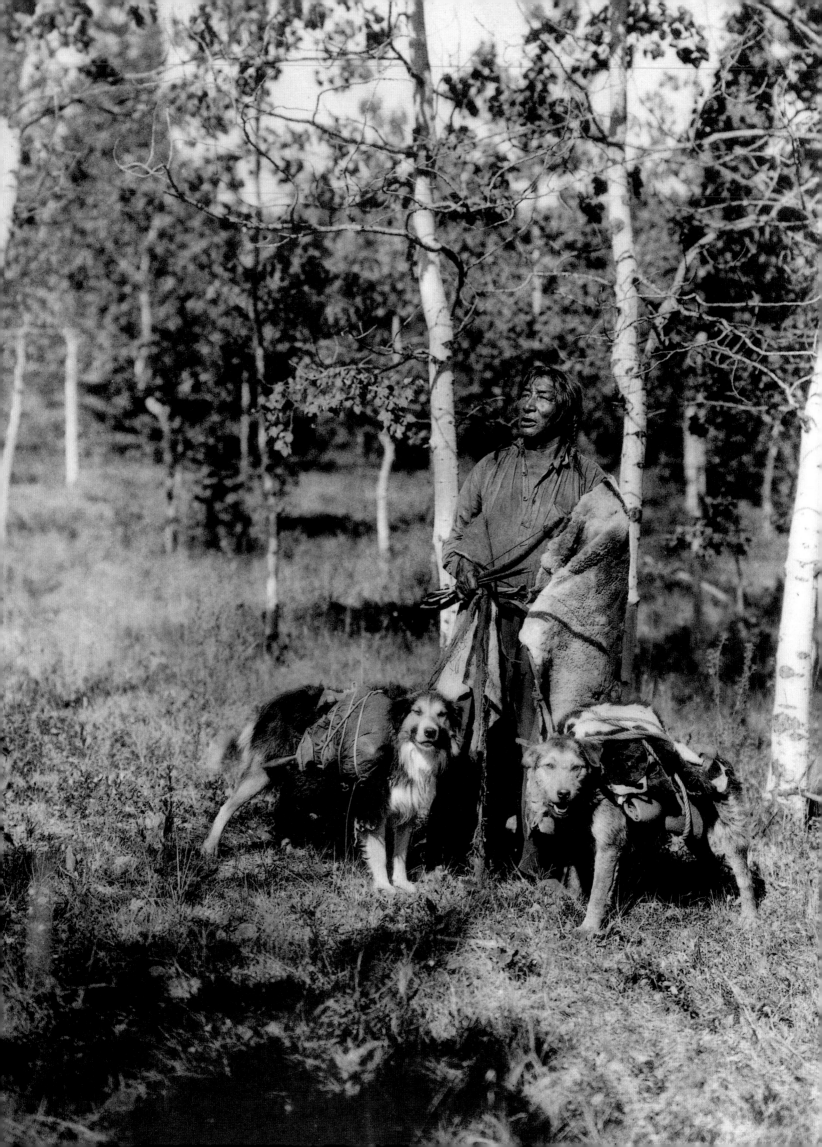

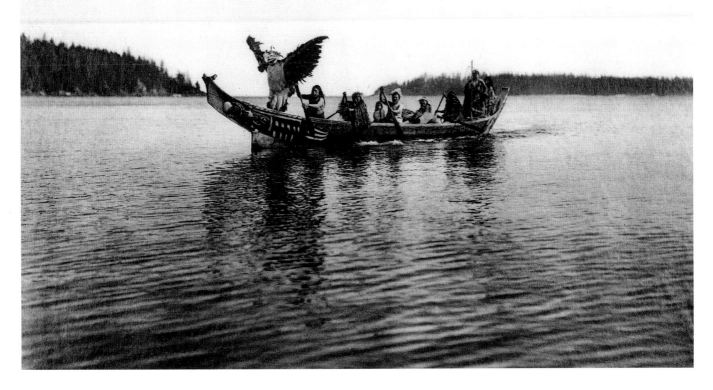

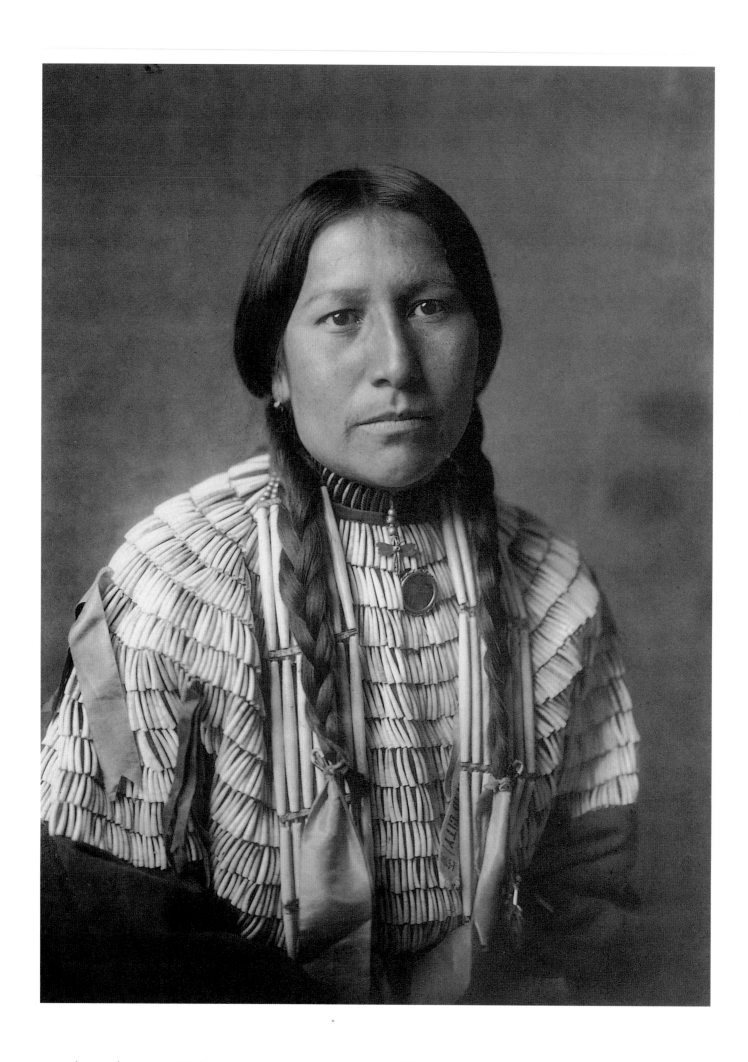

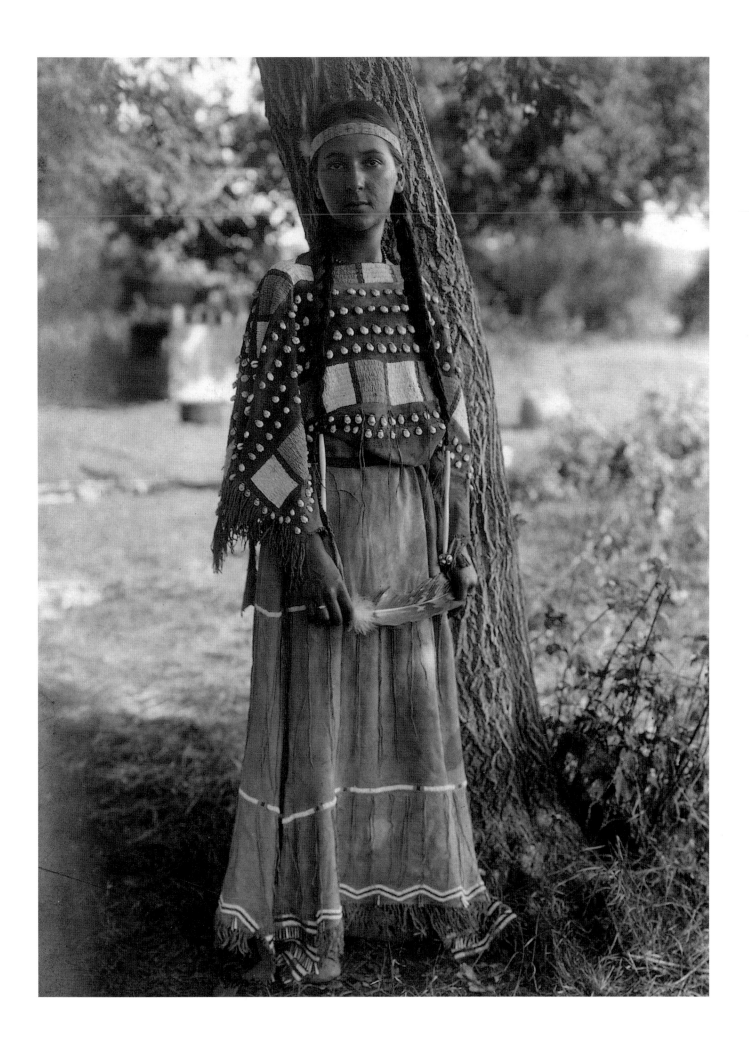

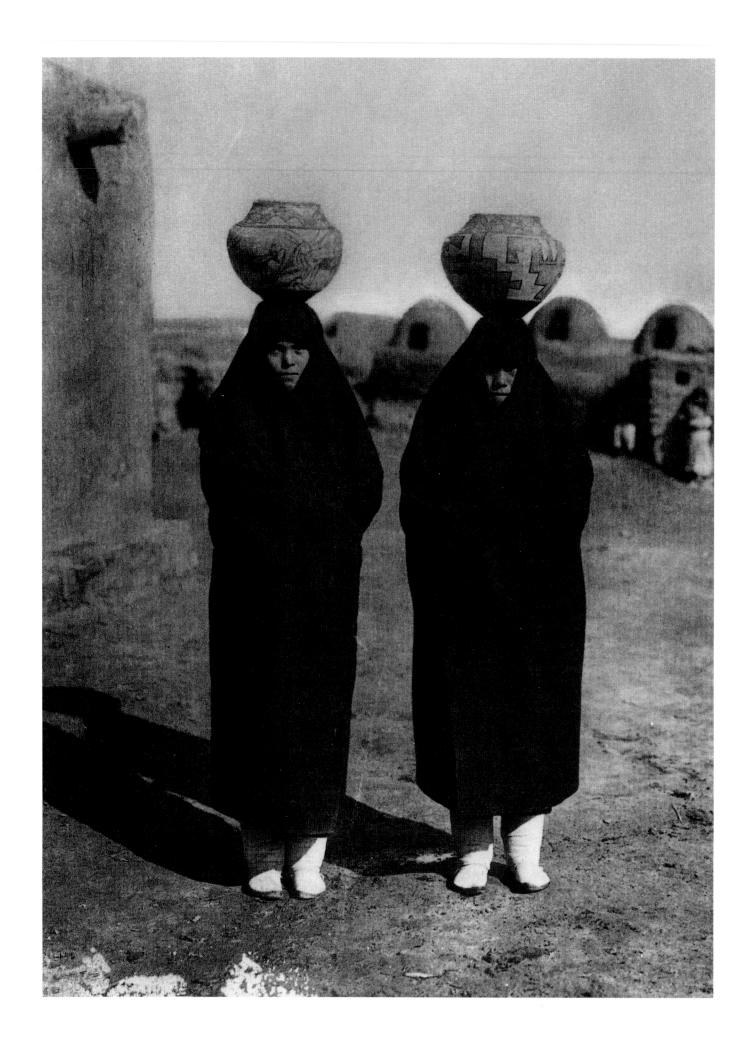

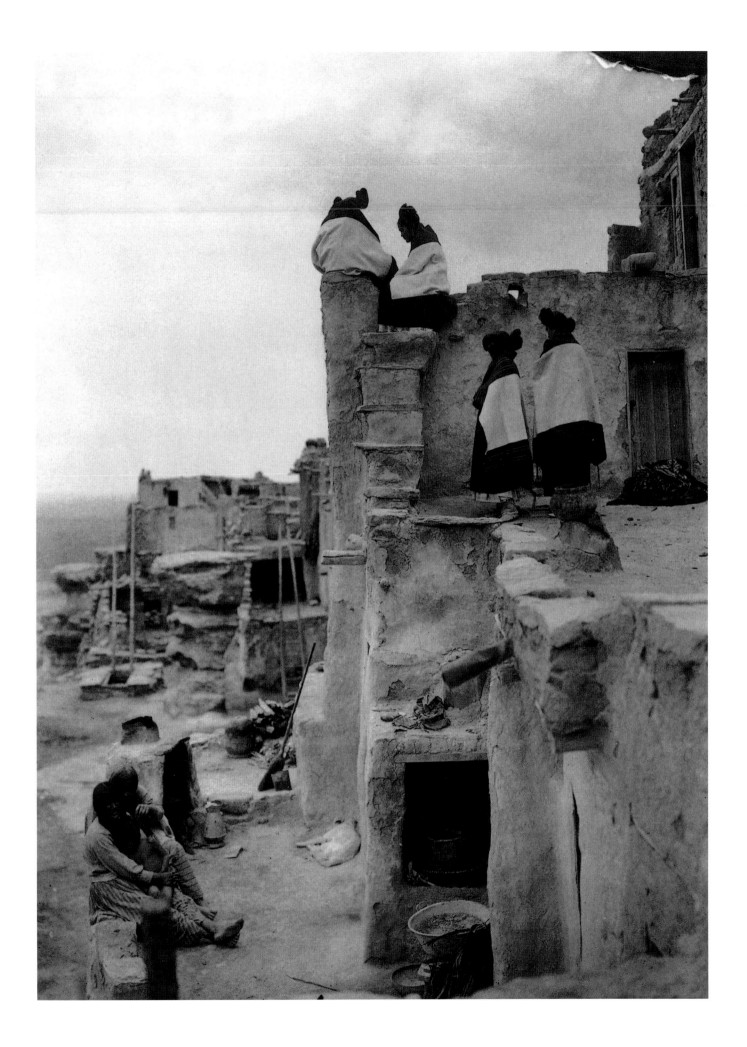

p. 174:
Edward S. Curtis
Zuñi Water Carriers
LIBRARY OF CONGRESS

p. 175:
Edward S. Curtis
On a Housetop — Walpi
LIBRARY OF CONGRESS

Above:
Laura Gilpin
Acoma, the Sky City. c. 1939
LIBRARY OF CONGRESS

Opposite:
Laura Gilpin
Taos Ovens, New Mexico. 1926
LIBRARY OF CONGRESS

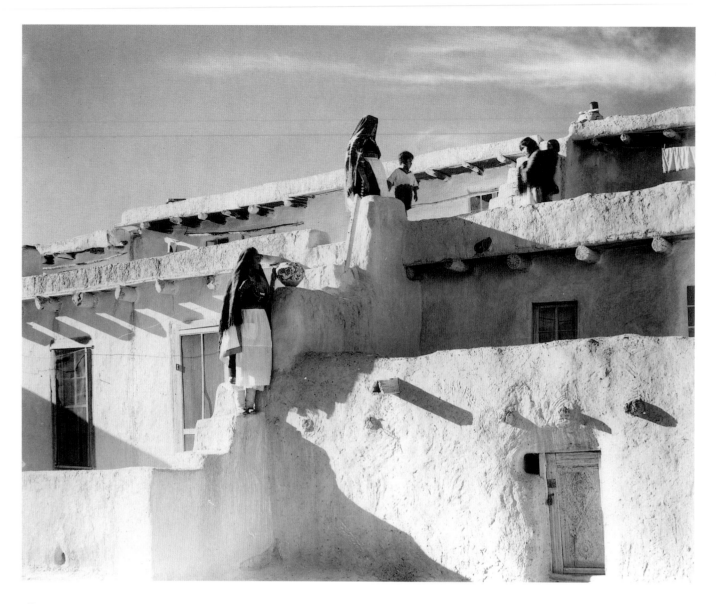

Above:
Laura Gilpin
*Terraced Houses, Acoma Pueblo,
New Mexico.* c. 1939
Library of Congress

Opposite:
Laura Gilpin
*The Water Hole, Acoma Pueblo,
New Mexico.* c. 1939
Library of Congress

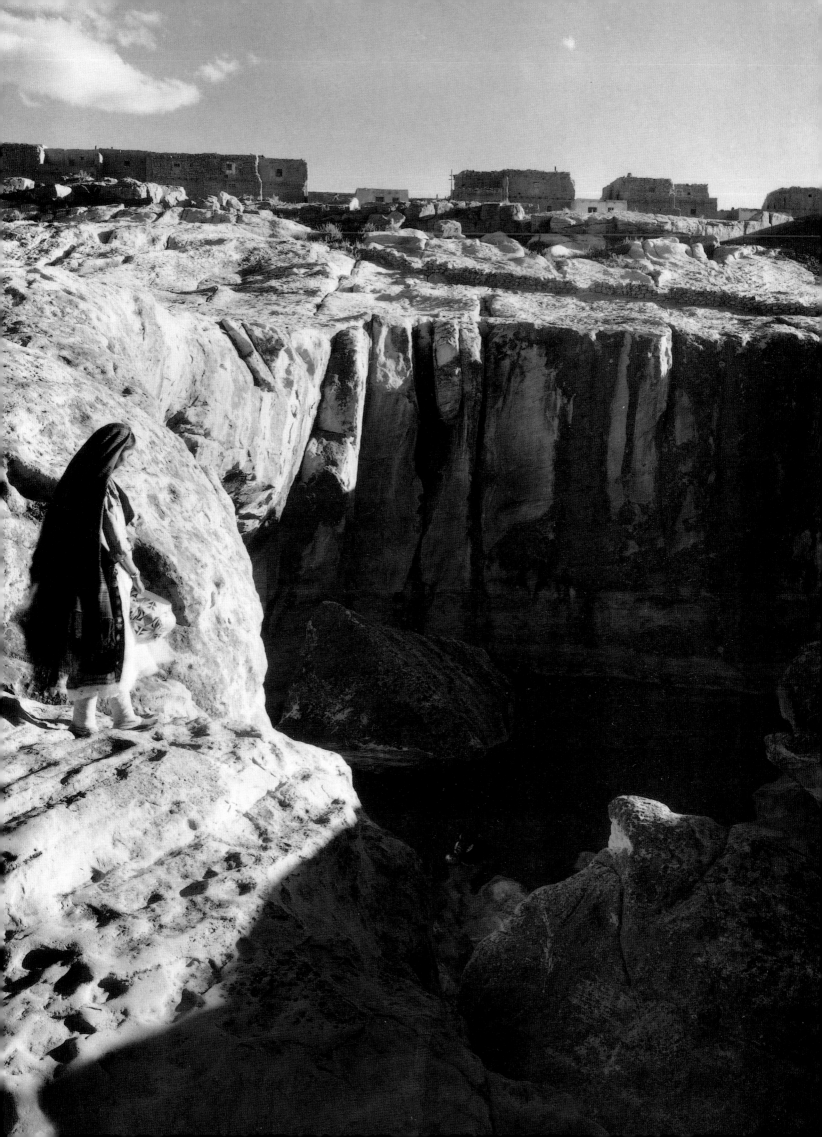

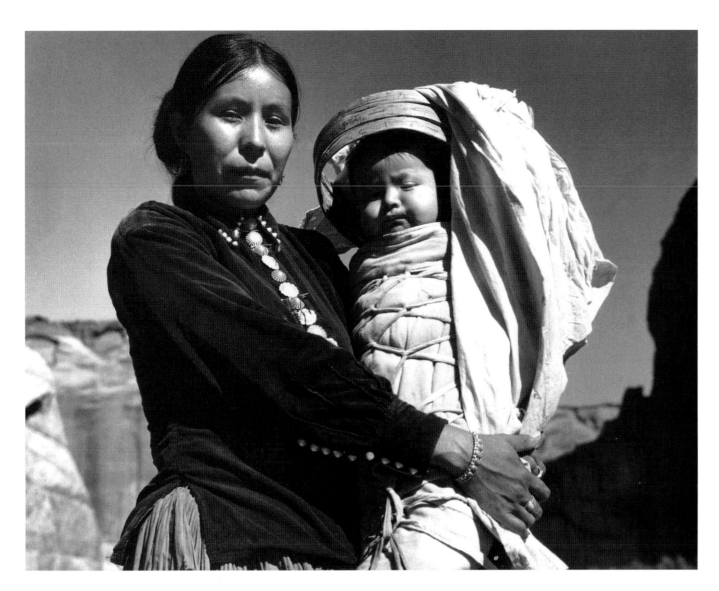

Opposite:
Ansel Adams
Navaho Girl
Canyon de Chelly, Arizona
NATIONAL ARCHIVES

Above:
Ansel Adams
Navaho Woman and Infant
Canyon de Chelly, Arizona
NATIONAL ARCHIVES

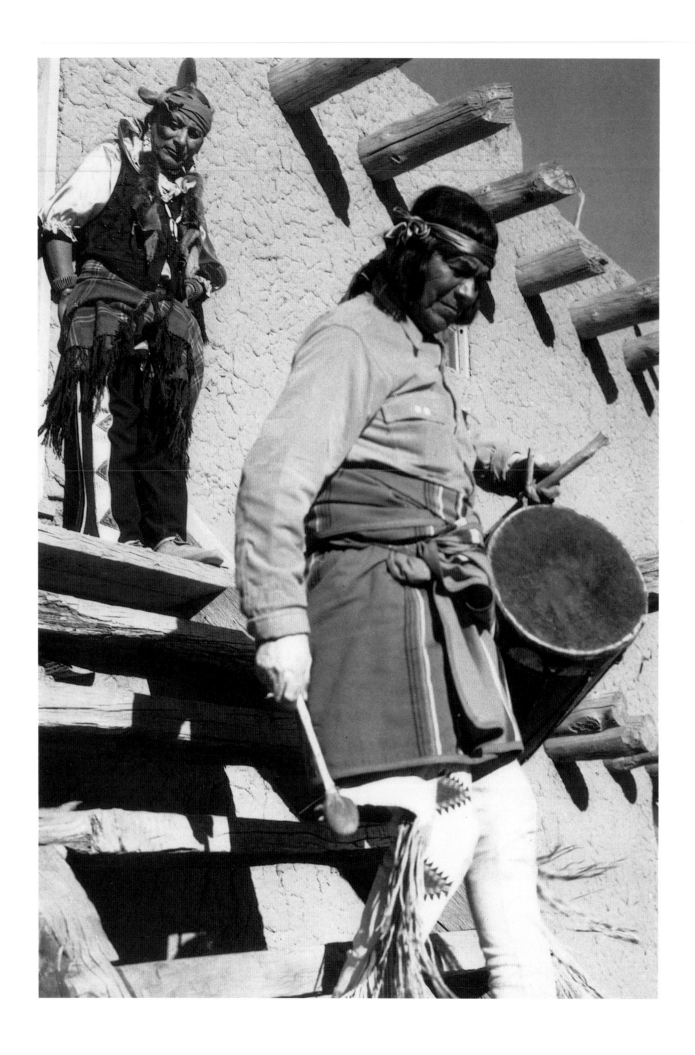

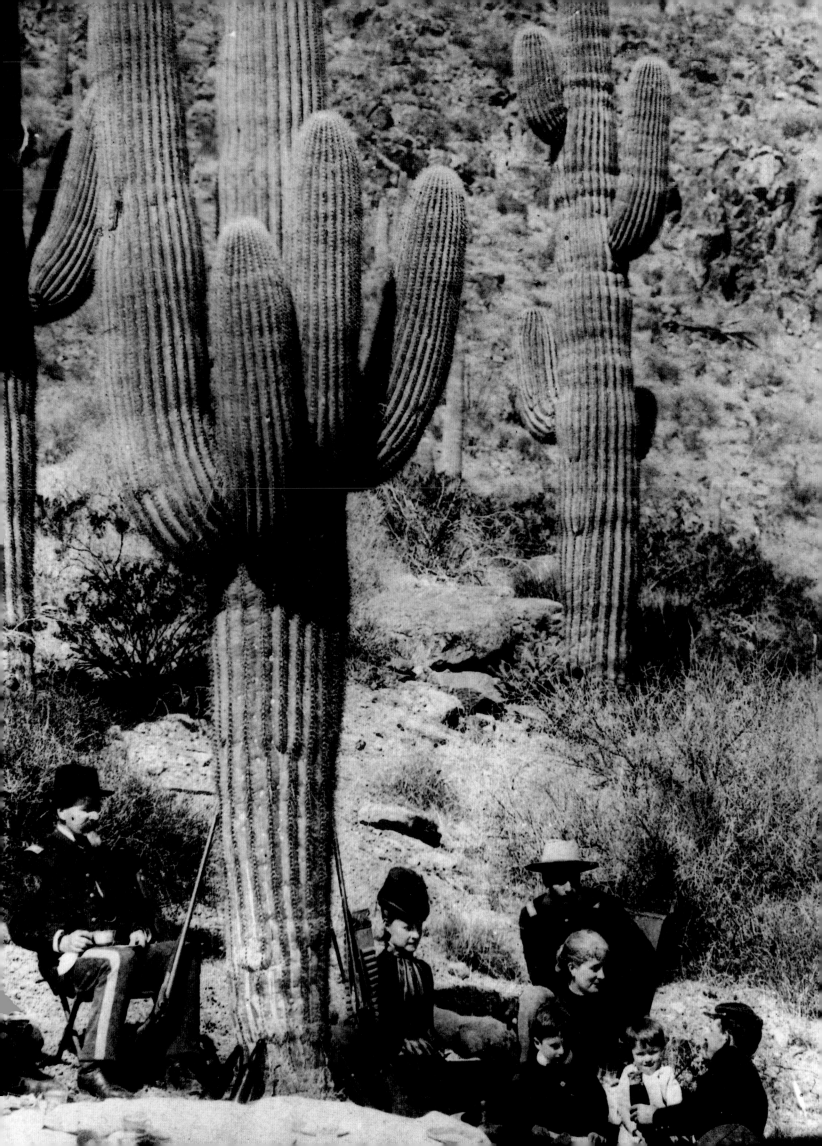

THE WEST TRANSFORMED

Even today, constant vigilance is required to protect the supposedly inviolate precincts of the national parks, so designated by Congress as repositories of the West's finest scenery. Although the total land area of the parks and national monuments comprises less than one percent of the nation's land mass, these great nature reservations remain under the threat of exploitation. Hundreds of thousands of acres within the parks still are owned privately or by the states, and throughout the twentieth century commercial entities sent bills to Congress to allow such activities in the parks as grazing, logging, mining, oil drilling, railroad construction, geothermal power projects, and damming and flooding to provide water for irrigation and hydroelectric power. Later in the century came new threats from air pollution, the encroachment of land development as surrounding buffer zones disappeared, and a disregard for endangered wildlife.

The first bitterly fought battle was lost when Congress authorized, in 1913, the flooding of Yosemite's Hetch Hetchy Valley, physically similar to and ranked second only in beauty to the Yosemite Valley. The Hetch Hetchy Valley was dammed in 1922 to provide a back-up water supply for San Francisco after a lengthy struggle between conservationists and politicians in which the city engineers used a retouched photograph to suggest that once the valley had been made into a lake, it would become a site of even more exquisite beauty.

The saga of Yosemite National Park and its vulnerability to exploitation parallels in microcosm what happened to the untouched areas of the entire West, which was transformed over the course of the nineteenth century. Again, photography was the primary visual medium that most vividly communicated the commercial potentialities of the Western lands.

The rallying slogan for territorial expansion westward became "manifest destiny." Newspaper editor John O'Sullivan introduced this phrase in 1845 to support the annexation of Texas. According to him, it was America's "manifest destiny to overspread the continent allotted by Providence for the free development of our yearly multiplying millions." Central to this agenda was the duty to impose enterprise, an obviously superior political system, and civilization on the undeveloped regions and their inhabitants. Approached from this viewpoint, Western landscape photographs were not only artistically, spiritually, and patriotically uplifting, as well as an inventory of scientific discoveries, they also documented an apparently boundless repository of commercially valuable natural resources.

Yet even as the great early photographers of the West often served commercial employers, their photographs—which were intended for publicity, advertising, and capital raising purposes—also became an important record of historic events and of artistic scenes of unique beauty. The railroad companies, then building their transcontinental lines, were among the first to hire photographers, not only to depict the different phases and aspects of construction, but also the nearby lands and attractions that would lure future settlers and tourists.

After hostilities ended, the prominent Civil War documentarian Alexander Gardner (1821–82) turned toward the West. In 1867 the Kansas Pacific and Union Pacific Railroads hired him as official photographer. (The Kansas Pacific Railroad eventually ran from Kansas City west to Denver, Colorado.) From the railhead around Abilene, he apparently followed the Chisholm Cattle Trail south to the Oklahoma Indian Territory, then veered westward to travel through Texas, New Mexico, and Arizona to California. The 1868 view of Seal Rocks off San Francisco was the final image in Gardner's album *Across the Continent on the Kansas Pacific Railroad (Route of*

William Henry Jackson
A Montana Ranch. 1872
National Archives

the 35th Parallel). In 1868 he also photographed the Fort Laramie treaty council in southern Wyoming Territory. By 1870 he was back at his Washington, D.C., studio where he continued to photograph Indian delegates, as he had done since the late 1850s.

The first of the great Civil War cameramen to begin photographing the West had been Andrew J. Russell. In 1865 the Union Pacific Railroad hired him as official photographer charged with documenting the epic construction of the transcontinental railroad across Wyoming and Utah. Along the way he also photographed the nearby landscape, exotic Western landforms, newly arriving settlers, and the Native Americans he encountered. In May 1869 he made what was probably the most famous photograph of the century's most publicized event—the driving of the golden spike linking the eastern and western tracks at Utah's Promontory Point. Expedition leader Clarence King also made use of Russell's services during his survey of Utah's Bear River region. Fifty of Russell's photographs were featured in the 1869 Union Pacific album *The Great West Illustrated in a Series of Photographic Views Across the Continent*, and Ferdinand Hayden included a selection of his images in the 1870 volume *Sun Pictures of Rocky Mountain Scenery*. By the early 1870s, Russell had returned East to open a New York studio, from which he continued to market at least 15 series of stereographs based on his Western travels. Among the other photographers who did work for the railroads were William Henry Jackson and Carleton E. Watkins, who in 1869 took over the post previously occupied by Alfred A. Hart (1816–1908) at the Central Pacific Railroad, the construction of which Hart had documented.

While most boosters of the West tended to publish idyllic prints and photographic views of prosperous farms, the photographs by Solomon D. Butcher (1856–1927) of Nebraska's early farmers were far more realistic. His artless depiction of homesteading families arrayed with their animals and their sparse possessions before their humble sod houses recorded a way of life soon to disappear. What emerges from these pictures, more than anything, is a sense of the settlers' rugged individualism and their pride of ownership based on hard work. From his Custer County, Nebraska, studio established in 1882, and later as an itinerant cameraman, Butcher exposed some 1,500 glass-plate negatives and took down the stories of his pioneer subjects. These he published in his 1901 *Pioneer History of Custer County, Nebraska*. He later traveled to other Western states to document life on the frontier. His images of cowboys, rodeos, and other aspects of popular culture were marketed in the format of nearly 2.5 million postcards.

The possibility of discovering rich mineral deposits rivaled the hunger for land in transforming the Western landscape. Promotional photographs commissioned by mine owners for the purpose of raising capital presented

Stereograph of Avalon Bay, Catalina Island, California, 1906.
LIBRARY OF CONGRESS

Eadweard Muybridge
Panorama of San Francisco.
1878
(Detail, about 90° of 360° view)
LIBRARY OF CONGRESS

mining in its most favorable light. Images of the industry's less appealing aspects were seen in newspaper engravings that pointed out the greed and moral decline of gold seekers, for example. The physical dangers to those working the mines were captured in remarkable underground photographs by Timothy O'Sullivan, who was not in the employ of the mine operators. Carleton E. Watkins, who completed commissions for a number of mining and other industrial operations, also produced 415 impressive views in the 1880s for the Kern County Land Company; these featured the irrigation system which made the land valuable.

In general, most examples of the arrival of industry and civilization in the West were depicted in a favorable light. Among them were views of bustling cities like San Francisco, of new prairie towns, and of military posts, along with their inhabitants—the farmers, ranchers, trappers, gamblers, lawmen, soldiers, and their families. The West, its landscapes, its legendary and anonymous inhabitants, and its transformation, even to the decimation of the buffalo, were a subject of constant fascination for many nineteenth-century Americans who eagerly collected the numerous sets of Western stereographs. Seen through the stereograph viewer, the twin images merged to render an astonishing illusion of three-dimensional depth and realism. As a vicarious form of travel and as a parlor entertainment, the stereograph could be likened to the television set of modern times.

Although Ansel Adams is notable for his preference for the primeval and pristine Western wilderness, he did depict agricultural scenes and allow the intrusion of contemporary motifs in certain of his Mural Project pictures. Some of his pueblo and Carlsbad Caverns scenes include tourists. And he considered his strikingly modernistic Boulder Dam photographs a celebration of America's technological and natural resources, reflecting public attitudes during the patriotic months leading up to World War II.

Alexander Gardner
Crossing the Line of Tecolate Creek,
New Mexico. 1867
Photo Archives, Museum of New Mexico,
Santa Fe
NEG. NO. 56266

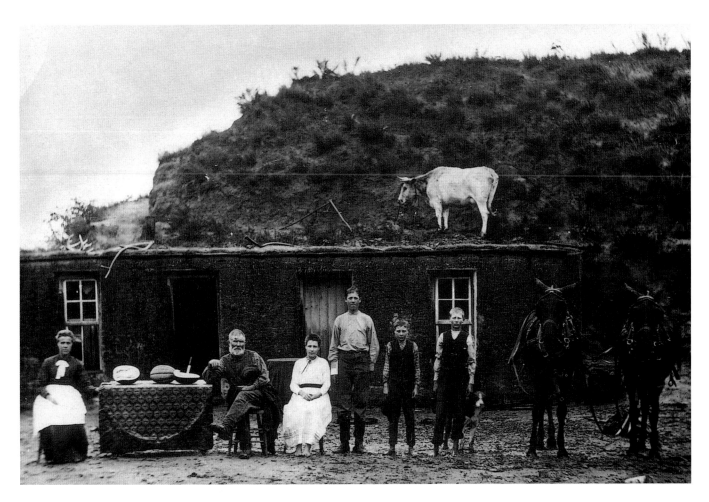

Solomon D. Butcher
Sylvester Rawding family, north of
Sargent, Custer County, Nebraska. 1886
Nebraska State Historical Society
NEG. NO. RG2608-PH-0-1784

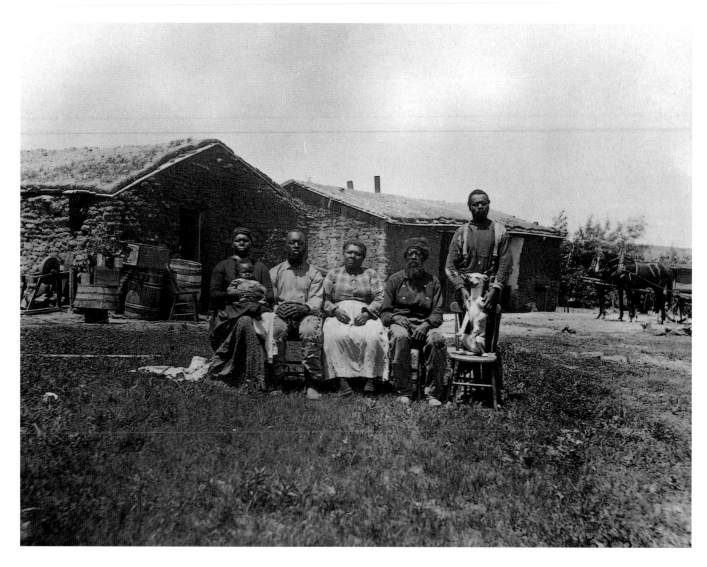

Solomon D. Butcher
Jerry Shores family, near Westerville,
Custer County, Nebraska, 1887
NEBRASKA STATE HISTORICAL SOCIETY

NEG. NO. RG2608-PH-0-1231

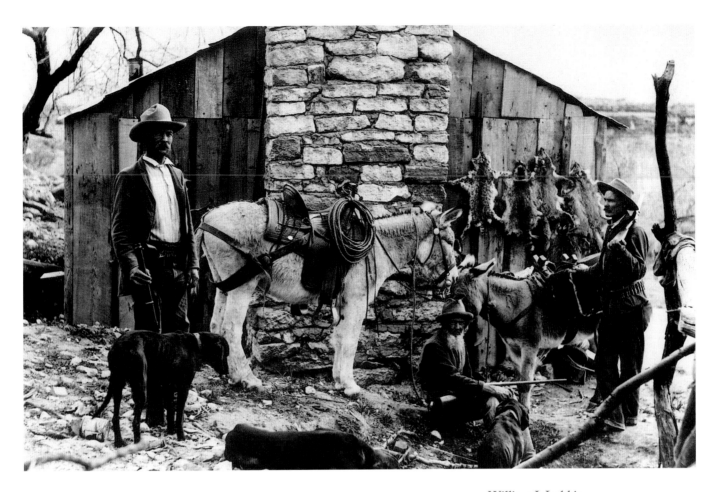

William J. Lubkin
*Trappers and Hunters in Four Peaks
County, Arizona Territory.* 1908
National Archives

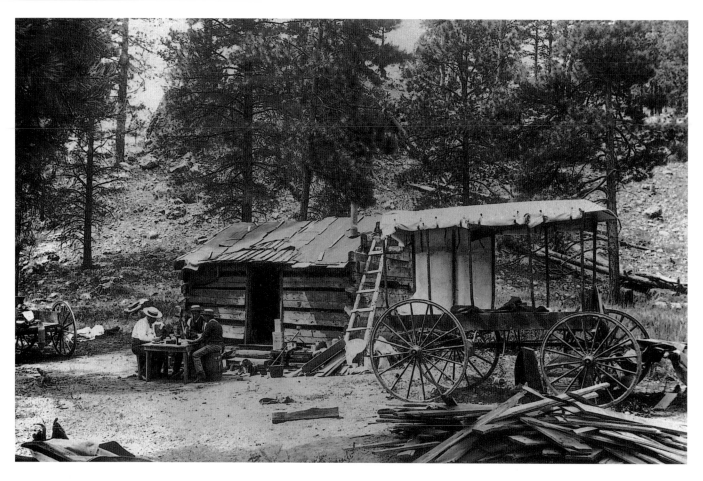

F. A. Ames
*An Arizona Poker Party at John Doyle's
Ranch.* 1887–89
NATIONAL ARCHIVES

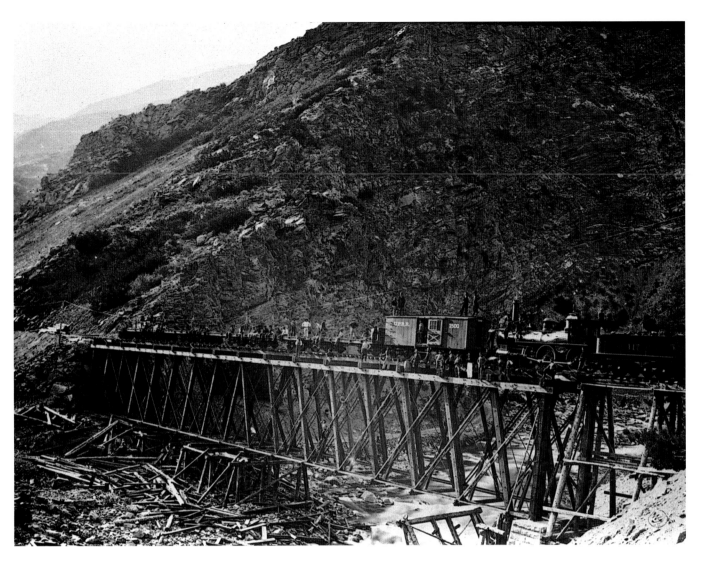

William Henry Jackson
Devil's Gate Bridge, Utah Territory. 1869

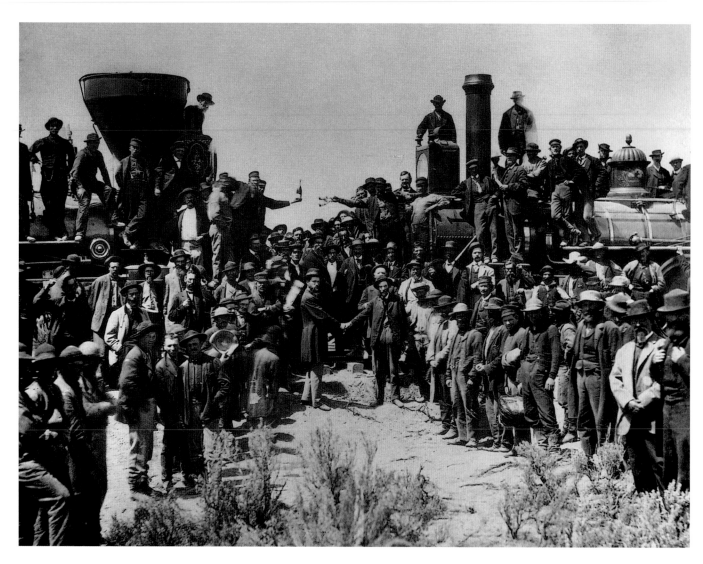

Andrew J. Russell
*Driving of the Golden Spike, Promontory
Point, Utah.* 1869
Yale Collection of Western Americana,
Beinecke Rare Book & Manuscript Library

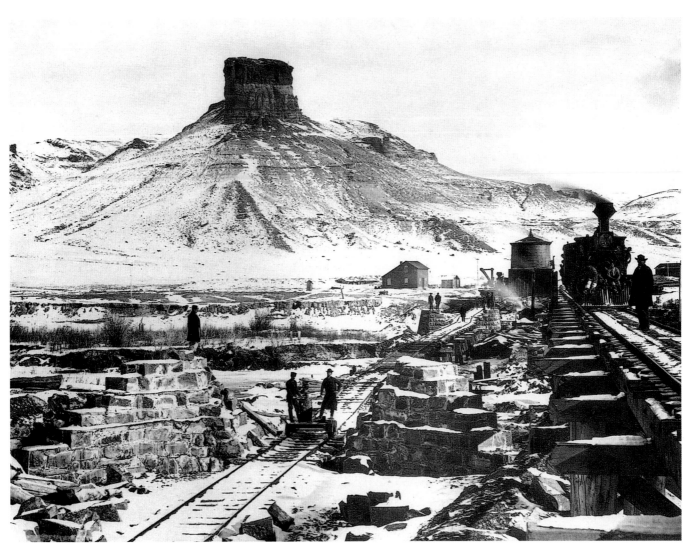

Andrew J. Russell
*Temporary and Permanent Bridges, and
Citadel Rock, Green River, Wyoming.*
1867–68

Andrew J. Russell
Weber Canyon, Utah. 1868
Russell Collection, Oakland Museum
History Department
Oakland, California

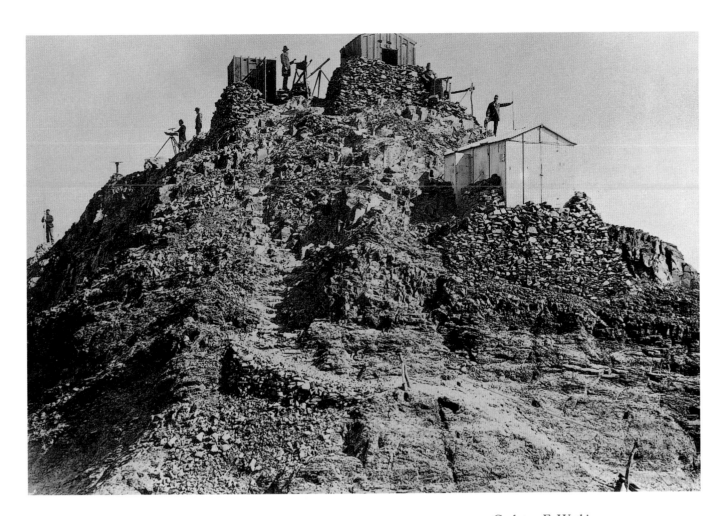

Carleton E. Watkins
Round Top. 1879
RARE BOOK DEPARTMENT, HISTORICAL
PHOTOGRAPHS
THE HUNTINGTON LIBRARY, SAN MARINO,
CALIFORNIA

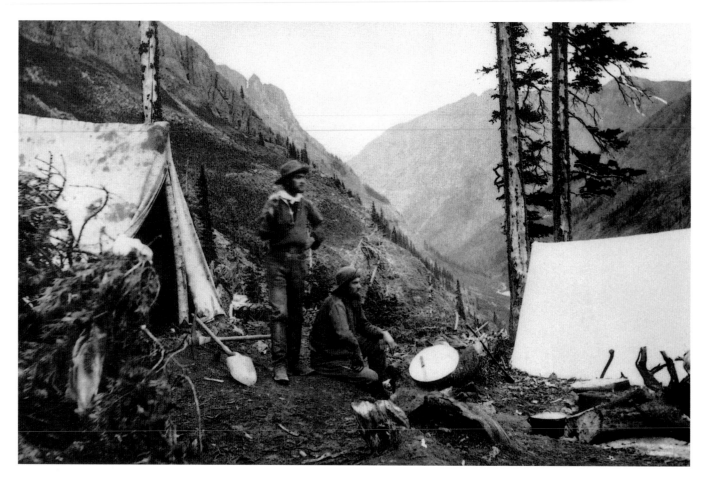

Above:
William Henry Jackson
*Camp of the Miners of the North Star and
Mountaineer Lodes on King Solomon
Mountain, Colorado Territory.* 1875

Opposite:
Stanley J. Morrow
*Gold Mining Crew, Deadwood, Dakota
Territory.* c. 1876

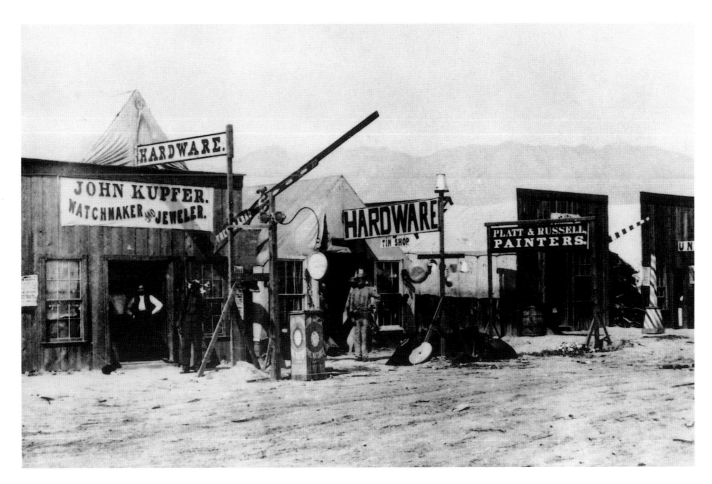

Opposite:
Stanley J. Morrow
Deadwood, Gold Rush Town, Dakota Territory. 1876

Above:
William Henry Jackson
Street Scene in Corinne, Boxelder County, Utah. 1869

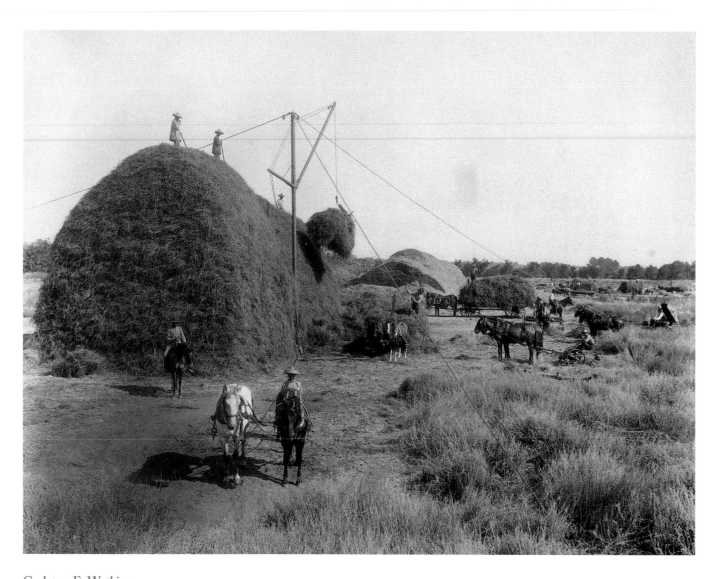

Carleton E. Watkins
Stacking Alfalfa Hay, Stockdale Ranch.
c. 1887-88

Carleton E. Watkins
Head Gate, Kern Island Canal.
c. 1887-88
Library of Congress

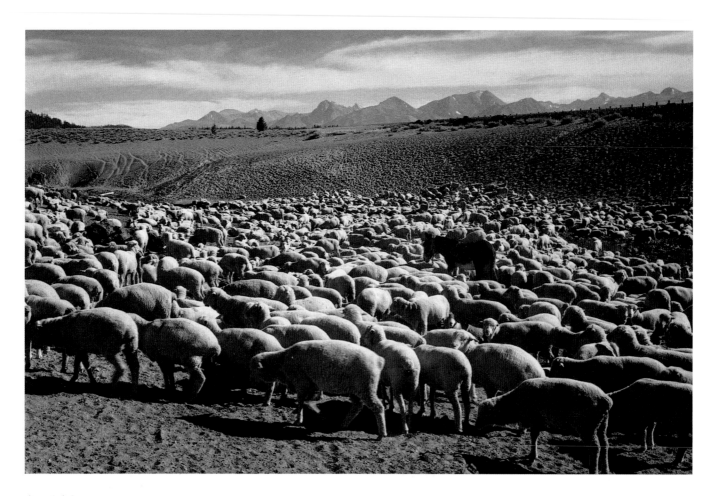

Ansel Adams
Flock in Owens Valley. 1941
Owens Valley, California

Ansel Adams
*Corn Field, Indian Farm near Tuba City,
Arizona, in Rain.* 1941
NATIONAL ARCHIVES

Opposite:
Ansel Adams
Boulder Dam, Colorado. 1941
NATIONAL ARCHIVES

Above:
Ansel Adams
Boulder Dam, Colorado. 1941
NATIONAL ARCHIVES

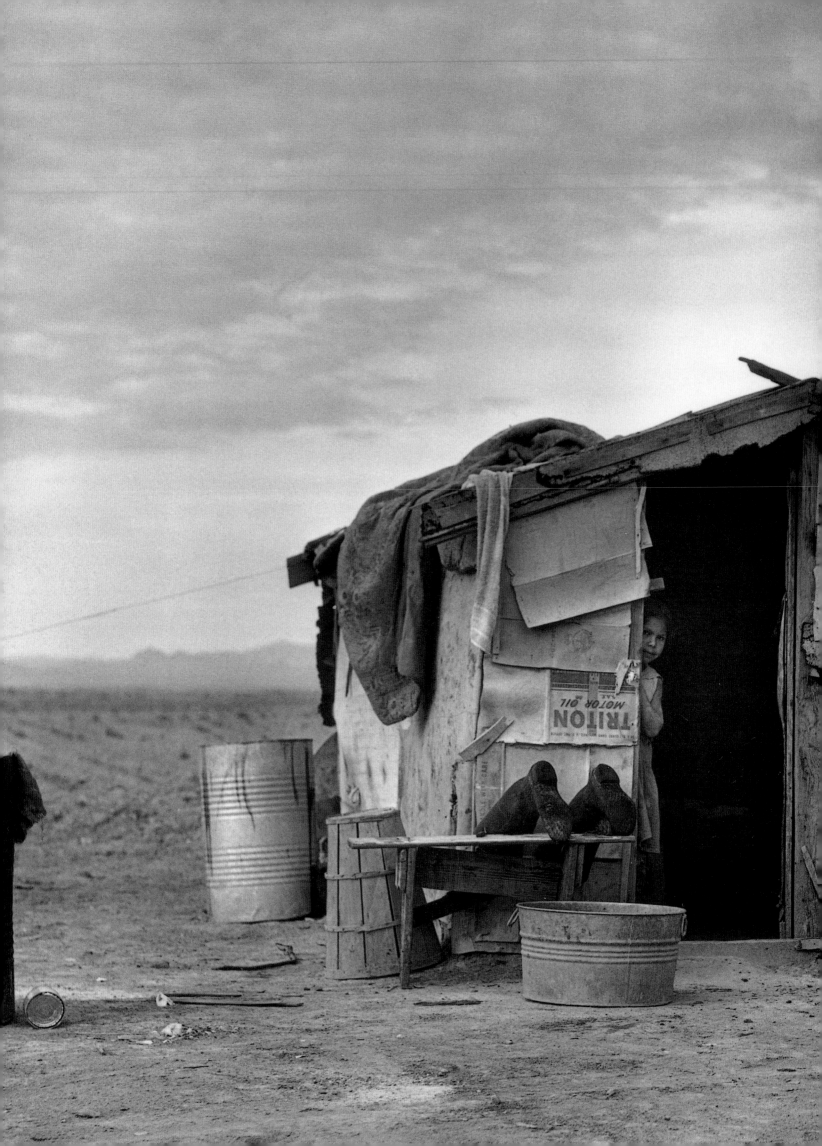

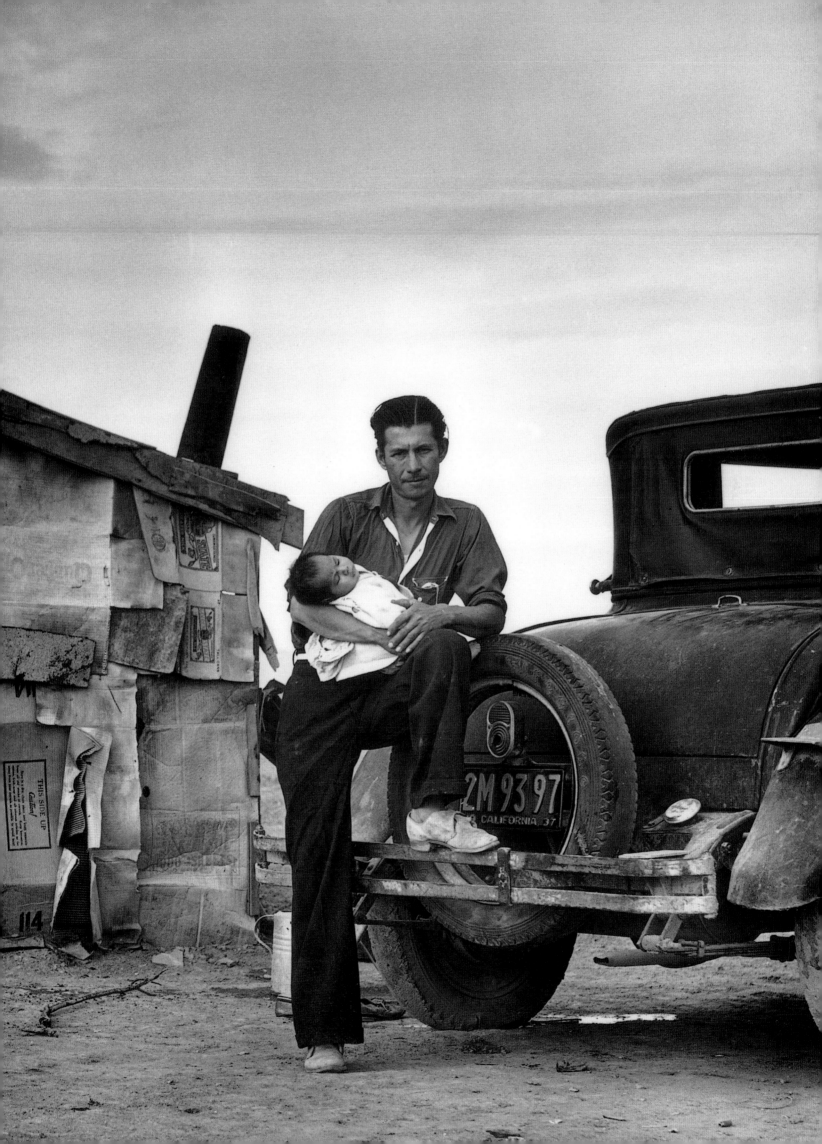

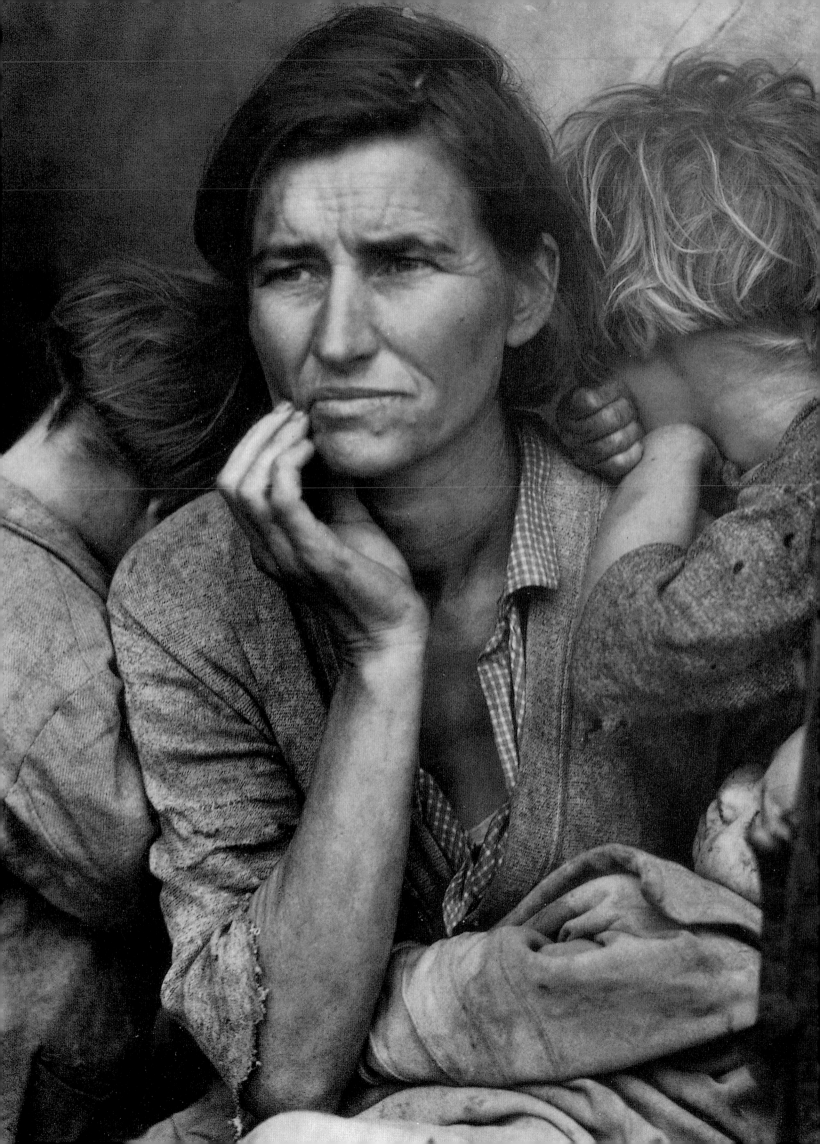

Documenting History and Society

Two Civil War photographs by Timothy O'Sullivan, *Harvest of Death, Gettysburg, July, 1863,* and *General Grant and Staff at Massaponax Church, May 21, 1864* (one of a series of shots of the same occasion), demonstrate the contrasting aspects of documentary photography, the subjective and the objective—expressing a point of view, as opposed to being an eyewitness. This dualism was to dominate the depiction of historic events and of social trends into modern times. Key to using documentary photographs to send a message was the skillful composition of the caption and of an explanatory text. The iconic *Harvest of Death* was included in the 1866 two-volume compendium *Gardner's Photographic Sketch Book of the War*, a chronological arrangement of 100 images taken by Alexander Gardner, O'Sullivan, and others. The text accompanying the pictures was written by Gardner, born in Scotland and a former editor of the Glasgow *Sentinel*. His partisan commentary, which portrays the Union side as patriots and the South as treasonous rebels deserving of their fate, nevertheless attributes heroism to both sides in the text for *Harvest of Death* which concludes, "Such a picture conveys a useful moral! It shows the blanket horror and reality of war, in opposition to its pageantry. Here are the dreadful details! Let them aid in preventing such another calamity falling upon the nation."

From its earliest days, photography appeared to be an ideal way to record history. At first, with the daguerreotype's lengthy exposure times, it was used mainly to capture historic personages in stiff studio poses. Fairly soon, though, advances in photographic technology allowed camera operators to range far afield, traveling in horse-drawn wagons rigged up as mobile darkrooms to permit the development of wet-plate glass negatives on location, as did Englishman Roger Fenton in his pioneering documentation of the 1855 Crimean War. In the United States, too, coverage of the War between the States became the grand project of the first great generation of documentarians. It all started after the nation's leading portraitist, Mathew Brady, rode out from Washington in July 1861 to observe the first Civil War land engagement and was caught in the chaotic retreat of Union soldiers from the Battle of Bull Run. He organized a cadre of exceptional photographers, led by Gardner and including O'Sullivan and others to cover

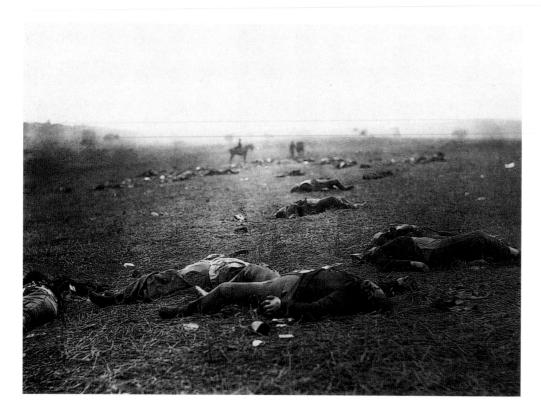

events as they unfolded and the daily lives of the soldiers, in the immediacy
of both trench and camp. After Brady persisted in appropriating the work of
his men (and others) as his own, he lost their allegiance in 1863. When
hostilities finally ended in 1865, Gardner, O'Sullivan, Andrew J. Russell,
and others turned their lenses to the West, the stage for the next epic drama
of the American saga.

The years following the Civil War were an era of intensive exploration
and settlement on the frontier, as pioneers forged across the Mississippi River
in search of land, would-be miners sought wealth in gold and silver by
staking claims at every promising site, and the first of several transcontinental
railroads was completed in 1869. All of this activity involved the seizure of
ancestral Indian lands and the confinement of the primarily nomadic
Western peoples on reservations. A total of some 25,000 American soldiers,
many of them Civil War veterans, enforced these federal policies over the
next decades by fighting in some 1,000 battles and skirmishes, many of them
surprise cavalry raids on native villages. Thus, the four years of the Civil War
were followed by a quarter of a century of Indian Wars. Frontier
photographers arrived to document the major episodes of and participants in
these hostilities.

Government attempts to seek a peaceful resolution by arranging councils
with the various Native American groups in order to forge treaties were not
a success, especially since most treaties were broken repeatedly, often when
pioneers or miners pushed onto Indian lands. Most treaties were altered
later by the government to take away even more tribal lands, and in 1871
Congress stopped making formal treaties entirely. Up to that time, the
councils, peace talks, and treaty sessions that occurred were, for the most

Timothy O'Sullivan
*General Grant and Staff
at Massaponax Church,
May 21, 1864*
LIBRARY OF CONGRESS

part, documented photographically as important historic occasions.

Probably the best documented was the 1868 council at Fort Laramie, Wyoming Territory, in which General William Tecumseh Sherman led an eight-man Peace Commission of military and civilian members to try to bring an end to Red Cloud's War. For two years, Red Cloud had blocked construction of the Bozeman Trail through Sioux lands to the Montana gold fields. Sherman met with representatives of the Oglala, Brule, and Miniconjou Sioux; the Northern Cheyenne; the Crow; and the Arapaho. As official governmental photographer for the Fort Laramie peace session, Alexander Gardner produced a substantial body of images, including nearly 100 stereographs, as well as large-format albumen prints. Over half were of Indian subjects, including group portraits of prominent chiefs, the peace-pipe smoking ceremonies, and the distribution of gifts to the native delegates. More remarkable were his candid shots of Indian camp life, including those of children and old women, which were uniquely successful at capturing Indians in infrequently seen private moments. Apparently Gardner never circulated this series commercially.

In 1873 hostilities broke out in southern Oregon when Modoc Indians were prevented by U.S. forces from leaving the Klamath reservation and sought refuge in northern California's Lava Beds. After shooting several peace commissioners, the Modoc band was hunted down and imprisoned, and its leaders hanged. Two photographers profited from their coverage of the Modoc Indian War. The first was Louis Herman Heller (1839–1928), who later marketed an albumen-print series of Modoc prisoner portraits. Eadweard Muybridge soon arrived at the Lava Beds with a commission from the Army Engineers to photograph Modoc hideouts among the volcanic caves and fissures; some of his pictures later were appended to an official reconnaissance report. He also took a stereograph series of the Modoc fortifications, the military officers, the army camp, and of some Warm Spring Indian scouts he had persuaded to pose as Modoc fighters. Engravings based on some of his pictures and Heller's appeared in *Harper's Weekly* in June as breaking news. Muybridge went on to market his "historic" Modoc War images as a series.

As the nation celebrated its centennial on July 4, 1876, in Philadelphia, the shocking news arrived of the defeat of George Armstrong Custer and his cavalrymen by Sioux and Cheyenne warriors near Montana's Little Big Horn River. Custer had led several campaigns against the Plains Indians before his

1874–75 expedition to the Dakota Territory's Black Hills to investigate reports of gold; his confirmation of the discovery led to the invasion of Sioux tribal lands by a torrent of would-be miners. Accompanying the Black Hills expedition was photographer W.H. Illingworth (1842–93), who documented the exploits of Custer, a celebrity since his Civil War days, and later marketed these images in the set *Custer's Expedition*, a series of hundreds of stereographs. The aftermath of this journey, the next year's Battle of the Little Big Horn, became a profitable enterprise for Stanley J. Morrow (1843–1923), David F. Barry (1854–1934), and others. Morrow, who operated a studio in Yankton, Dakota Territory, from 1868 to 1883, documented the Black Hills gold rush and General George Crook's 1876 expedition to the Red Cloud Agency in Nebraska; he just missed traveling with Custer to the Little Big Horn River. Morrow produced several sets of photographs for sale, including *Custer's Battlefield* (1877) and *Crook's Expedition Against Sitting Bull* (1876). In 1879 he was present for the Custer reburial expedition. Barry, working out of Bismarck, Dakota Territory, photographed Fort Custer in the 1880s and in 1896 covered the twentieth anniversary of the Battle of the Little Big Horn.

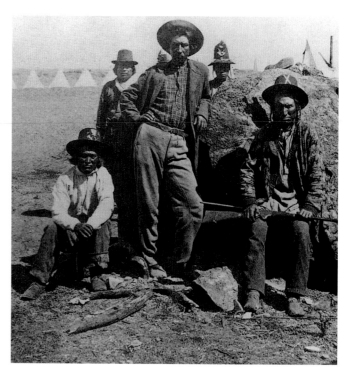

Eadweard Muybridge
*Modoc War: #1623
Donald McKay, the Celebrated
Warm Springs Scout and his
chief men.* 1873
California History Room,
California State Library,
Sacramento, California
neg. no. 5,978

Other episodes of Indian resistance brought their leaders into national prominence and made their images a subject of great interest to the public and thus to the era's photographers. Chief Joseph, the peaceful leader of the Nez Percé, became a national tragic hero when he led his band in a futile flight toward Canada. The Nez Percé had been stripped by treaty of their ancestral lands in western Oregon's Wallowa Valley and were ordered to move to Idaho. After a violent incident, Chief Joseph feared reprisals and sought to join Sitting Bull's Sioux, who had been driven into Canada after Little Big Horn. The Nez Percé fled northeastward some 1,600 miles. On the way they fought thirteen battles with ten different army units through Idaho and Montana, where Chief Joseph finally was forced to surrender with the haunting words, "My heart is sick and sad. From where the sun now stands, I will fight no more forever." When Chief Joseph visited President Theodore Roosevelt in Washington in 1903, he was accorded a hero's welcome.

Two years earlier, a participant in Roosevelt's inaugural parade had been the former Apache war chief Geronimo, a fierce campaigner against Anglo settlers in New Mexico and Arizona for nearly 30 years until his widely publicized surrender and escape in 1886, which ruined the career of General Crook, and his final capture some months later by General Nelson A. Miles. After imprisonment in Florida, Geronimo returned to Oklahoma to farm and became something of a tourist attraction.

Alexander Gardner
Treaty of Laramie, Medicine Creek Lodge, Indian Peace Commissioners in Council with the Cheyenne and Arapahoe. 1868
PHOTO ARCHIVES, MUSEUM OF NEW MEXICO, SANTA FE
NEG. NO. 58659

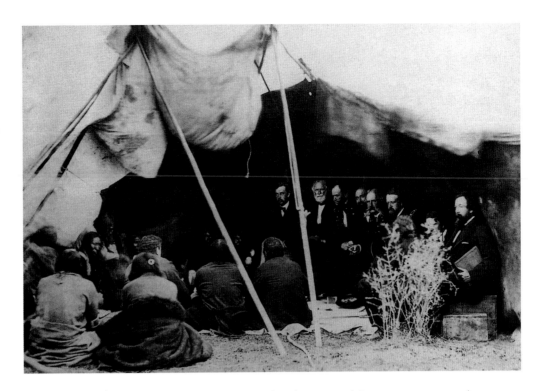

Another episode that received wide photographic coverage was the Oklahoma land rush of 1889. After the first railroad line crossed the region in 1872, squatters began to invade Oklahoma's Indian Territory. When the government opened a nearly two-million-acre tract to settlement in 1889, the area was overrun by some 50,000 land-hungry homesteaders who raced off to stake their claims following a pistol shot at noon on April 22; those who "jumped the gun" were nicknamed Sooners. Almost overnight, such towns as Guthrie, Stillwater, Kingfisher, Norman, and Oklahoma City sprang up.

The final blow to Native American resistance came in 1890. Around 1889, the Nevada Paiute medicine man Wovoka had a vision that led him to preach to Plains Indians that if they practiced the sacred Ghost Dance, the world would be transformed to one of peace and plenty, white men and all their works would vanish, the buffalo and other wild game would return, and all Indians, living and dead, would resume their traditional way of life. While some news photographers tried to secretly snap the banned Ghost Dance ritual, James Mooney (1861–1921) of the Bureau of American Ethnology gained greater access when he conducted field research on the ceremony from December 1890 on, even meeting with Wovoka in 1892. He used a hand-held Kodak camera to capture dance scenes remarkable for their depiction of the ritual's trancelike spirituality.

Alarmed, the government tried to suppress the rapidly spreading Ghost Dance movement. By mid-November 1890, some 3,000 soldiers led by General Miles were stationed around the Pine Ridge and Rosebud agencies in southwestern South Dakota. From these reservations, several thousand Sioux then fled northwest to the Badlands region. In early December, the Ghost Dance continued only at Sitting Bull's camp at Standing Rock and at the Cheyenne River camp of the aged Miniconjou chief Big Foot.

On December 15, Sitting Bull was killed by those who came to arrest him, and Big Foot and some 400 of his people fled for Pine Ridge to seek protection with Red Cloud's Oglala Sioux. Members of the U.S. Seventh Cavalry, Custer's old regiment, stopped them at the nearby Wounded Knee Creek, and in the chaos resulting from the military order for the Indians to disarm, the soldiers massacred 250 to 300 of them, mostly women and children, on December 29. Following several military attacks, the last of those in the Badlands surrendered on January 15, 1891, to General Miles.

Judge Roy Bean, the Law West of the Pecos, Langtry, Texas, 1900.

These events were most extensively covered by two frontier photographers, George Trager (1861–after 1895) and John C.H. Grabill (active 1880s–90s). From his studio in nearby Nebraska, Trager began to document events from autumn 1890 onward with views of the Rosebud and Pine Ridge reservations and the arrival of the military contingent. After the massacre, he photographed the Indian casualties under treatment, and on January 3 he went to the battlefield to photograph the dead, including Chief Big Foot, and their burial. A blizzard and continuing hostilities had delayed by five days the gathering up of the dead by a civilian detail under military escort. He also documented Sioux camps, councils, and related military activities. By January 9, Trager began to aggressively market a series of 11 views of the Wounded Knee battle site throughout the nation with the help of traveling salesmen and an additional staff of six to print up orders. Trager's leading competitor was Grabill, who completed panoramic vistas of reservation lands in January 1891 and made portraits of the important Sioux leaders. These images he included in the series *Indians and Indian Life,* published by his Deadwood company.

This photographic documentation of the Western wars was paralleled by a pictographic narrative record of key events painted by Plains Indians, first on buffalo hides and tipis, later on muslin cloth, and finally in paper booklets as ledger-book art. Beginning in the prehistoric era, the Native American peoples had recorded great historic and spiritual events by carving or painting abstracted sticklike figures into rock surfaces in the form of petroglyphs. During the course of the nineteenth century, as they became aware of the Anglo-European art of Catlin, Bodmer, and others in the form of prints, Indians adapted their artistic conventions. Their own imagery became more realistic in evoking hunting exploits and battle victories. These they sketched into "war books" which they carried into encounters with the U.S. military. At the end of the century, Indians in prison camps and on reservations turned to producing ledger book-art for sale, often depicting an idealized version of their tribal culture.

The photographers who documented the Western wars between the Indians and the cavalry apparently had little interest in exposing the injustices

committed by the United States against the Native Americans. Rather, their primary motivation was to record history and then market that visual evidence for their own profit. The photographers of the Muckrakers' era, which extended from around 1890 to 1912, had a different agenda. Although they did not deal with the Indian tragedy, their altruistic intent was to use visual evidence to inform the public about the plight of the underprivileged and the exploited, and to seek social reforms to ease their situation. Arriving in 1870, Danish emigré Jacob Riis (1849–1914) spent years as a New York City police reporter before starting work on *How the Other Half Lives* (1889), a powerful exposé of tenement life on the Lower East Side. Mainly a writer, he used photographs to authenticate his claims. Also in New York, teacher Lewis Hine (1874–1940) began in 1904 the documentation of immigrants arriving at Ellis Island, followed by his most famous project, the 1909–14 investigation of inhumane child-labor practices. The pioneering efforts of Riis, Hine, and others as social reformers would set a precedent for the later generation of documentarians who depicted those Americans most affected by the Great Depression of the 1930s.

Another exploited ethnic group bypassed by social-reform documentarians was the Chinese. Although Riis and Hine exposed to a remarkable degree the dire circumstances of their subjects, the photographic coverage of the Chinese in the West concealed more than it revealed. The Chinese had arrived in considerable numbers first to work on constructing the railroads in the 1860s; later they moved on to the mines, agricultural fields, and other enterprises in need of cheap labor. From the beginning, they became increasingly vulnerable to individual attack by racists, to mob violence instigated by labor factions who feared their effect on wages and jobs, and by political xenophobes who passed congressional legislation limiting further immigration by Chinese and other Asians. Though such events were reported in the press and depicted in illustrations and cartoons, their dilemma failed to attract photographic inquiry. Rather, as boosters of California tourism tried to gloss over such unpleasant truths, the Chinese enclaves in Los Angeles and San Francisco became, in the 1870s, a source of images showing Chinese Americans as picturesque specimens of an exotic and also vanishing culture. Frequently depicted in engravings, on souvenir postcards, and in sets of "California Views" stereographs were visually appealing images of the Chinese in traditional costume, often posed at their businesses, especially their restaurants.

The Chinese became a major subject for Arnold Genthe (1869–1942), a German emigré who arrived in the United States in 1896, taught himself photography in 1897, and until 1911 operated a leading San Francisco portrait studio. Fascinated with the culture of San Francisco's Chinatown, Genthe often used a concealed camera to capture apparently informal scenes of street life, merchants, children, and even opium addicts in a soft-focus pictorialist style that uniquely merged artistry and documentation. He eliminated

obvious evidence of assimilation and modernization. Indeed, in a number of photographs he made sure the subjects were dressed and posed appropriately for the occasion. Although this 10-year body of work, ending with the 1906 earthquake, started out as a purely personal project, it ended up spreading Genthe's reputation nationwide after the success of his 1908 book of selected photographs, *Pictures of Old Chinatown*. Genthe himself lacked reformist tendencies, but some of his Chinatown images were used in a 1901 article by Chinese Consul Ho Yow to support the contention that the Chinese were industrious, intelligent, and nonthreatening—in other words, "easy to control." In 1911 Genthe moved his studio to New York, where he became a leading portraitist of the era's celebrities, politicians, and dancers.

An overwhelming economic debacle, even greater than the financial excesses and crises that preceded the Muckrakers' era, resulted in the Great Depression of the 1930s, a decade of bank failures followed by widespread unemployment and accompanied by a monumental environmental disaster in the form of Western drought and wind erosion. This dealt a final blow to many already suffering farmers of the Great Plains in South Dakota, Nebraska, Colorado, Kansas, Oklahoma, and Texas. The resulting Dust Bowl forced more than half the population of the devastated regions to flee their homes. Many journeyed farther west, following in the footsteps of earlier pioneers, to seek a living as migrant workers in California farm fields.

Among the various New Deal federal agencies established to provide relief services, low-interest loans, soil-conservation programs, and to organize communal farms and migrant camps was the 1935 Resettlement Administration (RA), transformed two years later into the Farm Security Administration (FSA). Columbia University economics instructor Roy Stryker was hired to publicize and support the new agency's controversial programs by means of photography, often displayed in before-and-after layouts. Already familiar with the work of Riis, Hine, and other social reformers, Stryker hired an impressive phalanx of the era's more gifted photographers—among them Arthur Rothstein, Carl Mydans, Walker Evans, Ben Shahn, Dorothea Lange, Russell Lee, Marion Post Wolcott, Jack Delano, John Vachon, John Collier, Jr., and Gordon Parks—to join the RA-FSA Historical Section. He sent them out from Washington on assignment, often for months at a time, primarily throughout the rural United States to photograph RA-FSA projects, such natural disasters as floods, and ongoing situations like the Dust Bowl. Stryker's instructions included historic, economic, and social background information; lists of topics to be covered; and even detailed "shooting scripts," as the photo-essay approach became more important after 1940. All the while, the central subject of the agency photographers remained the common man and woman, not as a victim but as one heroically transcending unfortunate circumstances resulting from political and economic blunders. The FSA images also provided a way for citizens to view their government and its institutions in a new, more

A. J. McDonald
*Apache Prisoners near
Neches River, Texas*
(Geronimo in front,
third from right), 1886.
National Archives

beneficial, light. Yet, while out on assignment, the photographers had considerable leeway to pursue such specific interests as the recording of American material culture, both traditional and contemporary. Those operating in the Western states and California generally had the most freedom of all, as they were farthest away from headquarters.

Stryker distributed the photographs widely for free use in brochures, reports, books, exhibits, and slide lectures, and by newspapers and magazines. Sometimes the individual images were placed out of context with misleading new captions or were radically cropped—a loss of control disturbing to many of the photographers. Placed in sequenced narratives with appropriate captions, and text, the FSA photographs were central to the development of the photo-essay, which was devoted to a single story or theme. Such essays appeared not only in new picture magazines like *Life*, but also in the form of such socially conscious books as *Let Us Now Praise Famous Men* by James Agee and Walker Evans. As Arthur Rothstein remarked in 1942, this "forces the photographer to become not only a cameraman but a scenarist, dramatist, and director as well."

As the war approached, Stryker shifted the Historical Section focus to the depiction of rural life in a more positive way, and to a greater coverage of urban and industrial themes—in other words, to emphasizing the virtues of the American system rather than its problems. Near the end of the decade, Stryker urgently sought to preserve a historic record of as many of the nation's disappearing rural communities and ethnic enclaves as possible. Political controversy and funding deficits continued to plague the FSA, so Stryker also took on projects for other federal agencies as well as domestic propaganda work for the Office of War Information (OWI). In late 1942, the Historical Section was absorbed by the OWI. When it was all over in 1943, Stryker's relatively small crew had exposed nearly 350,000 negatives (of which he edited out some 100,000) to assemble a remarkable photographic archive of the nation and its people at a specific moment in time.

While formulating his approach to photographic social documentation, Stryker was impressed by reports on migrant farm workers written for the California State Emergency Relief Administration by economics professor Paul Taylor, with photographs by Dorothea Lange. She married Taylor months after Stryker hired her as an RA photographer in August 1935, and she continued to collaborate with Taylor on her subsequent FSA projects. Lange (1895–1965) had attended school in lower Manhattan, and when she became interested in photography around 1915, she approached Arnold Genthe, then a fashionable New York portraitist, who became her mentor. In 1919 she established her own successful portrait studio in San Francisco.

There she hosted a lively salon frequented by modernist West Coast photographers and other artistic types, among them painter Maynard Dixon, her first husband, whom she wed in 1920.

Lange was skilled at capturing fleeting facial expressions and informal poses. To evoke a sense of universality, she urged her sitters to wear simple, timeless apparel. When she attempted landscape photography in the mountains in 1929 and was caught in a terrifying thunderstorm, she recognized that her true subject was people. She also accompanied Dixon on painting trips to the Southwest where she photographed the Hopi. In 1932, as the economy crumbled, she turned to photographing the poor and dispossessed in San Francisco's streets, in breadlines, and at labor demonstrations. Early in her seven sometimes contentious years working for Stryker at the RA-FSA, she produced the iconic Depression-era photograph *Migrant Mother* (1936) near Nipomo, California. Much has been written about Lange's manipulations—shooting from below to evoke nobility and perseverance despite the woman's apparent anxiety, and carefully posing the children to turn away—to achieve that final powerful result after exposing five previous negatives. Lange once remarked that every image a photographer makes "becomes in a sense a self portrait." Possibly Lange's alienation from her own children also found its way into *Migrant Mother*.

In early 1937, she moved on to cover the migrant farm workers pouring into the Imperial Valley. These photographs were meant to win support for the construction of camps by the RA in order to relieve the dire circumstances. Again, she depicted the migrants not as victims but as tough survivors akin to nineteenth-century pioneers. Later she included a number of her migrant pictures in the 1939 book *An American Exodus: A Record of Human Erosion*, with text by Taylor. Lange herself became adept at writing captions and using comments elicited from her subjects, as she considered the written commentary essential to a proper understanding of the visual material. She ended her tour of duty with a project for the War Relocation Administration by documenting the round-up and deportation of Japanese-Americans to internment camps, an episode also covered by Russell Lee and Ansel Adams.

Arthur Rothstein (1915–87), Stryker's former student at Columbia University, became in 1935 his first employee at the RA. After setting up the darkroom, he photographed for the RA-FSA for the next five years, completing assignments from the East Coast and the South across the Midwest to Oklahoma, South Dakota, Montana, and Washington, in the process covering more territory than any other FSA cameraman. In order to counter opposition in Congress and from the right-wing business interests and growers opposed to the FSA migratory labor camps in California, Stryker sent him to take a series of photographs showing the camps in a favorable light. Visalia, like the other camps, was planned not as a temporary site, but apparently as a permanent facility intended to function as a well-

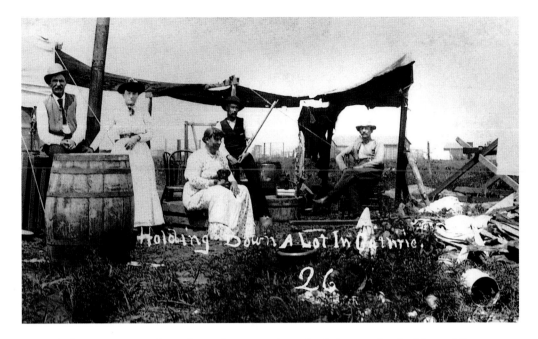

rounded community based on democratic principles and ruled by self-government. Rothstein spent March 1940 in Visalia, exposing nearly 200 negatives and following Stryker's orders to depict polite, attractive residents engaged in typical non-threatening activities ranging from medical care for mothers and children, work in the communal laundry, and participation in recreational events, including dances. Despite this extensive publicity effort, the controversy persisted, and in 1943 the California migrant farm labor program was transferred to the new War Food Administration.

John Vachon (1914–75) first joined the RA in 1936 as a messenger. There he received instruction in photography from Ben Shahn, Walker Evans, and Rothstein, and began to photograph around Washington, D.C. In October 1938, he was sent out on his first solo FSA assignment to Nebraska, where he spent two months covering agricultural activities and the state capital. In Omaha, where he took 208 images of its stockyards, streets, and architecture, he experienced a life-changing moment when he photographed the grain silos behind a railroad car. Recognizing that he finally had attained his own style, he stated, "I knew that I would photograph only what pleased me or astonished my eye, and only in the way I saw it." Edward Steichen later selected the silos picture for inclusion in the *U.S. Camera 1940* annual. Paradoxically, despite the FSA interest in regional America, Vachon's image of a long line of automobiles at Omaha parking meters with a Woolworth chain store in the background conveyed a new truth. The relentless advance of modernization was bringing national mass culture and its concomitant uniformity and standardization to the fiercely individualist West. In 1940 Vachon became an official FSA photographer and completed assignments in the Southwest, Midwest, and Great Plains.

John Collier, Jr. (1913–92) was the last photographer taken on at the FSA. Initially an art student, he had become interested in photography through early meetings with Dorothea Lange in the Southwest. Son of the

then-head of the Bureau of Indian Affairs, John Collier, Collier the younger had grown up for the most part in Taos, New Mexico, which Lange had visited. He sought her advice on a personal project to document a Mexican-American sheep camp, and on her recommendation sent the photographs to Stryker. After completing FSA assignments in New England and the South, he began exploring the life of the Hispanic-American Juan Lopez family in Trampas, northern New Mexico, in June 1943, after the OWI had taken over the FSA Historical Unit. Some of the later FSA projects covered ethnic groups, and these Trampas pictures were distributed as part of the OWI's "Portrait of America" series.

Collier saw his story as concentrating on the connections between the people and the land, the persistence of traditional ways in an era of modernization, and the role of religious and political institutions in their lives. While some images register as extemporaneous slices of life, as does that of Lopez and his son loading firewood on snowy land managed by the U.S. Forest Service, others were carefully posed, as was the *View Through Three Rooms*. This artistically pleasing tableau includes a visual inventory of material objects, a methodology Collier put to work in his postwar years as an anthropology fieldworker in the Andes and among the Navajo. The dried meat hanging from the foreground ceiling beam, the pail and footwear to the left of the doorway, the general bareness of the space, and on the far back wall the assemblage of religious images, frequently seen with family and mass-culture photographs—together, these elements all contribute to a unique perspective on the Lopez family and their traditions. Collier's use of photography to explore the complexities of cultures, the processes of change, and patterns of nonverbal communication later led him to write the key text *Visual Anthropology: Photography as a Research Method* (1967, 1986).

Russell Lee (1903–86), a one-time chemical engineer, joined the FSA in 1936, a year after he had taught himself photography to improve his art skills. Over the next seven years, he became one of the more active photographers of the FSA-OWI Historical Section as he explored communities from Michigan to California in exhaustive detail. Stryker later described him as a "taxonomist with a camera." Although Lee seemed to classify diverse social and cultural groups with almost scientific precision, despite his detailed approach and coherent unity of interpretation, he never lost sight of the humanity of his subjects. Following the completion of his most famous series, those on the small towns of San Augustine, Texas, in 1939 and Pie Town, New Mexico, in 1940, he continued to investigate northern New Mexico.

In July 1940 Lee visited the mountain villages of Chamisal and Peñasco to document the daily lives of their Hispanic residents, focusing on their spirit of cooperation, respect for the land, and self-sufficiency. To do so, he first viewed the villages from afar and gradually moved in ever closer, capturing the architecture, streets, gas station, blacksmith shop, and then

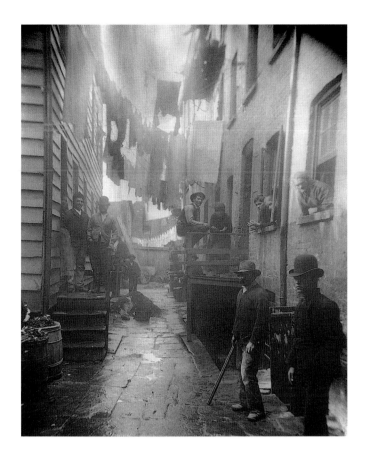

Jacob Riis
Bandit's Roost, c. 1889
39½ Mulberry Street,
New York
THE JACOB A. RIIS COLLECTION
#101, MUSEUM OF THE CITY OF
NEW YORK, NEW YORK

individuals at work on the land, examining their tools and methods, then moving on to domestic activities like hog butchering, canning, laundering. He tracked the erection of an adobe structure from the first step of making bricks to the final plastering by the women. He also surveyed the people's handicrafts, religious activities, and entertainments to re-create their way of life as fully as possible. Lee considered even the humblest moments of their days important because, as he asserted, "I'm taking pictures of the history of today." The FSA plan to publish these photographs in book form together with an interpretative commentary was abandoned at the outbreak of World War II.

While near Monterey, California, in the spring of 1942 to cover the cultivation of guayula, an alternate source of rubber, Lee turned to the plight of the Japanese-Americans being evacuated to inland internment camps.

The FSA reluctantly became involved in the situation when it had to find alternate sources of labor to run the approximately 6,000-odd farms left behind at a crucial stage in the growing season. The agency also recruited several hundred Japanese-Americans from the internment camps to work as migrant laborers on farms in the remote regions of eastern Oregon, Washington, and Idaho. In April and May, Lee took 263 pictures of Japanese-American farmers, migrant workers, Little Tokyo in Los Angeles, and the Santa Anita racetrack reception center. For its attempt to protect the rights of the evicted Japanese-Americans, the FSA was labeled by some as a "Jap-lover."

When the federal government rounded up some 110,000 to 120,000 West Coast Japanese-Americans following the Japanese surprise attack on Pearl Harbor on December 7, 1941, it committed a great injustice against its citizens. Farmers, businessmen, merchants, professionals, women, children, and the elderly were imprisoned in ten internment camps in Arizona, California, Colorado, Utah, Wyoming, and Arkansas for as long as several years during World War II. At the time, an imminent Japanese attack on the mainland was anticipated, and long-simmering racism toward those of Asian origin led many to question the loyalty of Japanese-Americans to the United States.

On hundreds of acres in California's barren Owens Valley, just west of the Sierra Nevada, Manzanar Relocation Center—504 tarpaper-and-board barrack buildings enclosed by barbed wire linking guard towers armed with machine guns and searchlights—soon became home to over 10,000

evacuees. Ansel Adams arrived by invitation in the fall of 1943 on the first of several trips to document conditions at Manzanar, "the largest city between Los Angeles and Reno," according to Ralph Merritt, his acquaintance and camp director. Adams depicted all aspects of Manzanar, ranging from distant camp vistas, agricultural and industrial work, educational and religious activities, and ball games, to individual portraits and family groups in their cramped living quarters. Also shown were residents involved in such quintessential American organizations as the town hall meetings and the camp newspaper. Critics have commented that Adams's Manzanar photographs were too positive and that the sense of injustice is lacking. According to Adams, who once stated that he was not a sociologist with a camera, such was not his intention nor did his subjects wish to be portrayed as victims. Rather, they wished to demonstrate their worthiness to be treated as full-fledged American citizens. In his introduction to *Born Free and Equal: Photographs of the Loyal Japanese-Americans at Manzanar Relocation Center, Inyo County, California*, the 1944 book based on this material, Adams expressed his own viewpoint: "I believe that the arid splendor of the desert, ringed with towering mountains, has strengthened the spirit of the people of Manzanar.... Out of the jostling, dusty confusion of the first bleak days in raw barracks they have modulated to a democratic internal society and a praiseworthy personal adjustment to conditions beyond their control." Furthermore, in carrying out this project Adams and all other photographers visiting camp, among them Dorothea Lange, were subject to strict censorship. They were not allowed to depict the guards, sentry towers, or barbed wire. In his own subtle way, Adams bypassed some of these restrictions. For example, the camp vista of Manzanar obviously was taken from a guard tower.

Although the book had a foreword by Secretary of the Interior Harold Ickes, one of two Roosevelt Cabinet members who opposed the evacuations (Attorney General Francis Biddle was the other), many considered it offensive, partially because of the sometimes accusatory tone of Adams's text, and numerous copies were burned in protest. On the other hand, the fact that those in Manzanar valued this kind of portrayal is shown in several ways. In January 1944, some 80 of the Adams photographs were exhibited in the camp museum, and the final issues of the *Manzanar Free Press* advertised the book and copies of single prints for sale to residents.

As is the case with socially conscious photo-essays, the context and further information provided by a written text are essential. The knowledge, for instance, that in order to create the Pleasure Garden, camp residents traveled under guard to nearby Yosemite National Park to bring back trees and rocks enriches the viewer's understanding of the image, as does the fact that the father of the Miyatake family was an uprooted professional photographer from Los Angeles, who initially smuggled in a lens and shutter to build a wooden box camera so that he could take his own Manzanar

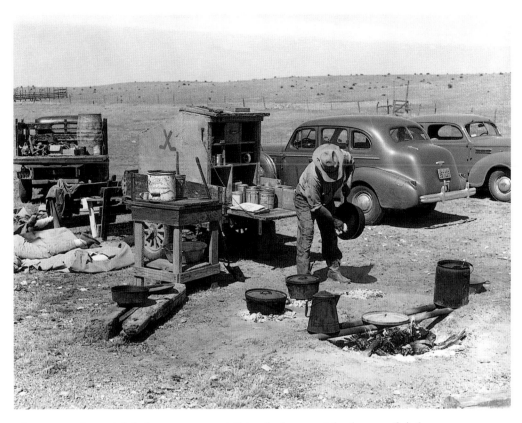

photographs, which later were exhibited along with those of Adams. The Miyatakes and other family group portraits also convey the idea that the traditionally strong family structure made it possible for the Manzanar evacuees not only to survive, but prosper. After the initially disappointing public reception of *Born Free and Equal*, the Manzanar photographs were republished in 1988 with John Hersey's essay "A Mistake of Terrifically Horrible Proportions" in the book *Manzanar*, to a considerably more enlightened response.

Born Free and Equal was to remain Adams's sole foray into the type of book photo-essay that investigated specific social or cultural groups. Around the same time, he also took photographs of pueblo life as part of his Mural Project portfolio for the Interior Department, but he made no extensive investigation of living conditions in San Ildefonso, for example, nor were these images accompanied by a commentary. In subsequent year he collaborated with Dorothea Lange on two magazine photo-essays—one in *Fortune* in 1945 on the "Pacific Coast Issue," and a second in *Life* in 1954 on "Three Mormon Towns."

Throughout his career, Adams was a prolific publisher of his landscape and nature photographs in both books and magazine articles. Underlying these exquisite images of America's natural wonders was an environmentalist message that became more explicit as time went on. An increasing awareness of the interdependence of man and nature, and of humanity's vulnerability to the effects of environmental degradation—the 1930s Dust Bowl was a prime example—made the protection of these assets an urgent matter and motivated Adams's personal activism during his later decades.

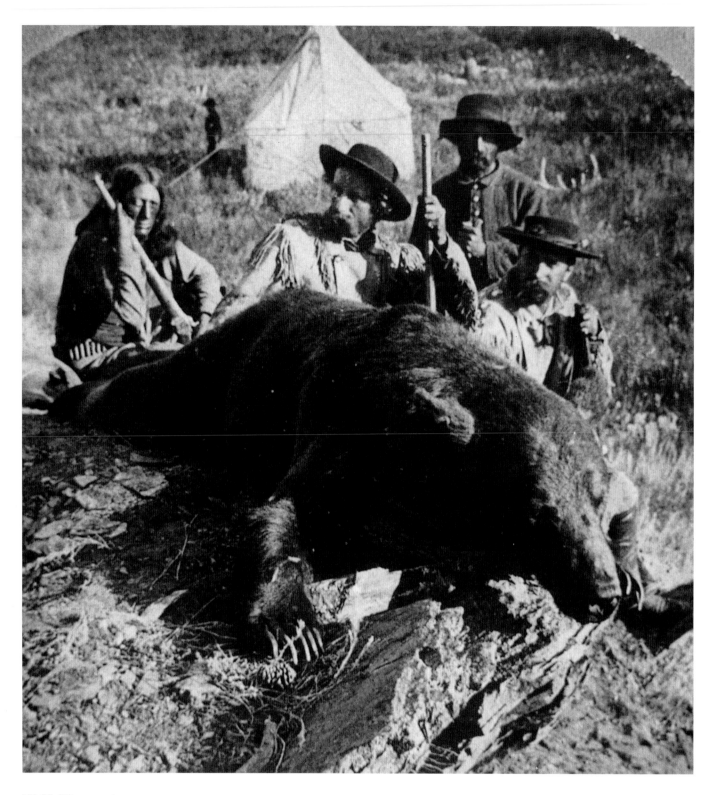

W. H. Illingworth
*Our First Grizzly, Killed by General
Custer and Colonel Ludlow.* 1874

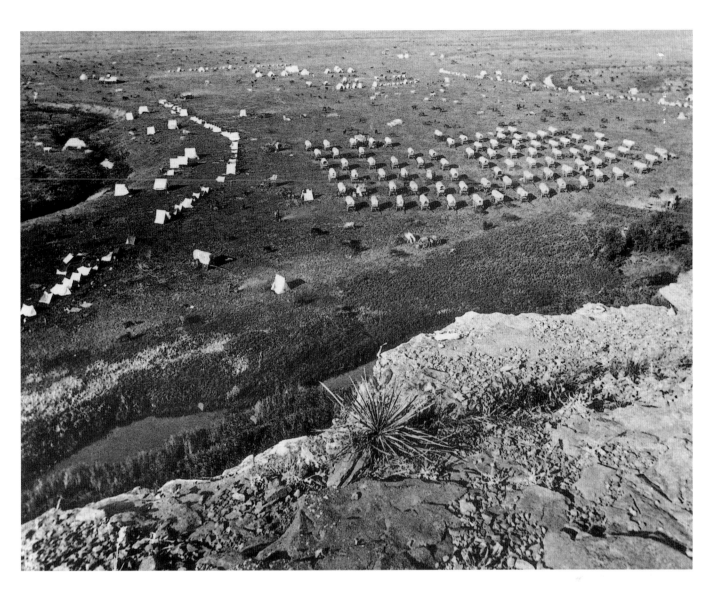

W. H. Illingworth
*Panoramic View of the Camp at Hidden
Wood Creek, on Custer's Black Hills
Expedition.* 1874
National Archives

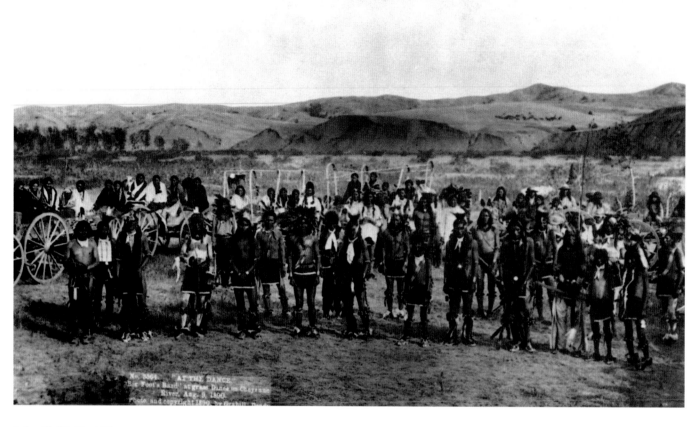

John C. H. Grabill
*Big Foot's Band of Miniconjou Sioux at
Dance, Cheyenne River, South Dakota.*
1890
National Archives

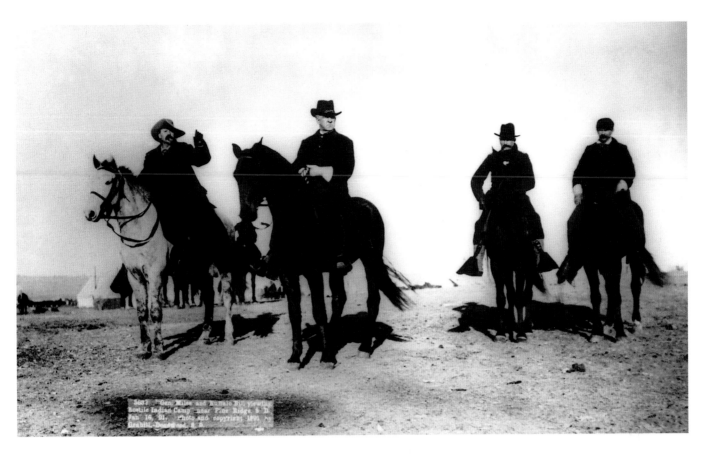

John C. H. Grabill
Brigadier General Nelson A. Miles and
Buffalo Bill near Pine Ridge Agency,
South Dakota. 1891

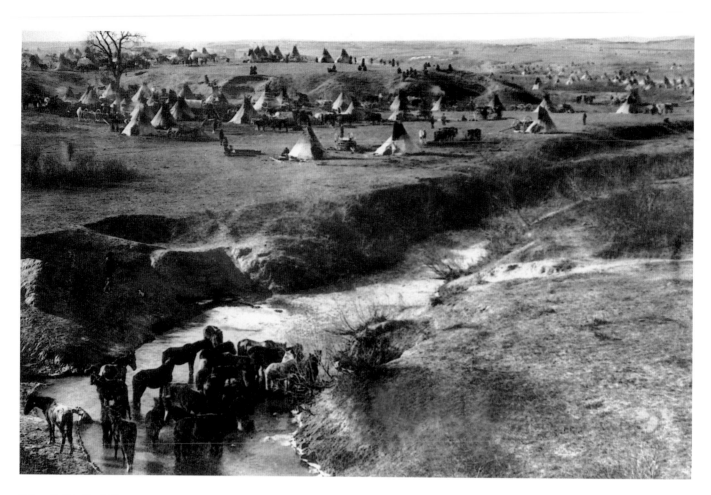

John C. H. Grabill
*Indian Camp on River Brule, near Pine
Ridge, South Dakota.* 1891

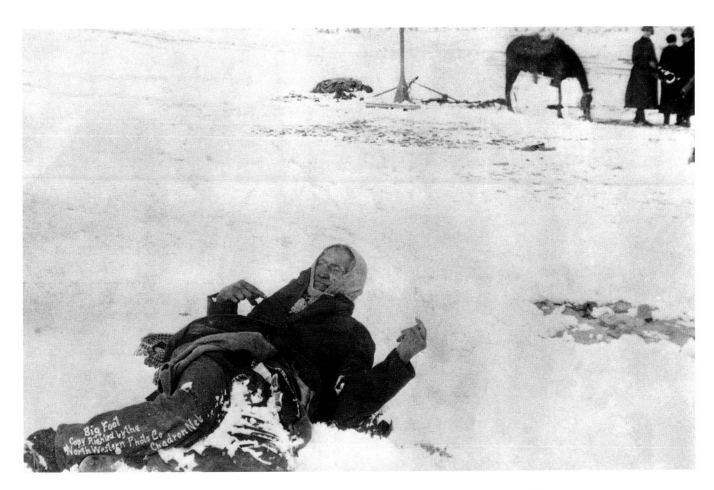

George Trager
*Big Foot, Leader of the Sioux, after Battle
of Wounded Knee, South Dakota.* 1890
National Archives

Charles H. Townsend
*Chinese Drying Shrimps and Mending
Nets, San Francisco Bay.* c. 1889
NATIONAL ARCHIVES

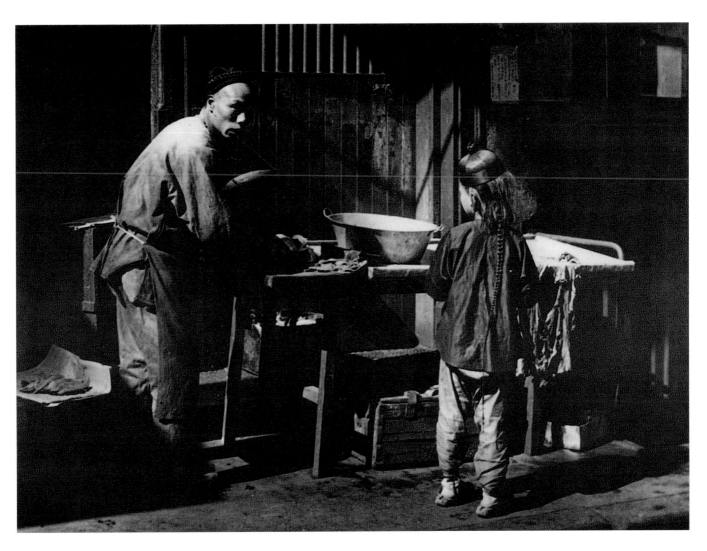

Arnold Genthe
The Butcher, Old China Town, San Francisco

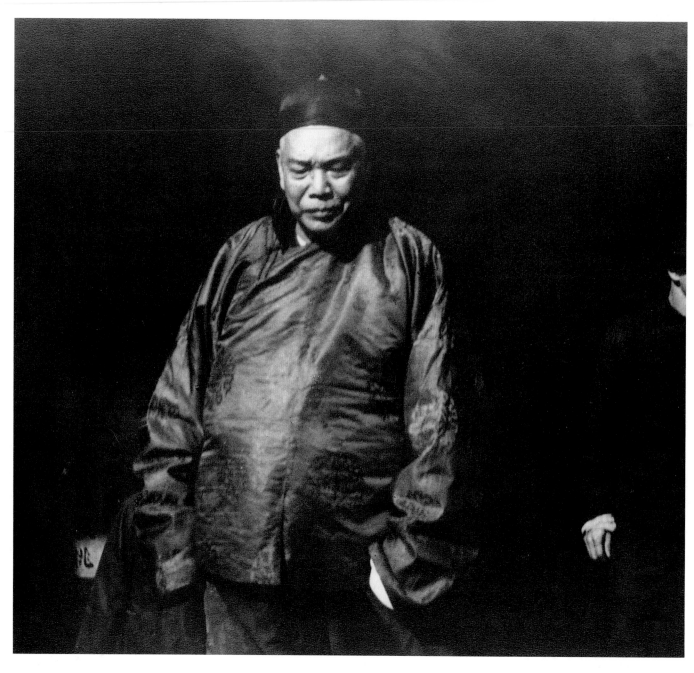

Above:
Arnold Genthe
Merchant with Bodyguard. c. 1896
LIBRARY OF CONGRESS

Opposite:
Arnold Genthe
Toy Vendor, San Francisco
LIBRARY OF CONGRESS

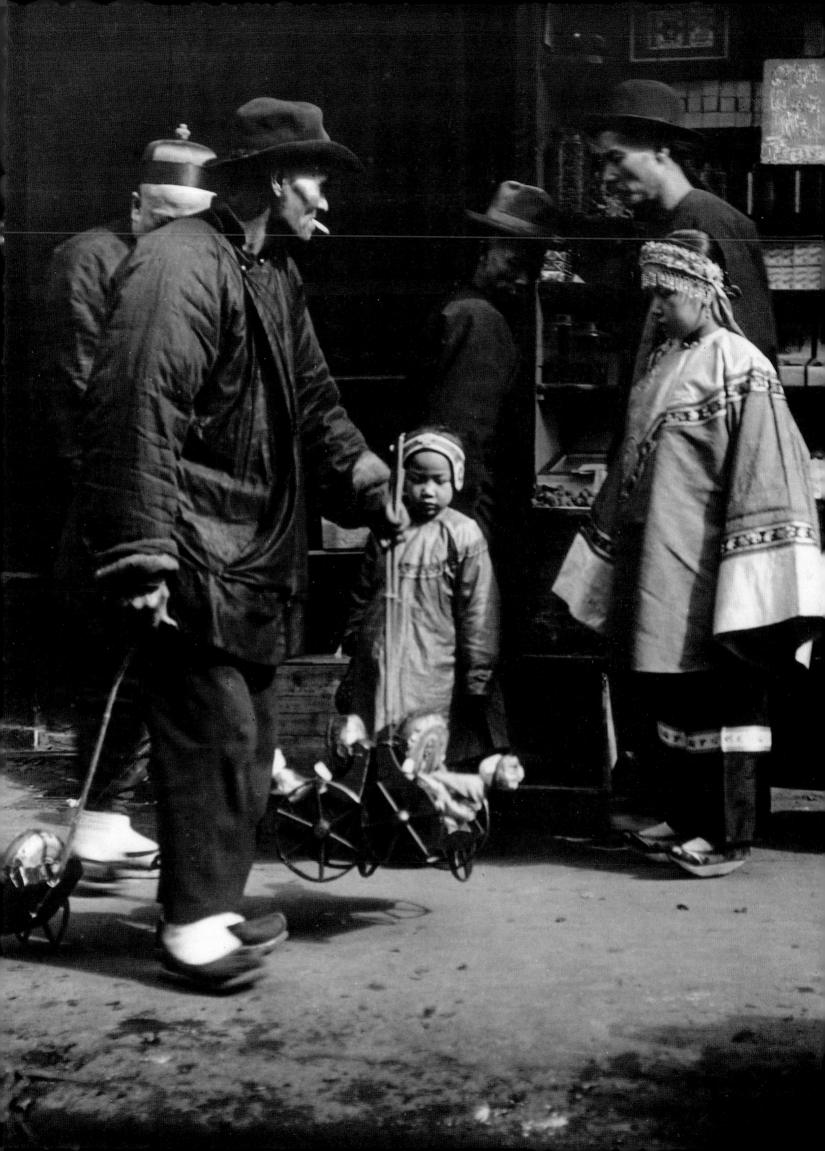

John Vachon
Cars and Parking Meters, Omaha,
Nebraska. 1938
LIBRARY OF CONGRESS

John Vachon
Boxcar and Grain Elevators, Omaha,
Nebraska. 1938

Above:
Dorothea Lange
Refugee Camp near Holtville. 1937
Imperial Valley, California
LIBRARY OF CONGRESS

Opposite:
Dorothea Lange
*Ditch Bank Housing for Mexican Field
Workers.* 1937
Imperial Valley, California
LIBRARY OF CONGRESS

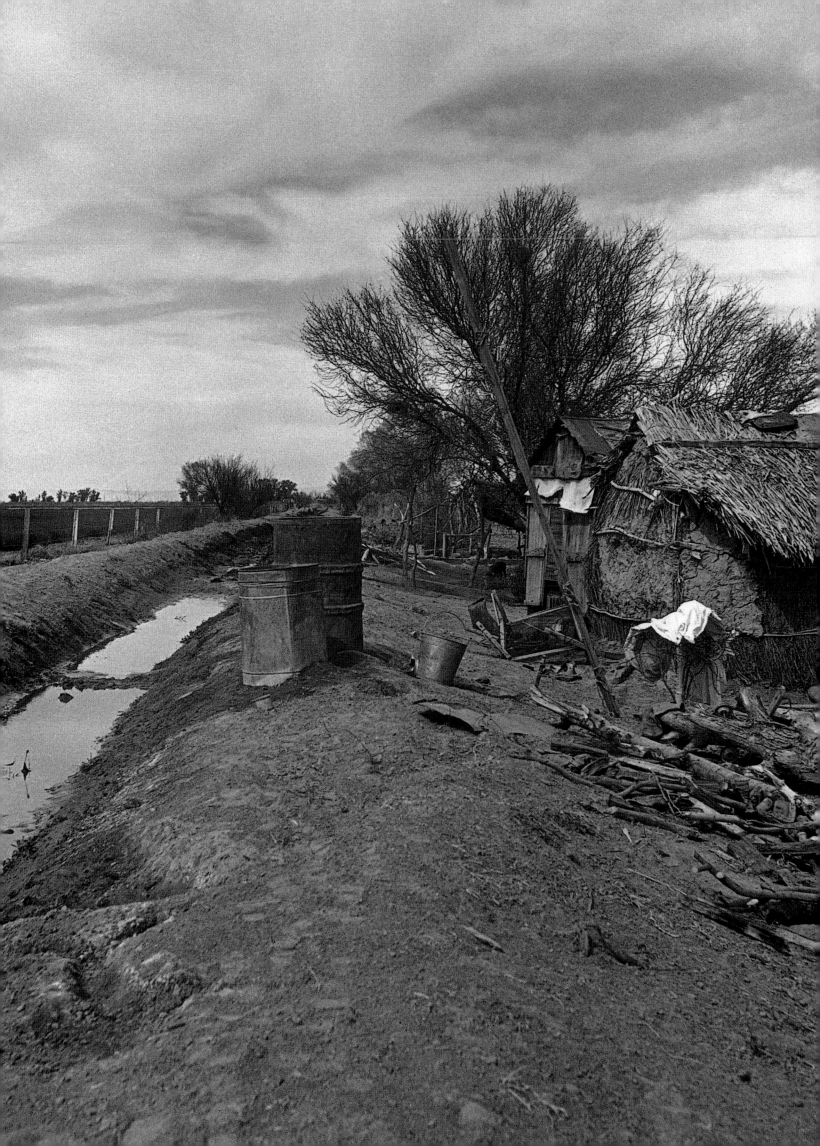

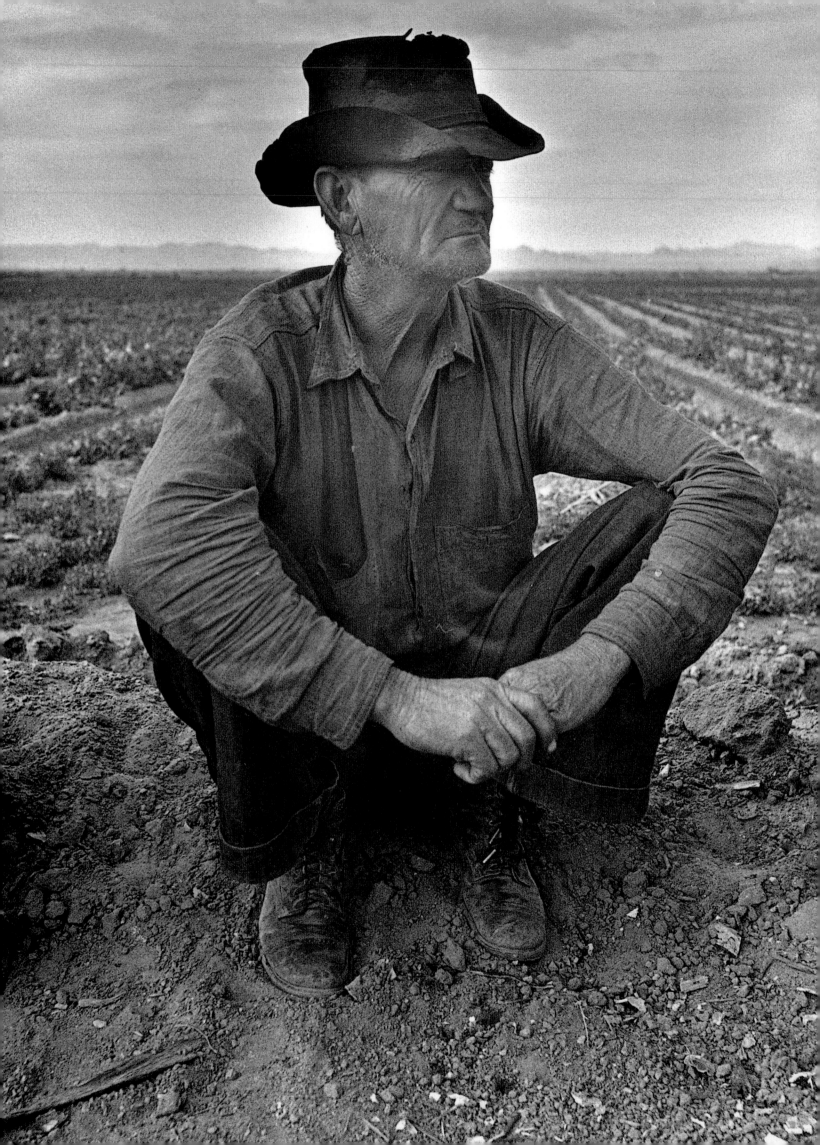

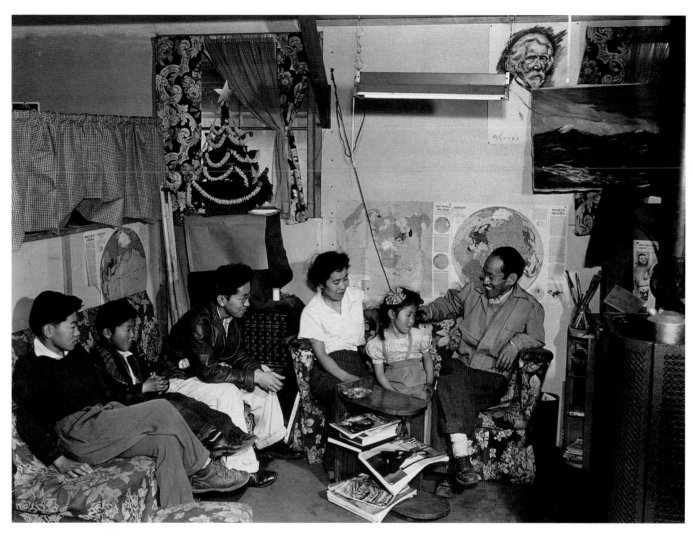

Opposite:
Dorothea Lange
Migrant Agricultural Worker in Holtville.
1937
Imperial Valley, California
LIBRARY OF CONGRESS

Above:
Ansel Adams
Toyo Miyatake Family. 1943
Manzanar Relocation Center
LIBRARY OF CONGRESS

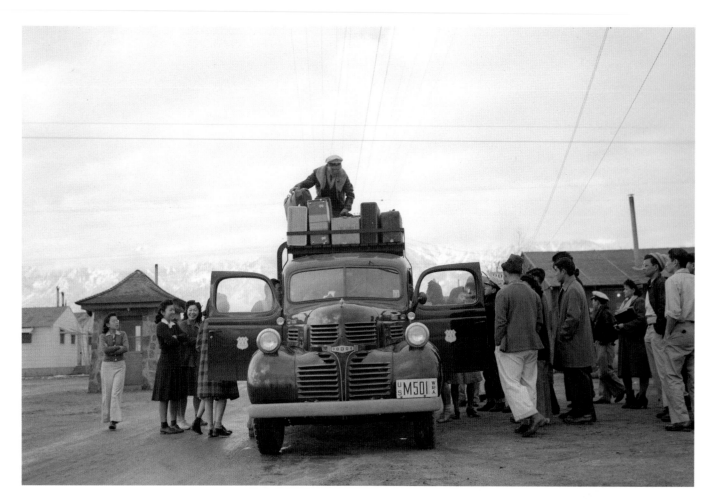

Ansel Adams
Relocation: Packing up to Leave. 1943
Manzanar Relocation Center

Ansel Adams
Pool in Pleasure Park, Manzanar. 1943

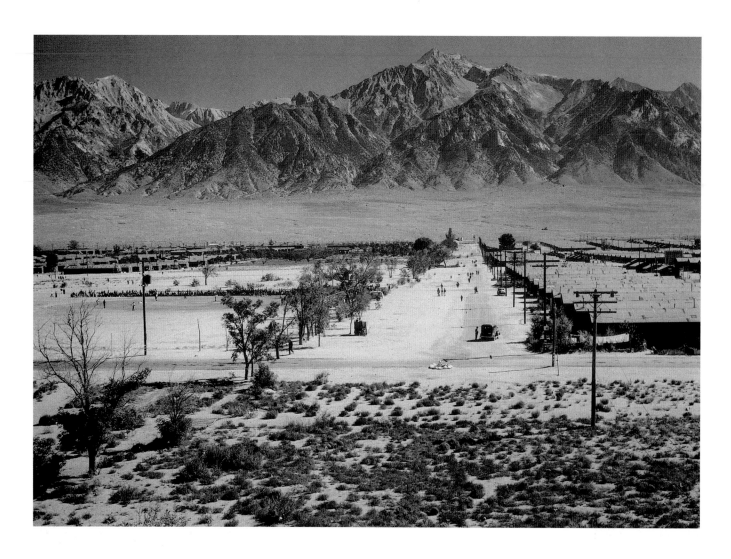

Ansel Adams
Manzanar Relocation Center from Tower.
1943
Library of Congress

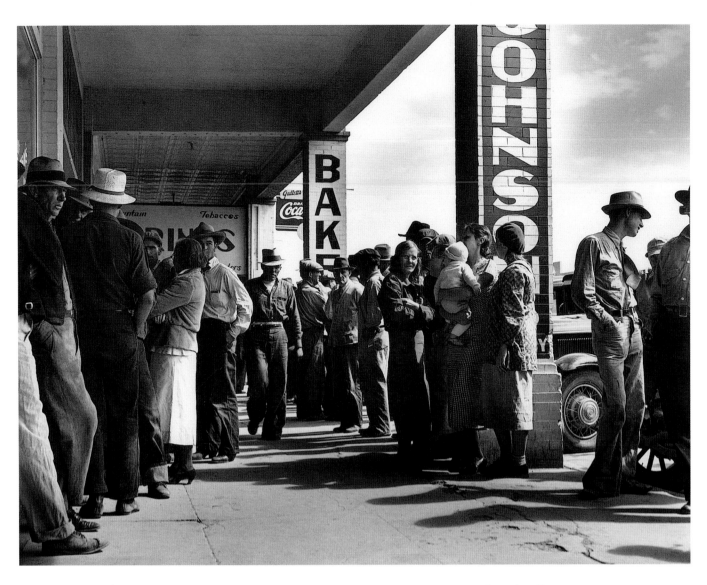

Dorothea Lange
Waiting for Relief Checks in Calipatria.
1937
Imperial Valley, California
LIBRARY OF CONGRESS

Above:
Arthur Rothstein
*At a Saturday Night Dance; a String Band
with its Kitty for Contributions.* 1940
Visalia, California
Library of Congress

Opposite:
Russell Lee
*Spanish-American Farmer Slaughtering
Hog, Chamisal, New Mexico.* 1940
Library of Congress

Russell Lee
Farmstead of a Spanish–American Farmer,
Chamisal, New Mexico. 1940

Russell Lee
Filling Station, Peñasco, New Mexico.
1940
Library of Congress

Russell Lee
*Spanish–American Women Replastering
an Adobe House, Chamisal, New Mexico.*
1940
LIBRARY OF CONGRESS

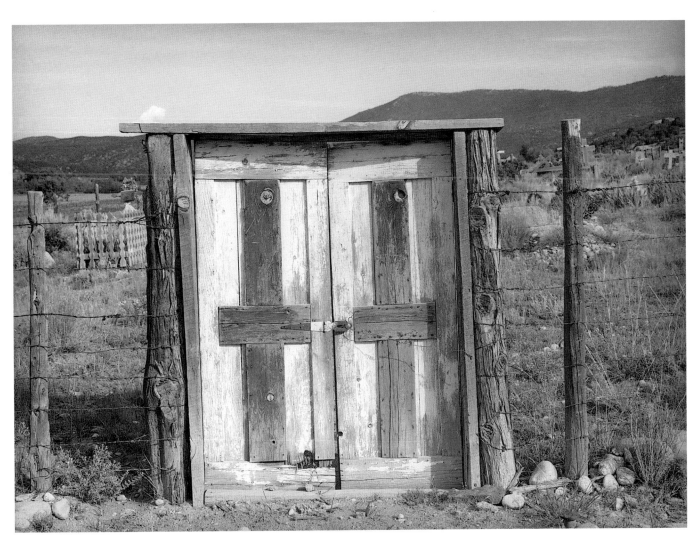

Russell Lee
*Entrance to the Cemetery, Peñasco,
New Mexico.* 1940

LIST OF PHOTOGRAPHS